Charley is a contemporary art publication series edited by
Maurizio Cattelan, Massimiliano Gioni, Ali Subotnick, and
designed by The Purtill Family Business.

The new volume of this independent series brings together the
stray dogs of contemporary art: *Charley 05* features artists that
have remained isolated, forgotten, proudly secluded or slightly
unnoticed, in spite of their visionary work.

Mixing professionals and amateurs, cult figures and unknowns,
Charley 05 composes a gallery of obsessions. It collects the
art of unheard prophets, voluntary outcasts, great solitary masters
and freaks.

Celebrating the extreme subjectivity of nearly 100 artists,
Charley 05 questions accepted hierarchies by insinuating new,
infective doubts.

A multiform creature, *Charley* is bound to transform at each
new appearance. The first volume featured 400 emerging artists
from around the world, selected by a pool of international artists,
curators, critics and art professionals. *Charley 02* provided a
snapshot of the New York City art season in 2001–2002. *Charley
03* looked back in angora to the art of the 80s and 90s. The 4th
issue, *Checkpoint Charley*, was born out of the research conducted
by the curators of the 4th berlin biennial for contemporary art
(2006) and brought together images of works produced by more
than 700 artists. *Charley 05* looks at the periphery, or maybe just
sideways, trying to escape from the center.

Charley is powered by the Deste Foundation, Athens, Greece.

ISBN 10: 1-933045-67-1
ISBN 13: 978-1-933045-67-2

Charley 05

John Altoon
Keith Arnatt
Robert Arneson
Ruth Asawa
Alice Aycock
Morton Bartlett
Gianfranco Baruchello
Thomas Bayrle
Gene Beery
Karl Benjamin
Forrest Clemenger Bess
Scott a.a. Bibus
Douglas Blau
Bill Bollinger
Ian Breakwell
Robert Breer
Sarina J. Brewer
Heidi Bucher
Lowry Burgess
Cameron
James Castle
Joe Coleman
Bill Daniel
Peter Dean
Baby Dee
Jacqueline Fahey
John Fare
Lorser Feitelson
Stano Filko
Roland Flexner
Peter Fritz
Frank Gaard
Jan Groover
Frederick Hammersley
Margaret Harrison
Barkley Hendricks
Edi Hila
Jess Hilliard

Mark Hogancamp
Dorothy Iannone
Will Insley
Jess
Stephen Kaltenbach
Tina Keane
Patrick Keiller
Sister Mary Corita Kent
Konrad Klapheck
Hilma af Klint
Leonard Knight
Christopher Knowles
Július Koller
Panos Koutrouboussis
Jirí Kovanda
Evgenij Kozlov
Jaroslaw Kozlowski
Harry Kramer
Jim Krewson
Ferdinand Kriwet
Tetsumi Kudo
Emma Kunz
Manfred Kuttner
Paul Laffoley
Suzy Lake
Ketty La Rocca
Michael Bernard Loggins
Helen Lundeberg
Manon
Robert Marbury
John Patrick McKenzie
David Medalla
Dan Miller
Richard Allen Morris
Ree Morton
David Novros
Lorraine O'Grady
OHO

Niko Pirosmani
Charlotte Posenenske
Emilio Prini
Noah Purifoy
Miriam Schapiro
Michael Schmidt
Jean-Frederic Schnyder
Colin Self
Stuart Sherman
Sylvia Sleigh
Barbara T. Smith
Francisco Sobrino
Anita Steckel
Harold Stevenson
Myron Stout
Ionel Talpazan
Al Taylor
James "Son" Thomas
Miroslav Tichý
Betty Tompkins
Cleveland Turner
Jeffery Vallance
Stan VanDerBeek
Daan van Golden
Eugene Von Bruenchenhein
Ian Wallace
Melvin Way
Emmett Williams
The Philadelphia Wireman
Paul Wunderlich

John Altoon

John Altoon, an American artist, was born in Los
Angeles, California. From 1947–1949 he attended
the Otis Art Institute, from 1947 to 1950 he at-
tended the Art Center College of Design in L.A.,
and in 1950 the Chouinard Art Institute. Altoon
was one of the interesting characters in the LA
art scene in the 1950's and 1960's. Leah Ollman[1]
describes his life the best in an 1999 article in Art
in America, "With his outsized personality and
reckless intensity, John Altoon loomed large in
the L.A. art scene of the '50s and '60s. Almost 30
years after his death, a survey exhibition[2] afforded
another look at this provocative artist.

John Altoon was one of the baddest of the bad
boys who shaped the Los Angeles art scene of the
1950s and '60s. A swarthy, imposing figure, he
boasted of riding his motorcycle at speeds over 100
mph, and of driving a car blindfolded. Diagnosed
as schizophrenic in his late 30s, Altoon suffered
depression as well as paranoid episodes during
which he destroyed much of his work and threat-
ened to demolish that of others. He was "possessed
by real demons," Larry Bell remembers.[3] Irving
Blum, partner in the legendary Ferus Gallery, re-
calls: "If the gallery was closest in spirit to a single
person, that person was John Altoon—dearly
loved, defiant, romantic, highly ambitious—and
slightly mad."[4] Altoon's struggle with mental ill-
ness, his big, dark, robust personality and his early
death from a heart attack at 43 have, even more
than his art itself, come to define his legacy."

(1925–1969)

Notes
1. Leah Ollman, Art in America, Feb. 1999, "Altoon: Beyond the
Aura—Works of John Altoon."
2. Exhibition held at the Museum of Contemporary Art San
Diego, in 1997, curated by Hugh M. Davies and Andrea Hales.
3. Craig Krull, *Photographing the L.A. Art Scene 1955–1975*, Santa
Monica, Smart Art Press, 1996, p. 5.
4. Ibid.

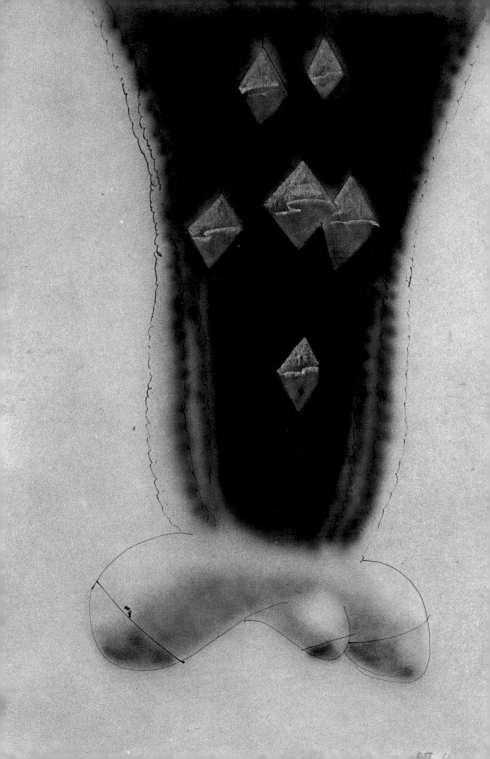

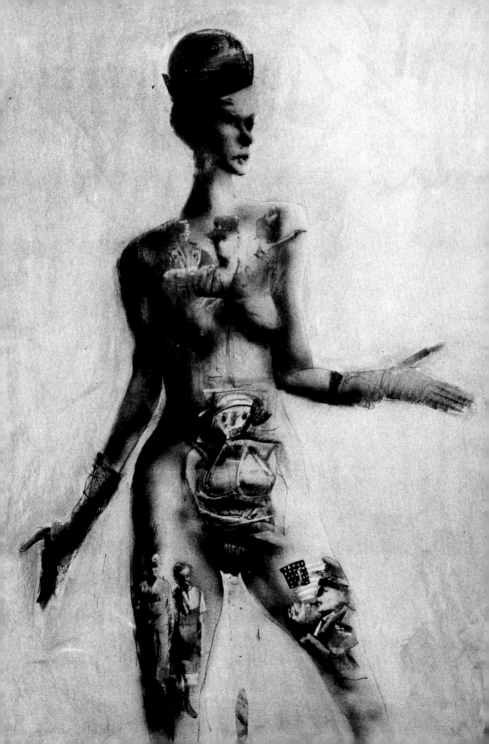

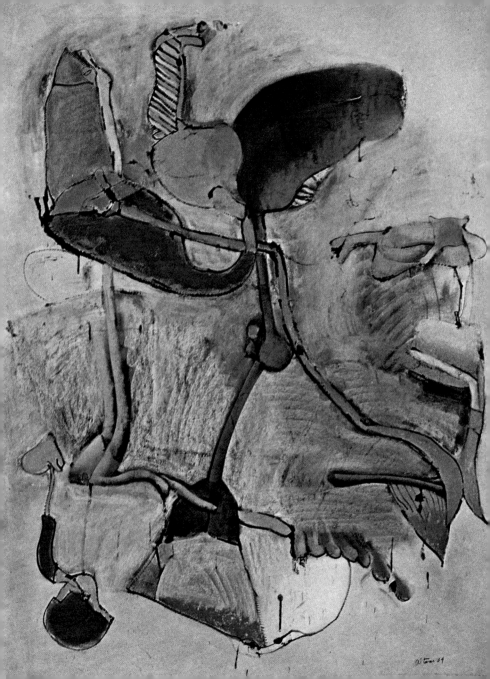

Keith Arnatt

http://collection.britishcouncil.org/html/artist/artist.
aspx?id=18607

Keith Arnatt was born in Oxford and studied at
Oxford School of Art and at the Royal Academy
Schools in London. From a first interest in figure
and portrait painting, he moved towards painting
and sculpture in a style related to Minimal Art.
In 1967 began to make what he called 'situa-
tions'—involving objects and people situated in
landscape and indoor settings which were recorded
photographically and in which the artist and his
behaviour were increasingly important as subject
matter. Arnatt first used photography purely for
the purpose of recording otherwise ephemeral
manifestations, but after a time began to think the
photograph as something separate and to devise
situations in order to get a photographic result.
Partly through the influence of the photographer
David Hurn, who had taught him at Newport
College of Art, Arnatt became interested in the
history and tradition of 'straight' or documentary
photography and the very particular character of
the photographic art.

(1930–)

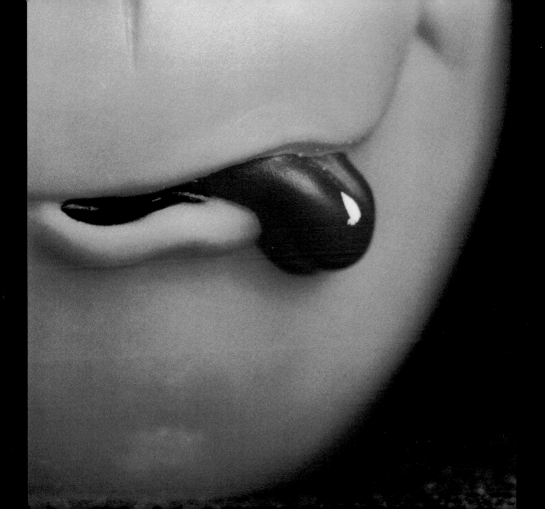

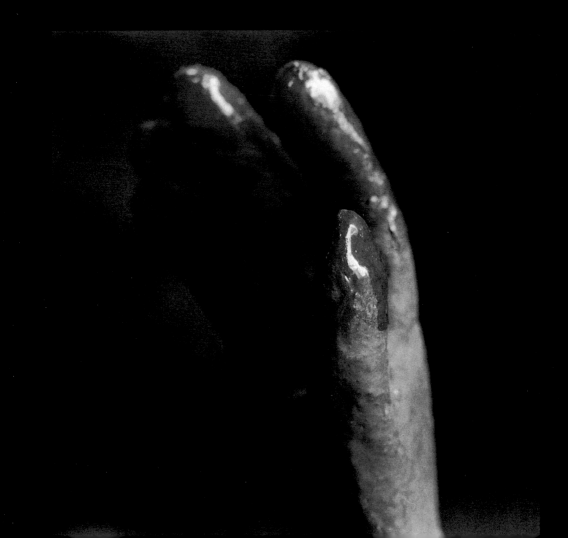

Robert Arneson

Robert Carston Arneson was an American sculptor and professor of ceramics in the Art department at UC Davis for four decades.

Arneson was born in Benicia, California. After spending time early in life as a cartoonist for a local paper, Arneson studied art education in Oakland, California, and went on to receive an MFA in 1958. Starting in the 1960s, Arneson and several other California artists began to abandon the traditional manufacture of functional items in favor of using everyday objects to make confrontational statements. The new movement was dubbed "Funk Art," and Arneson is considered the "father of the ceramic Funk movement." One of Arneson's most famous and controversial works is a bust of George Moscone, the mayor of San Francisco who was assassinated in 1978. Inscribed on the pedestal of the bust are words representing events in Moscone's life, including his assassination: the words "Bang Bang Bang Bang" and "Harvey Milk Too!" are visible in on the front of the pedestal. In 1992 Robert Arneson died after a long battle with cancer.

Arneson used common objects in his work, which included both ceramic sculptures and drawings. He appeared in many of his own pieces—as a chef, a man picking his nose, a jean-jacketed hipster in sunglasses.

Even his Eggheads bear a self-resemblance. Among the last works Arneson completed before his death, the last of the Eggheads were installed on campus at UC Davis in 1994. The controversial pieces continue to serve as a source of interest and discussion on the campus, even inspiring a campus blog by the same name.

(1930–1992)

Extenal link: http://verisimilitudo.com/arneson/

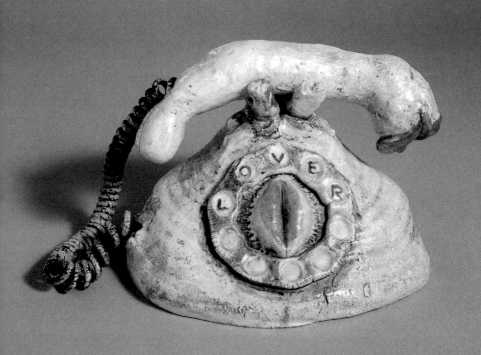

Homage to
Philip Guston
1913-1980

Ruth Asawa

Ruth Asawa is an American artist, who is nationally recognized for her wire sculpture, public commissions, and her activism in education and the arts. In San Francisco, she has been called the "fountain lady" because so many of her fountains are on public view. In this website, you can learn about her life, her work, and her development as an artist.

When Ruth was 16, she and her family were interned along with 120,000 other people of Japanese ancestry who lived along the West Coast of the United States. For many, the upheaval of losing everything, most importantly their right to freedom and a private, family life, caused irreparable harm. For Ruth, the internment was the first step on a journey to a world of art that profoundly changed who she was and what she thought was possible in life. In 1994, when she was 68 years old, she reflected on the experience: "I hold no hostilities for what happened; I blame no one. Sometimes good comes through adversity. I would not be who I am today had it not been for the Internment, and I like who I am."

(1926–)

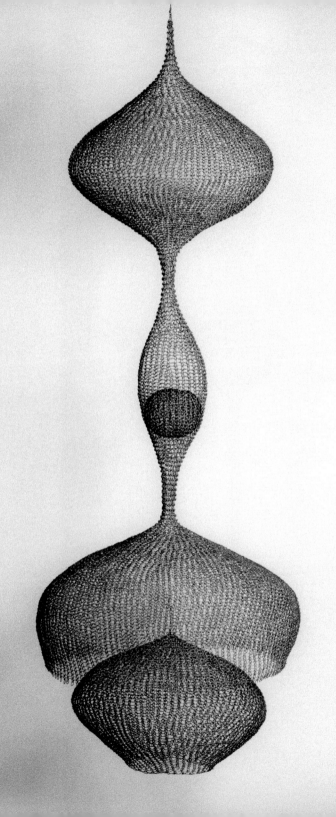

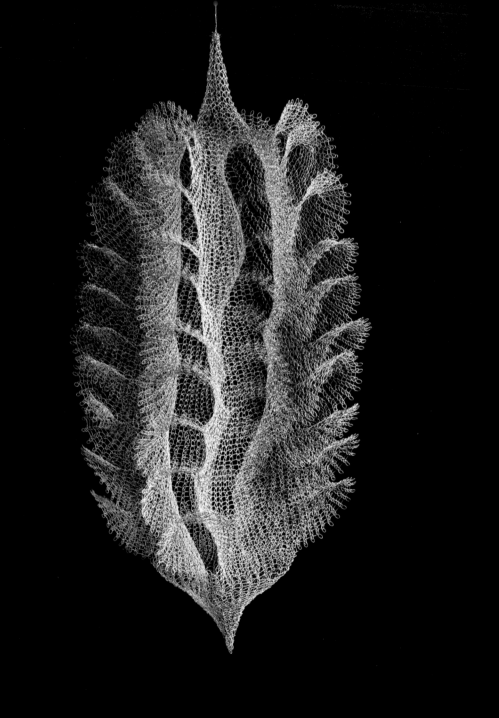

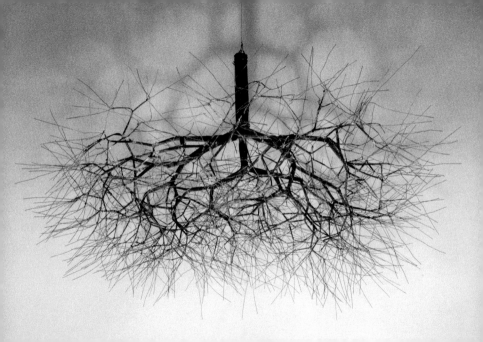

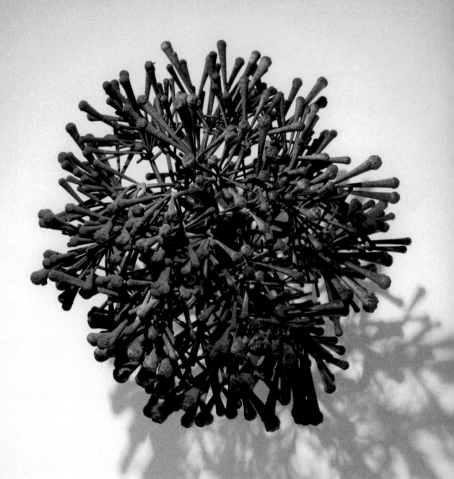

Alice Aycock

Aycock studied at Douglass College in New Brunswick, New Jersey graduating with a bachelor of arts in 1968, she then went to New York where she studied for her masters at Hunter College where she was taught and supervised by Robert Morris, she graduated in 1971. Her early sculptures were site specific and were largely made from wood and stone, in the 1980s she began to use steel.

She has created installations at the Museum of Modern Art, New York (1977), the San Francisco Art Institute (1979), Museum of Contemporary Art, Chicago (1983), and outside the United States including Israel, Germany, The Netherlands, Italy, Switzerland, and Japan. In 1983 a retrospective exhibition was organized by the Württembergischer Kunstverein and traveled in Germany, The Netherlands, and Switzerland.

She is currently a member of the faculty at the School of Visual Arts in New York.

Her current project is the *Ghost Ballet* for the East Bank Machineworks, a public sculpture placed on the Cumberland River in Nashville Tennessee.

(1946–)

She has written several books about her work, including:
1. *Alice Aycock projects and proposals, 1971-1978*, Muhlenberg College Center for the Arts, 1978.
2. *Alice Aycock projects, 1979-1981*, University of South Florida, 1981.

References:
1. Hobbs, Robert. *Alice Aycock: Sculpture and Projects*. The MIT Press, 2005. 400pp.
2. National Gallery of Art. Alice Aycock.

Morton Bartlett

Born an orphan, Morton Bartlett attended
Harvard University and worked in a series of jobs,
including advertising, furniture sales, a stint in
the United States Army and, finally, a printing
business. He never married and had no children,
but created a family by sculpting 15 dolls—12
girls and 3 boys, ranging in age from 8 to 16. He
then dressed and posed these dolls, in sometimes
sexually loaded photographs. His work was not
discovered until his death at age 83.

Marion Harris bought the 15 sculptures and 200
photographs and later published a book on Mor-
ton entitled *Family Found, The Lifetime Obsession
of Morton Bartlett*. Morton has been compared
with Henry Darger, another outsider artist who
lived alone and created a vivid and sometimes
disturbing fantasy life involving young girls. Both
Darger and Morton have avid cult followings,
although some critics have charged that both men
are being exploited by having their very private art
showcased publicly. Some critics have suggested
that both Morton and Darger were pedophiles,
although there is no evidence to suggest that either
man ever actually committed any crimes against
children. In a Harvard 25th anniversary report,
Morton obliquely commented on his motivations,
writing, "My hobby is sculpting in plaster. Its pur-
pose is that of all proper hobbies—to let out urges
that do not find expression in other channels."

(1909–1992)

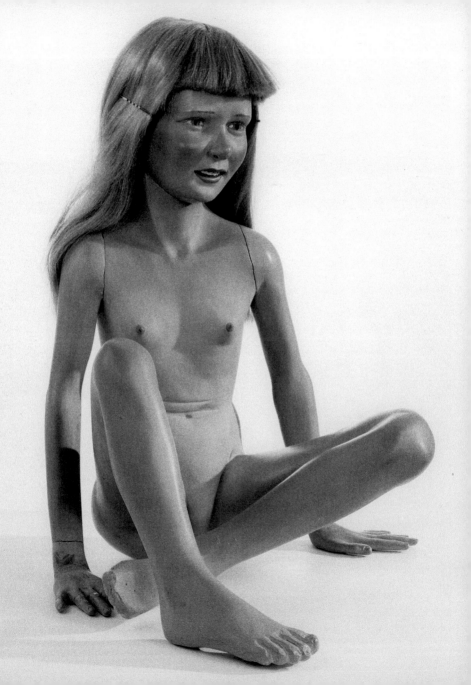

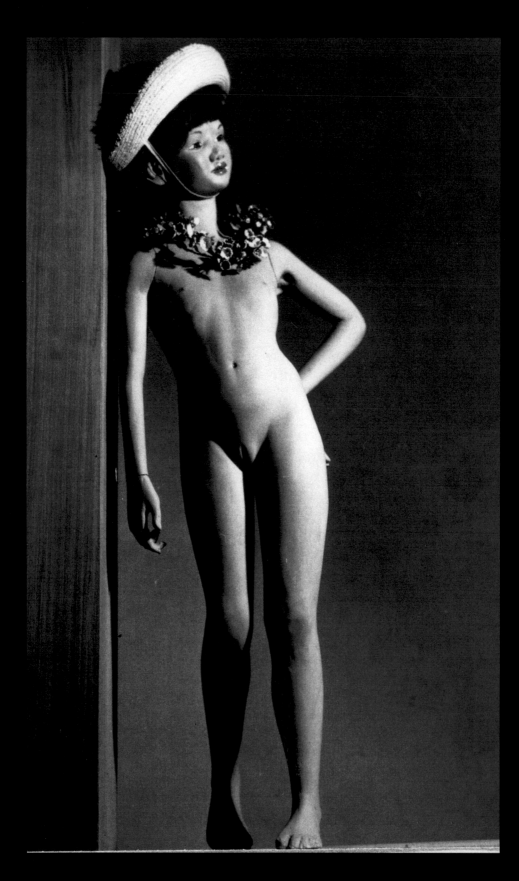

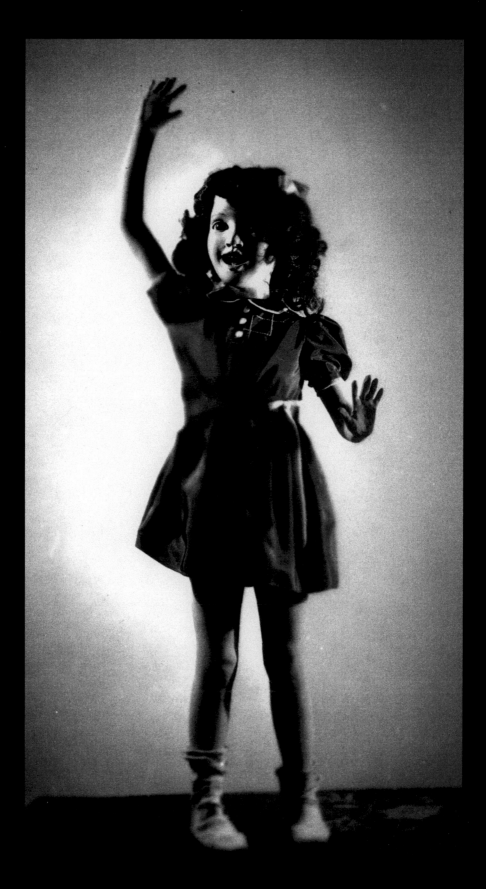

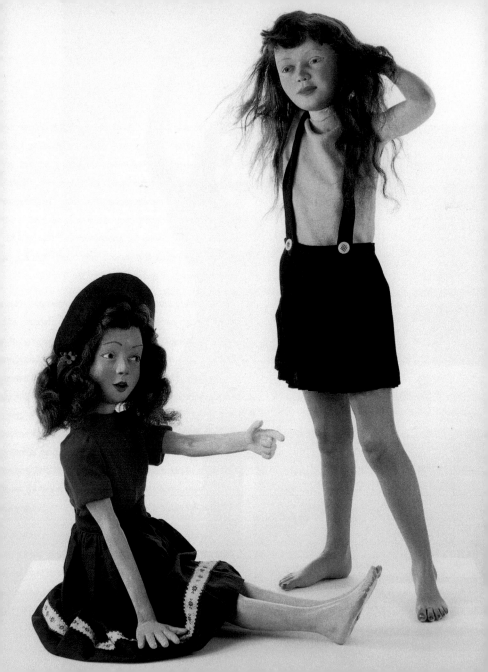

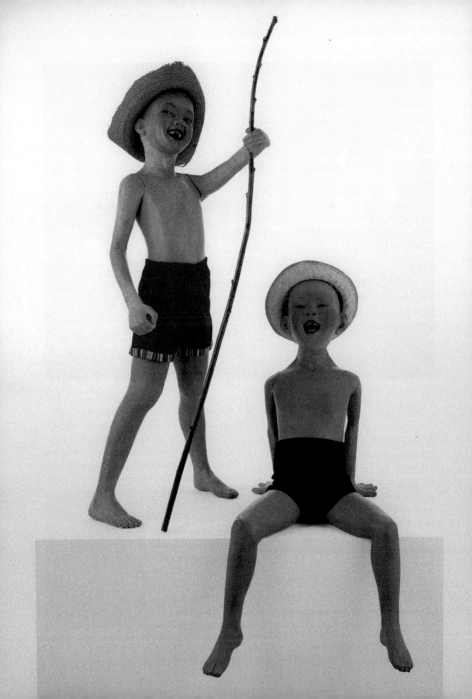

Gianfranco Baruchello

www.museion.it/eng/668.html

Gianfranco Baruchello was born in Livorno in 1924 and lives and works in Rome. His work, like that of Öyvind Fahlström, has been a part of the international scene ever since the early 1960s, and appropriates modes of awareness that seem to derive from the media of mass communications. His subjects can be anything at all, from politics to philosophy, from sexual desire to archaic and classical philosophy, to images derived from comic strips. Each of his works turns its attention to a vast range of experience that finds articulation on any number of levels. He himself has recently written: "I paint because I think, because I desire, because I see. My painting isn't simply an homage to the existence of the eye. Everything—fear, suffering, dreams, pain, love, change—becomes a part of my painting. There's a sense in which I paint in much the same way that I give my life over to the experience of all these other things that apparently have nothing to do with painting. It's obvious, yet bears repeating, that painting isn't made with colors and brushes alone. A painting comes into existence when you somehow manage to aggregate things on a surface in a way that gives rise to an image, even if this image is pure color. A painting is a total image, or an image that itself grows total".

"...Throughout my life, I have played role of both spectator and target in the game of the interpretations of what I do, sometimes intervening to no particular effect, at other times holding silence (and thus consenting). But one also reaches the moment of experiencing the imperious temptation to subtract oneself from all external measures, from other people's opinions, and from the very possibility of communicating something to others, even involuntarily. This doesn't however imply any loss of the impulse to continue to paint for myself, simplifying, and making things ever more essential, while searching out a "stenography of origins." I refer to this phase of my life and the recent works that have marked it as "Via libera al Narciso," or "An Open Road for Narcissus" (seeing it as well to include the video tapes of 1996 and 1997 that appeared at much the same time as the paintings). All formal considerations are reduced to a minimum, and I have been able more clearly than ever to make full use of my huge and highly private repertory of mental images, employing them in much the same way in which I might make use of any graphic sign at all, such as a blot or a patch of color. The goal, in short, is to reaffirm the absence of any intention to delineate stories, concepts, or projects, and exclusively to deal with modes, humors, irony and "nonsense," just as occurred at the very beginning of my attempt to approach the world of images."

(1924–)

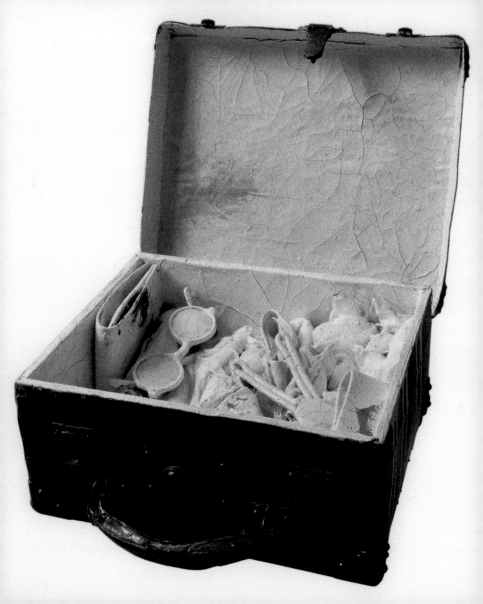

Thomas Bayrle

www.kulturstiftung-des-bundes.de/main.jsp?articleID=1091&ap
plicationID=203&languageID=2

This well-known Frankfurt artist (born in 1937)
and prominent representative of German art
taught at the Academy of Fine Arts, Städelschule
in Frankfurt am Main from 1975 to 2002. He has
received a number of awards and prizes, includ-
ing the Prix Ars Electronica, Linz (A) in 1995,
the Hessischer Staatspreis für Kultur (Hessian
State Prize for Culture) in 1998 and the Kölner
Kunstpreis (Cologne Art Prize) in 2000. Like
Andy Warhol, Bayrle also examined the phenom-
enon of the "masses" in the 1960s in his drawings,
photocopy collages and film animation sequences,
examining the idea of generating "superstructures"
through geometric patterns of images with a vari-
ety of techniques and materials. Bayrle has char-
acterised his work method as follows: "My view of
society is flat—horizontal—(electric) field / fabric
/ network. The vertical elements are plucked from
the surface, like hay grass in a meadow." In 2002
and 2003, the Städelschule in Frankfurt honoured
their longstanding professor with an exhibition
featuring a wide range of works created by the
artist throughout his lifetime. Bayrle's artwork
has been shown in 33 solo exhibitions at venues
around the world including the Documenta III
and IV. Many of his catalogues have also appeared
in China where Bayrle worked as a lecturer at the
Qinghua University in Beijing in 1997. Bayrle
plans to use his scholarship to create a computer
animation based on Maoist propaganda photog-
raphy which will confront the image of the old,
"static" China with images of high-speed urbanism
typical of "new" China.

(1937–)

Gene Beery

Married to Florence L. Merritt
5 Children
Attended Art School and University
did not graduate
Many Shows and Collections
Painted the masterpiece "this painting temporarily
out of style watch for reopening soon," 1960

The Artist's Statement
Art is my mistake free activity I'd like to share it
with others!
Imagination experiece and content are my forms.

—Gene Beery '06

(1937–)

LIFE WITHOUT A
SOUND SENSE OF TRA
CAN SEEM LIKE
AN INCOMPREHENSIBLE NUP

GLART TODAY

THESE DAYS THERE
ARE MANY ZARTISTS, SOME
GOOD MARTISTS AND MANY YARTISTS
AND SO THERE IS ENOUGH
GLART FOR ALL SMART TASTE,
A PART OF THE WART
SCENE SEEMS TO INDICATE
THOUGH, THAT SOMETIMES,
THERE IS MORE FART THAN
HEART IN THE CHART! SINCE
A TRUE TART CAN NEVER
BE DEPARTED, START
SHOULD BE CARTED IF DART

THIS PAINTING WILL ALWAYS BE INTERESTING

Karl Benjamin

Color is the subject matter of painting. It possesses a powerful emotive quality, unique in each individual. Regardless of style or content, color is the material from which paintings are made. This understanding has guided the work of Karl Benjamin since the inception of his career as a painter in the early fifties.

A dazzling practitioner of what critic Jules Langsner termed hard edge painting and one of the four artists featured in the landmark 1959 Abstract Classicists exhibition, Benjamin fills each canvas with meticulously orchestrated color. A sharp-angled wedge of forest green lined by the tenderest block of spring green forms something like the feeling of a hill or does it? Benjamin's intuitive sensitivity to the peculiar union of form and color produces works that defy reason and return the viewer to the purely sensual delight of seeing.

Karl Benjamin's work has been exhibited throughout the United States and is included in a number of prestigious private and public collections. Louis Stern Fine Arts is the exclusive representative of his work and this exhibition marks his first with the gallery.

Karl Benjamin was born in Chicago, IL in 1925. He received his BA from University of Redlands, Redlands, CA and his MFA at Claremont Graduate School, Claremont, CA. He was awarded the National Endowment for the Arts Grant for Visual Arts in both 1983 and 1989. His work has been featured in numerous museum exhibitions and is included in the public collections of the Los Angeles County Museum of Art; Museum of Contemporary Art, Los Angeles; Museum of Modern Art, Israel; Oakland Museum, Oakland, CA; San Francisco Museum of Modern Art, CA; Seattle Art Museum, WA; and the Whitney Museum of American Art, NY, among others. For many years, Benjamin taught painting at Pomona College and Claremont Graduate School, and currently is Professor Emeritus. He lives in Claremont, CA.

(1925–)

Forrest Clemenger Bess

"I term myself a visionary painter for lack of a bet-
ter word. I can close my eyes in a dark room and if
there is no outside noise or attraction, plus, if there
is no conscious effort on my part—then I can see
color, lines, patterns, and forms that make up my
canvases. I have always copied these arrangements
exactly without elaboration." Throughout his life
as an artist, Forrest Bess strove to invest a personal
symbology with meaning, developing a complex
visual vocabulary to accompany his obsessive devo-
tion to beliefs and theories that alienated him from
the mainstream.

Bess's small paintings are filled with elemental
and highly personal images. To Bess, his visions
and the resulting paintings came to represent a
pictorial language that he believed had universal
significance. Along with medical and psychological
theories based on his own unguided scholarship,
he believed his imagery formed a blueprint for an
ideal human state, with the potential to relieve
mankind of suffering and death.

Born October 5, 1911, in Bay City, Texas, Bess
lived his life there in virtual isolation, on a strip of
land accessible only by boat. "I try to tell myself
that only by breaking completely away from soci-
ety can I arrive at a reasonable existence." A semi-
migrant childhood was followed by some years at
college, where he began by studying architecture
but found himself diverted into studies of religion,
psychology, and anthropology, readings that would
later inform his own radical theories.

Forrest Bess died in a Bay City nursing home in
1977 from skin cancer. In the years following his
death, his reputation as an artist began to build,
and he is now regarded as a unique phenomenon,
an artist who cannot be grouped with any one
school but who answered solely and completely to
his own vivid personal vision.

(1911–1977)

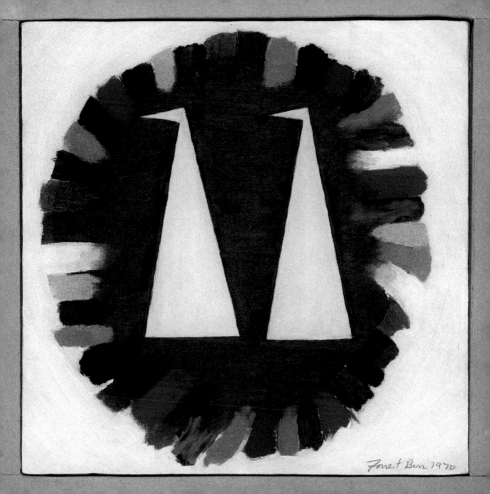

Forest Bess 1970

Scott a.a. Bibus

"from blobs to beasts..."

The youngest member of the M.A.R.T., Scott a.
a. Bibus was classically trained in the hermetic
art of taxidermy in the rural woodland of East
Central Minnesota. Now, from the bowels of a NE
Minneapolis warehouse, he administers Liquid
Fish Taxidermy, an artistic enterprise dedicated to
creating the most extreme taxidermy on the planet.
If there's tons of blood, a severed digit or two, and
a pile of steaming viscera, you can bet it is the
work of Liquid Fish.

M.A.R.T.—The Minnesota Association of Rogue
Taxidermists—is a veritable rout dedicated to a
shared mandate to advocate the showmanship of
oddities; espouse the belief in natural adaptation
and mutation; and encourage the desire to create
displays of curiosity.

Member since Nov 14, 2004.

For more about Scott a.a. Bibus: http://www.liquid-fish.com/

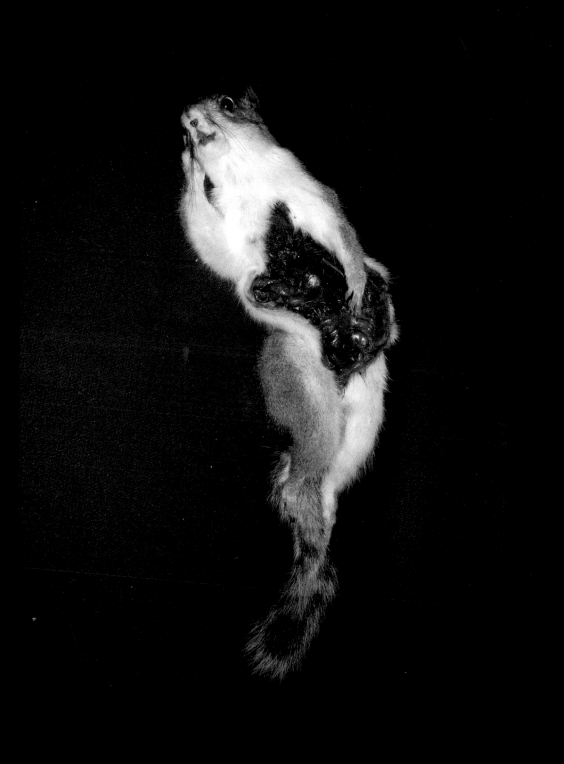

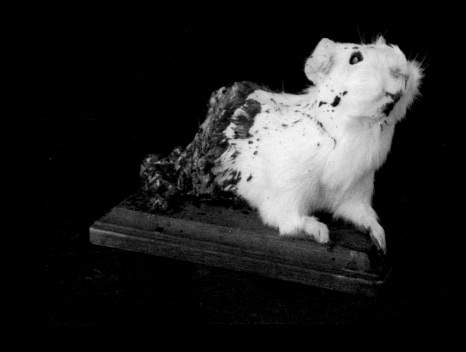

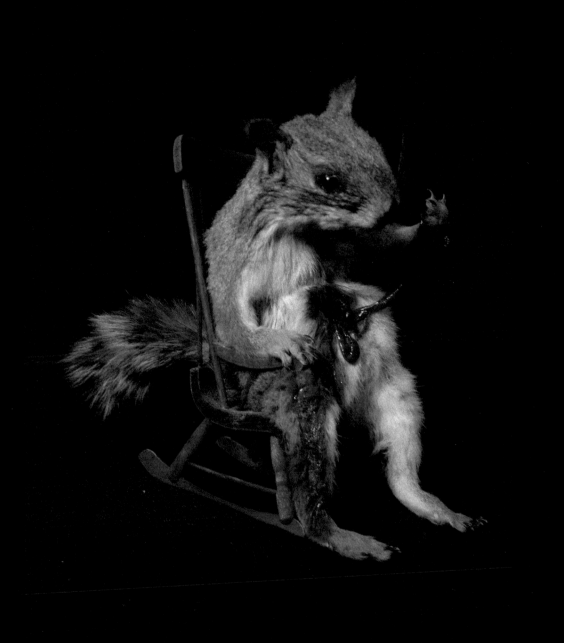

Douglas Blau

Today, to be an artist trying to give private experi-
ences or avidities or interests a form that is lucid
but not slick is to refuse both the Barney route
and the Beacon route, and among those who this
spring were going their own ways were artists of
such utterly different persuasions as Douglas Blau,
Scott Brodie, and Barbara Goodstein. Blau, whose
Annunciation was included in a show called "Liv-
ing Inside the Grid," at the New Museum, makes
variations-on-a-theme assemblages out of found
photographs—often film stills and reproductions
of paintings—which in this instance compose a
Post-Minimalist hymn to women in bed, or just
waking up, or receiving some piece of startling
news.... Only Blau, who presents his found
photographs as discrete images in uniform black
frames, does work that is related to the stream of
Minimalist thinking that dominates Dia:Beacon.
Yet he, as much as Brodie or Goodstein, views the
making of art as the revelation of an enigma, and
such a view is, paradoxically, endangered by the
wholesale acceptance of artistic obscurity that Dia:
Beacon proposes. Of course, the situation is not
black and white (though that is the overwhelm-
ing no-color scheme at Dia:Beacon). I know that
Barney's admirers speak of his richly allegorical
themes, and there is an imaginative lift here and
there at Dia:Beacon—in Blinky Palermo's playful
array of black, red, and yellow paintings, and in the
visionary perversities of the sculpture of Louise
Bourgeois, whose work has been installed in a
top-floor space, where she seems to be meant to
play the role of the madwoman in the attic. Yet
the unquestioning enthusiasm for a Minimalist
temple such as Dia:Beacon can be indistinguish-
able from a refusal to engage with the very matters
of form, sensibility, iconography, personal touch,
and psychological shading that give modern art
its complex energy. The difficulty of modern art
is not a challenge to be met; it is a permanent and
healthy condition. The audience that has accepted
everything will never really see anything.

(1955–)

Fictions

The Times
The Chronicle &
The Observer

Bill Bollinger

www.mitchellalgus.com/pr/bollingerevans07.html
http://findarticles.com/p/articles/mi_m1248/is_3_88/ai_60130186

Bill Bollinger's work of the 1960s and 1970s, widely shown and highly regarded at the time, is now dauntingly obscure. Bollinger exhibited at the Bianchini and Bykert Galleries, Rolf Ricke in Cologne, and in the early 1970s at OK Harris. He was the elusive subject of a revelatory article in *Art in America* by Wade Saunders, "Not Lost, Not Found" (March 2000). The sculptures being shown here were done in 1973 and comprised Bollinger's last exhibition in New York in 1974. They are roughhewn, sand-cast, iron pourings made in chapfallen response to Henry Moore; an exposé of the illusion of solidity and weight flaunted by traditional cast-metal sculpture.

from *Not Lost, Not Found: Bill Bollinger*
Art in America, March, 2000, by Wade Saunders

In the late 1960s, sculptor Bill Bollinger showed with—and was routinely compared to—such other emerging artists as Richard Serra, Keith Sonnier and Bruce Nauman, all of whom admired his work. Today, 12 years after his death, Bollinger is forgotten, and his radically original sculpture has been lost virtually in toto. Here a fellow sculptor traces Bollinger's career, uncovering the dark realities of a life in art.

(…)

History, we are told, is written by the winners, in the art world as elsewhere. Fellow artists, curators, dealers and some critics recognized William (Bill) Bollinger as one of the important sculptors exhibiting in New York City in the late 1960s, yet his work is now invisible, and few remember his name. Bollinger's sculpture mattered, and I decided to write about him so others would know his work. The writing took longer than I'd planned. Two intertwined stories follow; one concerns Bollinger's sculpture and life, the second my passion for his work. This account is incomplete, but there's been no other in 25 years.

(1939–1988)

Ian Breakwell

Ian Breakwell was a world renowned British fine artist. He was a prolific artist who took a multi-media approach to his observation of society. Breakwell was born in Derby and studied at Derby College of Art, graduating in 1964.

During the 1970s Breakwell worked with the Artist Placement Group (APG), which dropped artists into government departments in the perhaps forlorn hope that their intuition would improve the decision-making process. Breakwell's placements included the Department for Health and Social Security; under its auspices he worked in Broadmoor and Rampton hospitals. The results included a report, co-written with a group of architects, recommending top-to-bottom changes at Rampton, and a film, *The Institution* (1978), made with the singer-songwriter and artist Kevin Coyne. A diary entry recalls Breakwell's first APG visit to Rampton, which immediately stirred memories of performing there as a child-conjuror: the incongruous juxtaposition is entirely characteristic.

In the 1980s, he made a number of adaptations of his diary for Channel 4. Later he co-edited (with Paul Hammond) two important anthologies, akin to the work of Mass Observation: *Seeing in the Dark* (1990), an assemblage of hundreds of accounts of cinema-going; and *Brought to Book* (1994), which documented the myriad forms of bibliophiliac obsession. Although he had a longstanding relationship with the Anthony Reynolds Gallery in London, his keenness to develop new ways of working led to residencies with, among others, Tyne Tees Television (1985) and Durham Cathedral (1994–95).

Works of this period included *Auditorium* (1994), a film made with composer Ron Geesin, in which we are taken to a variety show, but are only allowed to see the audience's reactions; the results are hilarious and touching.

(1943–2005)

1973 JANUARY

FEBRUARY

S 4 11 18 25
M 5 12 19 26
T 6 13 20 27
W 7 14 21 28
T 1 8 15 22
F 2 9 16 23
S 3 10 17 24

(7-358) Week 1

1st after Epiphany Sunday **7**

Sunset. The sea is flat calm.
The flags hang limp on the
flagpoles. All the deckchairs
which line the promenade are
empty except for one, in which
sits a blind man with a cane,
staring blankly out to sea.
Just offshore a pair of black
flipper-clad feet rise above
the water and then sink back
down again.

The mothers are chanting :
"Castrate black men!
Castrate black men!
Castrate black men!"

London.
: Smithfield Market.
3 years ago.

This date ten years ago:
29 JUL 1975 TUES

Robert Breer

For more than 40 years, Robert Breer has been making films that push the aesthetic and technical boundaries of conventional animation. Incorporating variation, repetition, rhythm, and motion, his animations are moving collages, a playful mix of drawings, cartoons, photographs, and ephemera from everyday life. Expressive and downright delightful, Breer's work varies in tone from kinetic explorations of abstraction to poetic mediations on life and death. He extracts the element of parable from the simplest of human activities and natural occurrences. His most recent film, *What Goes Up*, cycles through several intervals framed by the drawn animations of an ascending plane and a variety of images that offer a succinct summary of the joys of being alive—photographs of the artist's family, home and studio, food, drink, the changing leaves, and a drawing of a voluptuous woman. Breer gives us his personal take on the everyday in images that zoom past us like a flashback of a thousand perfectly lived moments rolled into one four-minute epic. The final scene of a derailed train provides a metaphor for the absurdity of the notion that a big, beautiful, well-lived life simply runs out.

(1926–)

Selected Bibliography:
1. Burford, Jennifer L. Robert Breer. *Paris: Paris Expérimental/ Re:Voir Vidéo*, 1999. Includes videotape.
2. *Film Culture*, nos. 56–57 (Spring 1973): 39–70. Special section, including interviews by Jonas Mekas and P. Adams Sitney, and Charles Levine.
3. Hoberman, J. "Robert Breer's Animated World." *American Film* 5 (September 1980): 46.
4. Maldonado, Guitemie. "Robert Breer: &: gb agency." *Artforum* 40, no. 5 (January 2002): 149–50.
5. Smith, Roberta. "Art in Review; Robert Breer." *New York Times*, January 7, 2000.

Sarina J. Brewer

"I call it art, you can call it whatever you want."

Artist and naturalist Sarina Brewer recycles the natural into the unnatural. She is a licensed professional taxidermist who also holds a B.F.A. from the Minneapolis College of Art and Design. Specializing in creating one-of-a-kind sideshow gaffs, she utilizes animals that are roadkill, discarded livestock, destroyed nuisance animals, casualties of the pet trade, or animals that died of natural causes. None of the animals she uses are hunting trophies or were killed for the purpose of using them in her art. A strict "waste not, want not" policy is adhered to in her studio—virtually every part of the animal is used in some manner. Her highly sought after eccentric taxidermy works have appeared in dozens of publications here and abroad, including *El Correo Español* (Spain), *Front* magazine (England), *Bizarre* magazine (England) *Last* magazine (Australia), *Choc* magazine (France), *P-Magazine* (Belgium), *FHM* magazine (Lithuania) and here at home in *Maxim* magazine, *Fortune Small Business* magazine, *Minneapolis Saint Paul* magazine, *Juxtapoz* magazine, *The Weekly World News, The Sun, The San Francisco Chronicle*, and *The New York Times* as well as dozens of other national and regional newspapers. She also appeared on the nationally syndicated television talk show "Call of the Wild" with Ron Schara and has interviewed for Minnesota public radio. You are invited to peruse the culmination of nearly 3 decades of the study of art and the natural sciences in her work

M.A.R.T.—The Minnesota Association of Rogue Taxidermists—is a veritable rout dedicated to a shared mandate to advocate the showmanship of oddities; espouse the belief in natural adaptation and mutation; and encourage the desire to create displays of curiosity.

Co-Founder & Rogue Taxidermy Diva
Member since Nov 14, 2004

For more about Sarina J. Brewer, visit:
www.CustomCreatureTaxidermy.com/

Heidi Bucher

www.migrosmuseum.ch/ausstellung/fs_main.php?object=ausstell&
key=80&lang=en&back=/ausstellung/archiv.php

During the 1970s and 1980s, Heidi Bucher became known for the latex "layerings" that she crafted for spatial architectures. As well as these layers or "skins", which represent the core of the exhibition, the show includes drawings, sculptures and a video performance, together with the film "spaces are shells, are skins", by George Reinhart.

Heidi Bucher was born 1926 in Winterthur (Switzerland) and was brought up in a late 19th century bourgeois villa. After her school education in Teufen, she studied at the Zurich Kunstgewer-beschule (Academy for Applied Arts) from 1942 until 1946; among her instructors were Johannes Itten and Max Bill. After graduating, Bucher focused mainly on linear drawings and collages, working as an illustrator for the Zurich daily *Tages-Anzeiger*. In the 1950s, she held exhibitions of drawings and silk collages.

In 1969, Heidi Bucher lived in Canada for a year, before moving to the West Coast of the USA until 1972. In Los Angeles, she produced, together with her former husband Carl Bucher, her large-scale foam sculptures Body Shells (1972). The portable sculptures enclose and separate the human subject from its environment, offering a retreat into privacy; their alienating form is reminiscent of the futuristic fashion of the time. In 1974, back in Zurich, Heidi Bucher began to embalm clothes, blankets, cushions and other objects with "rubber milk", and to as-semble them into simple arrangements.

In 1991, Heidi Bucher began layering the Villa Bleuler in Zurich. The villa, built in the 19th century Italian new-Renaissance style, houses the Swiss Institute for Art Research. In collaboration with the Institute, Bucher, fascinated by the walls, floors, ceilings, oven flaps and other items, layered the entire house. In 1993, Heidi Bucher died of cancer in Brunnen (Switzerland).

(1926–1993)

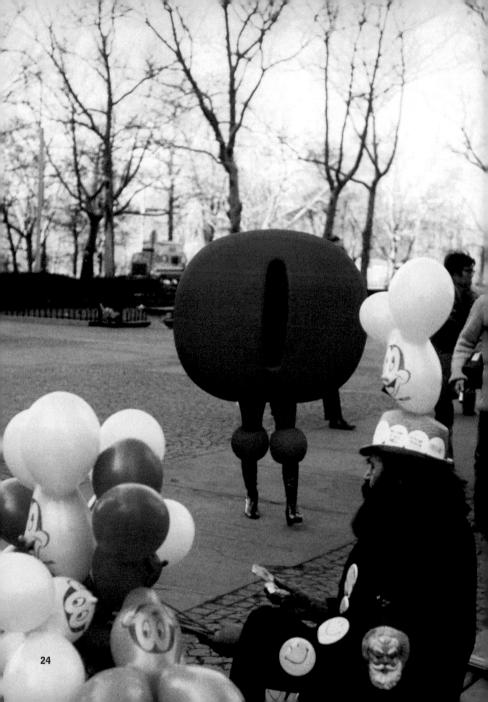

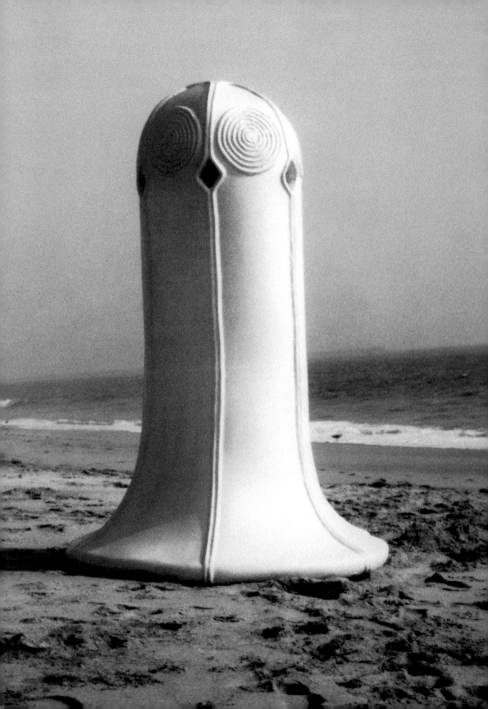

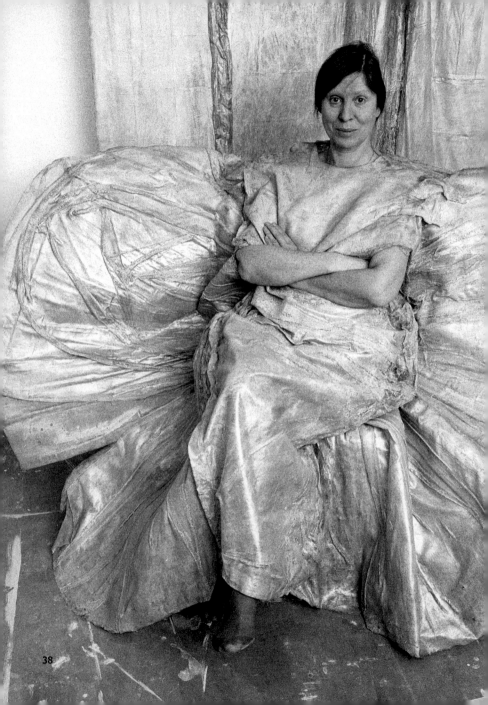

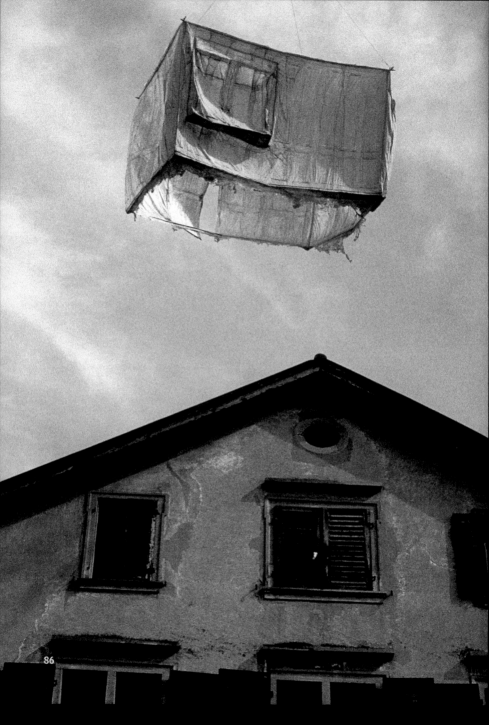

Lowry Burgess

Lowry Burgess is an internationally renowned artist and educator who created the first official art payload taken into outer space by NASA in 1989 among his many Space Art works. His artworks are in museums and archives in the US and Europe. He has exhibited widely in museums in the US, Canada, throughout Europe, as well as Japan. He is Professor of Art and former Dean of the College of Fine Arts and Distinguished Fellow in the STUDIO for Creative Inquiry at Carnegie Mellon. He has founded and administrated many departments, programs and institutions during his 40 years as an educator in the arts. He has created curricula in the arts and humanities in the US and Europe while serving for twelve years on the National Humanities Faculty. For 27 years he has been a Fellow, Senior Consultant and Advisor at the Center for Advanced Visual Studies at MIT in Cambridge, Massachusetts where he created and directed large collaborative projects and festivals in the US and Europe. He has received awards from the American Academy of Arts and Letters, the National Institute of Arts and Letters, the Guggenheim Foundation, the Rockefeller Foundation and several awards from the National Endowment for the Arts and the Massachusetts Artists Foundation, and the Kellogg Foundation. He received the Leonardo Da Vinci Space Art Award from the National Space Society. His book, *Burgess, the Quiet Axis* received the Imperishable Gold Award from Le Devoir in Montreal. He has been featured in television and radio broadcasts in the US, Europe, Canada and Japan, and more than two hundred national and international radio broadcasts including 3 NPR broadcasts on his works.

Cameron

Cameron was born in Belle Plain, Iowa, the eldest of four children. As a child, Cameron began to have strange and powerful visions that were so vivid, she could not be sure if they were real or imaginary. One night from her bedroom, she saw a ghostly procession of four white horses float by her window.

In 1943, in the midst of World War II, the 21 year-old Cameron joined the Navy-turning down several scholarships. She was sent along with 3000 other women to boot camp in Cedar Falls, Iowa. Soon she was selected for a high-level job in Washington, DC, where she applied her artistic skills by drawing maps for the war efforts. She was then sent to the Joint Chiefs of Staff where she once met Winston Churchill. She had a drafting table at the head of their conference room. Later, she felt that many men died in the South Pacific as a result of her drawings, Cameron considered all of her drawings to be magical talismans that had a very real effect on the world, she always felt a karmic connection to these men and believed that later tragic events in her life were the result of her participation in their deaths.

When rocket propulsion researcher and occultist Jack Parsons met Marjorie Cameron, he regarded her as the fulfilment of magical rituals he had been performing as the beginning of the Babalon Working, roughly, an attempt to incarnate in a physical body a divine entity that would bring about great change for the Aeon of Horus.
-blind, terrible, unlimited force."

After her husband Jack Parsons' death, she starred in Kenneth Anger's 1965 cult-film *Inauguration of the Pleasure Dome*. Cameron's two brothers, her sister and also her father worked JPL, the company co-founded by her husband, Jack Parsons. She was a protegé of mythologist Joseph Campbell.

Marjorie Elizabeth Cameron was an American writer, painter and occultist.

(1922–1995)

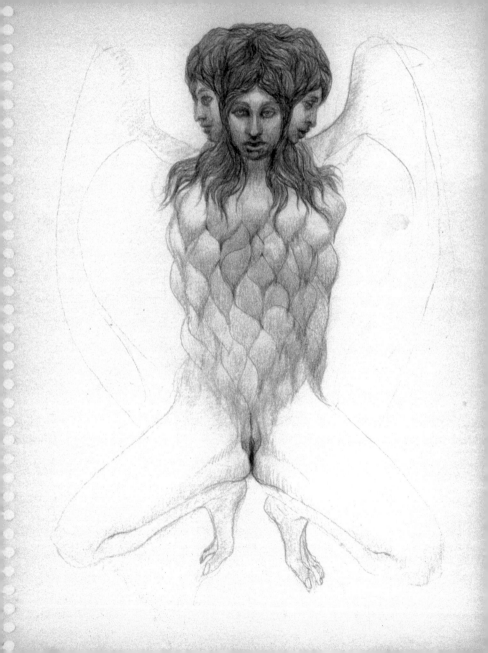

James Castle

Born in Garden Valley, Idaho, James Castle was a
self-taught artist who created drawings, assem-
blage and books throughout his lifetime. James
Castle was profoundly deaf and is believed to have
never learned to read and write. Castle's artworks
are generally small in scale considering he worked
exclusively with found materials such as papers
salvaged from common packaging and mail, in
addition to food containers of all types.

James Castle's work is now included in major
museum collections throughout the U.S. including
the American Folk Art Museum, the Museum of
Modern Art and the Whitney Museum of Ameri-
can Art in New York, the Philadelphia Museum
of Art, the High Museum in Atlanta, Georgia and
the Art Institute of Chicago. In March 2005 the
Boise Art Museum presented an exhibition featur-
ing their extensive collection of Castle's work.

J Crist Gallery is the primary representative for the
work of James Castle.

(1900–1977)

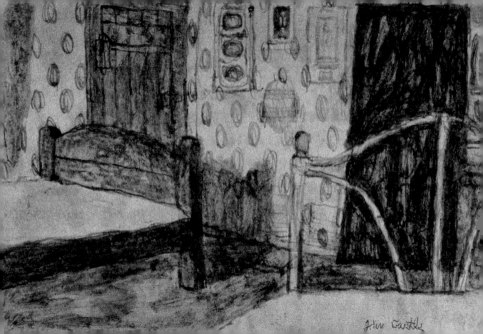

Joe Coleman

http://en.wikipedia.org/wiki/Joe_Coleman_%28painter%29

Joe Coleman is an American illustrator and paint-er. He was born Joseph Coleman, Jr. in Norwalk, Connecticut to a World War II-veteran father and the daughter of a professional prizefighter. He was raised Roman Catholic.

Coleman's subjects are pop icons of a sort who are often transgressive, criminal, and "outside" the mainstream radar. In some ways, much of his style makes reference to the Spanish-Mexican religious tradition upon which Frida Kahlo also drew. Coleman's work is sometimes reminiscent of Basil Wolverton's work.

Coleman's work has been featured on the covers of many books including: *Apocalypse Culture*; *You Can't Win*; *The Mystery of Wolverine Woo-Bait*; *Apocalypse Culture II*; *Under the Empire of the Birds*

His pranks—including appearing to blow himself up and medieval-style geek antics—have been documented in the *Pranks!* volume of Re/Search Books, along with the works of some of his con-temporaries such as Boyd Rice.

Coleman is an avid enthusiast for weird, dark American culture and a serious collector of sideshow oddities. He's a patron of Johnny Fox's Freakatorium in New York City (where he lives) and was a supporter and good friend of the late rockabilly eccentric Hasil Adkins. He also acted in *Black Hearts Bleed Red*, a 1992 film adaptation of Flannery O'Connor's short story "A Good Man Is Hard To Find," made by New York independent film director Jeri Cain Rossi, and also in *Scarlet Diva*, Asia Argento's 2003 film debut as director.

(1955–)

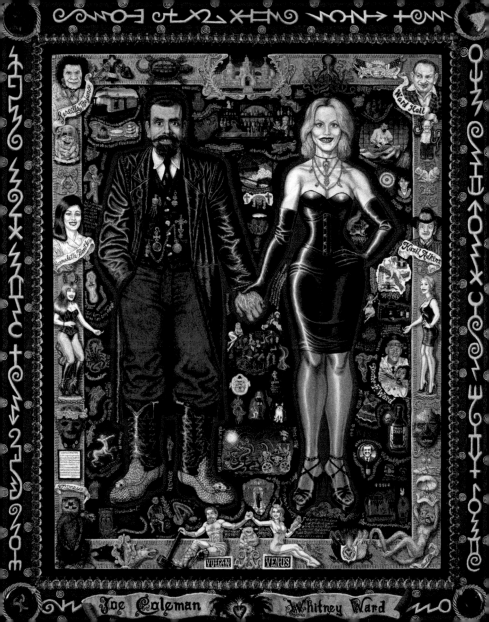

Joe Coleman Whitney Ward

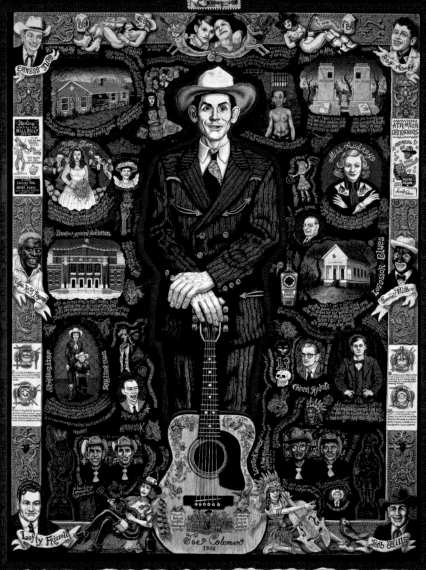

Hank "King Hiriam" Williams

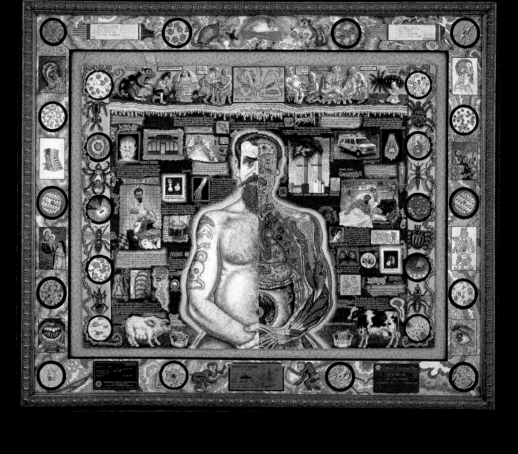

Bill Daniel

Bill Daniel is an American experimental documentary film artist, photographer, film editor, and cinematographer. He is also an installation artist, curator and former zine publisher. His full length film, Who is *Bozo Texino?* about the tradition of hobo and railworker boxcar graffiti was completed in 2005 and has screened extensively throughout the United States and Europe. Bill Daniel has collaborated with several artists from the Bay Area Mission School art movement, notably Margaret Kilgallen, and has worked on multiple projects with underground director Craig Baldwin. Film/video artist Vanessa Renwick of the Oregon Department of Kick Ass has been a frequent touring partner, collaborator and co-curator.

Bill Daniel has received numerous awards including grants from the Film Arts Foundation, Creative Capital, the R&B Feber Charitable Foundation for the Beaux Arts and residencies at the Yerba Buena Center for the Arts, the Headlands Center for the Arts and the Center for Land Use Interpretation. His films have been featured at numerous film festivals including the prestigious Viennale or Vienna International Film Festival, The Portland Art Museum's Northwest Film and Video Festival (where his Selective Service System Story was awarded best documentary film), and the True/False Festival, where he has been a panelist. In 2006, Bill Daniel was a judge for the Iowa City International Documentary Film Festival.

Bill Daniel was born in Houston, Texas and has lived and worked in Austin, New York, San Francisco, Portland and Shreveport. He attended college at the University of Texas at Austin where he majored in Marketing. His brother Lee Daniel is also a cinematographer and is best known for his work with director Richard Linklater.

(1959–)

External Links:
www.billdaniel.net
Craig Baldwin's Other Cinema
Oregon Department of Kick Ass
Bozo Texino Stock Exchange

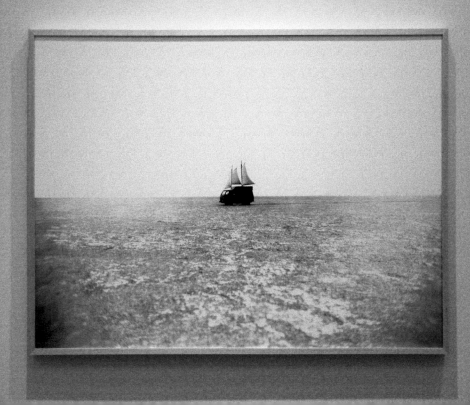

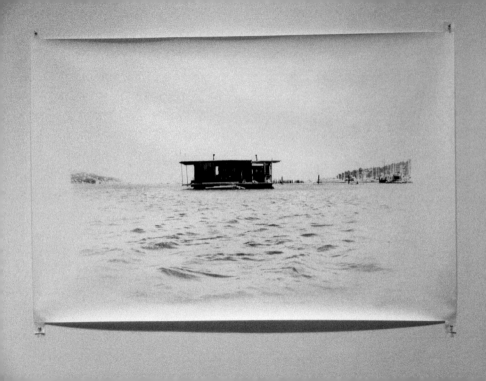

Peter Dean

http://findarticles.com/p/articles/mi_m1248/is_n1_v81/ai_13294878

Twenty years ago, Peter Dean signed a manifesto. Along with Benny Andrews, Ken Bowman, Peter Passuntino and other artists aggressively calling themselves Rhino Horn, Dean proclaimed that "our art is involved with life...with humanity, with emotion....We are not concerned with making pure color or pure form the subject of painting; we are concerned with, and express, a harsher reality." In its language, this declaration echoed the one written years earlier by Adolph Gottlieb, Barnett Newman and Mark Rothko, who also rejected formalism and insisted on the primacy of content in a work of art. Yet the paintings, drawings and assemblages in this 35-year retrospective of Dean's work have little in common with anything imagined by the New York School.

Dean's expressive paintings are overwhelmingly narrative, based on unusual real-life incidents that carry the weight of parables or allegories. They are lessons in luck or tales of courage and resourcefulness, often involving narrow escapes. Underlying all of Dean's stories is a worldview that marvels at the precariousness of existence and the wonder that human beings manage to survive at all. Perhaps his own deliverance as a child from Nazi Germany in 1938 set the tone for his future preoccupation with harrowing experiences; his timely departure from Berlin, hugging a stuffed bear and grasping his mother's hand, is memorialized in *The Expulsion* (1988). Here Dean's parents, dressed for travel and sporting yellow arm bands, prepare to board the Paris-Brussels train with their two tiny children. The family is spied upon by a Nazi agent lurking in the background, and a broken-hearted grandmother mourns their leavetaking. Hovering above the group is an angel of death, wearing a robe adorned with bloodred skulls and swastikas

(...)

Such adventures provide Dean with material for his most engaging works, in which the characteristically thick impasto, rich colors and agitated figuration serve intriguing anecdotal ends. The artist's vibrant landscapes, intensely worked in volcanic hues, register his fervent experiences of nature; sufficient in themselves, these pictures do not require the texts (wall labels and catalogue descriptions) that supplement Dean's narrative paintings. In some instances, one detects an additive impulse: embellishments such as glitter, sequins, fur or dollar bills stuck to the canvas seem gratuitous when Dean's handling of paint itself is so completely successful. His flirtation with collage culminates in a group of little mixed-medium sculptures from 1991, incorporating found objects and kitsch miniatures of Michelangelo's *Pieta*, a meditating Buddha, or a bust of Dante to produce unnerving tableaux. The most disturbing of these includes a rubber baby doll impaled on medical syringes; it bristles like a porcupine with a hundred needles. Here Dean's awestruck wonder at human survival gives way to the darkest visions of mortality and pain, surrendering to the "harsher reality" referred to in his earlier manifesto.

(1939–1993)

Taylor, Sue. "Peter Dean at the UWM Art Museum— Minneapolis, Minnesota," *Art in America*, January, 1993.

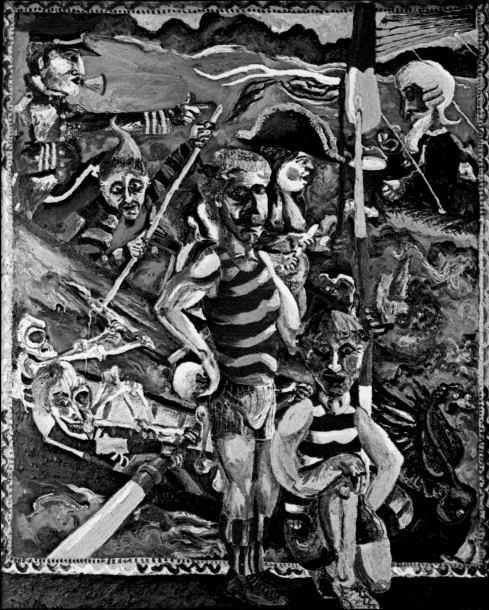

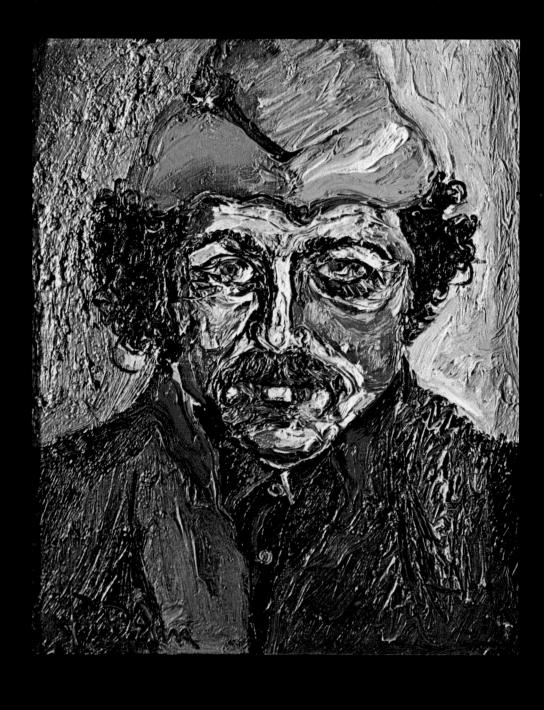

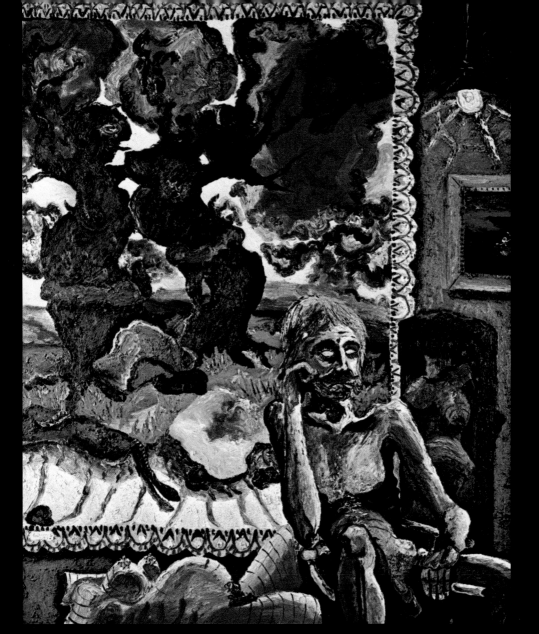

Baby Dee

Performance artist, songwriter, classically trained
harpist, circus sideshow veteran, and transgen-
der street legend Baby Dee was born in 1953 in
Cleveland, OH. She spent ten years as music
director and organist for a Catholic church in the
Bronx before joining the circus as the bilateral
hermaphrodite at Coney Island. This landed her
a gig as the bandleader for performance art group
the Bindlestiff Family Circus and a tour with the
Kamikaze Freak Show in Europe. After moving
back to New York City, she became a fixture in
lower Manhattan with a street act on a high-rise
tricycle with a concert harp. She recorded her first
record, *Little Window*, on the Durtro label in 2000,
a four-track EP in 2001, and her second full-
length, the double-disc *Love's Small Song*, in 2002.
Dee returned to Ohio during the latter record's
recording, taking vows as a novitiate of the Little
Sisters of Crabby Doom (a Cleveland-based order
dedicated to the care of smelly old men), vows that
she has since forsaken.

—James Christopher Monger, *All Music Guide*

(1953–)

Jacqueline Fahey

Fahey's paintings predominantly depict domestic settings that reflect the artist's personal life, in particular her relationships with her children and other women. In *The Birthday Party* Fahey presents the aftermath of a child's birthday party. The figures in the painting—an older woman and two children—are separated by a large table which dominates the picture space. The table can be read as a metaphor for the generation gap between them. The expansive tabletop, covered with the remains of the party, also separates the viewer from the scene. Fahey highlights the chaos of family life, stressing the distances, rather than the intimacy of family relationships. She describes the home as "the battlefield of the psyche".

Fahey's choice of subject reflects her experience as a mother and 'housewife', thereby challenging traditional patriarchal notions about 'appropriate' subjects for art. By representing domestic scenes the artist seeks to validate women's experience.

Fahey's figurative style also presents a challenge to traditional masculine representations of the female form. Her subjects are not romanticised or idealised but portray real women as real people, often tired and worn out by the everyday realities of their lives. Fahey has described herself as "The Artist Militant, working with savage dedication, the palette my shield, the paint brush my weapon."

Born in Timaru, Fahey began her studies at Canterbury College School of Art in Christchurch at age sixteen, where she was taught by illustrator Russell Clark. In 1964, with Rita Angus, Fahey organised a painting exhibition at the Centre Gallery, Wellington, which is believed to be the first in New Zealand to feature both male and female artists in equal numbers. Fahey has exhibited in numerous solo and group shows throughout her career. In 1985 she was selected to represent New Zealand at the *Sydney Perspecta*.

(1929–)

John Fare

The legend of John Charles Fare (or Faré) is the story of a man who slowly destroyed his own body.

As one version of the story goes, Fare was a performance artist whose performances involved the amputation of parts of his body and their replacement with metal or plastic decorations. Between 1964 and 1968, performing across Europe and Canada, he was lobotomized and lost a thumb, two fingers, eight toes, one eye, both testicles, his right hand, and several patches of skin. The amputated parts were preserved in alcohol. It is also said that Fare had the amputations performed by a randomly-controlled machine and ended his career by having his head amputated.

The legend was published by Tim Craig in *Studio International* in 1972; this version of the legend was reprinted in a fanzine made in collaboration with the band Coil in 1987.

Fare has been mentioned in connection with body art, industrial culture, and the practices of Rudolf Schwarzkogler and Bob Flanagan, and, like other performance artists, has been seen as a successor of the Christian martyrs. He has also been mentioned in the *Guardian* in connection with the German artist Gregor Schneider.

Fare was impersonated during a Nocturnal Emissions concert in London in 1997. Writing about the event, a British music journalist recounts: "Fare cuts an eccentric figure. He wears trousers made from zips and has a diagram of a brain tattooed onto his shaven scalp. The performance artist placed his left hand on a chopping board with the fingers spread. Fare's assistant, Jill Orr, is partially sighted and she slammed an axe between her boyfriend's pinkies with increasing speed. Eventually the axe severed Fare's little finger. This was the end of the performance art element within the evening's entertainment".

Lorser Feitelson

Lorser Feitelson was born in Savannah, Georgia, but raised in New York, where he received his early art training at the Art Students League. He was influenced by European modernist ideas after seeing the Armory Show in 1913. Between 1919 and 1926, he lived and worked in Paris, included in exhibition at the famous Salon d'Automne. His paintings and drawings were exhibited in New York and in Paris. Upon his return to the United States, in 1926, Feitelson rejected the incestuous influences of the New York art scene and made a decision to move to West.

Upon arriving in Los Angeles in 1927, Feitelson set out to change the cultural landscape of the growing city. In 1930, he taught at the Stickney Memorial Art School where he met and eventually married student Helen Lundeberg. He and Lundeberg proclaimed 'New Classicism/Post Surrealism'. Working within a classical figurative context, Feitelson combined symbolic elements into a structured surreal time-space, opposing the irrationality of European surrealism. This movement became the basis of the 1935 San Francisco Museum of Art's exhibition "Post-Surrealism", which went on to the Brooklyn Museum. As a result of that show, his and Lundeberg's paintings were included in the Museum of Modern Art's "Fantastic Art, Dada and Surrealism" in 1936. Simultaneously, Feitelson directed the Hollywood Gallery of Modern Art, he taught and painted for the Federal Arts Project, while serving as the director for its mural division, and he co-directed the Los Angeles Art Association. He also taught at the Chouinard Art Institute and, until his death, at the Art Center College in Los Angeles and Pasadena.

Though a post-surreal element remained in his work, by the 1940s Feitelson moved into anthropomorphic abstraction, creating canvases of 'Magical Forms'. By 1950, this movement evolved into non-objective geometric abstraction termed 'Magical Space Forms'. Meanwhile, between 1956 and 1963, Feitelson hosted "Feitelson on Art", a weekly NBC television series....

(1898–1978)

Stano Filko

www.kontakt-collection.net/artists/Filko+Stano/
www.ckr.sk/en/projects-rameno.html

In Stano Filko's symbolic system, the White Space
of the 1970s stands as a continuation of an interest
in spatial concepts that began in the artist's earlier
works. They demonstrate a tendency to experi-
ment with formal boundaries. From an art-histori-
cal point of view, this White Space is astonishing,
even disconcerting, on account of the way it
reverses established (Western) art values by giving
old metaphysical notions a place within the con-
text of a subversive art praxis. The White Space
concept covers a multi-phase, multi-part complex
of ideas and works, some of which were made in
cooperation with Milos Laky and Ján Zavarsky.
One of the accompanying manifestos, "Emotion.
White Space in a White Space" (1977), postulates
an infinite space of "non-physical, pure art and
emotion," whose non-color white represents an
absolute. This space stands "above" future, present,
and past, and it is "super-cosmic." In a certain
sense, it surpasses all existing spaces and symbol-
izes a state before the act of artistic creation where
everything is open, possible, and not determined.

He is a painter, creates installations, video art,
photography, and uses a number of other artistic
approaches. He lives in Bratislava. He finished the
Academy of Fine Arts in Bratislava. Selection of
his exhibitions: documenta (1981, Kassel), Gallery
Manes (1993, Prague), Biennale di Venezia (2005,
Venezia), Tranzit (2005, Bratislava).

Filko represented Slovakia at Biennale di Vene-
zia and belongs among internationally most
recognized Slovak artists. His works are in the
Slovak National Gallery, in the National Gallery
in Prague, but also in Guggenheim Museum in
New York. Although educated as a painter he does
not represent the observable world but he mostly
works on installations and environments, i.e. the
ordering and constructing the object and materials,
the transformation of spaces according to a single
artistic concept. His lifelong work leads to depict
the hidden significant forces of our existence. He
works symbolically to express the question of life
cycle and its anchoring in the infinity.

(1937–)

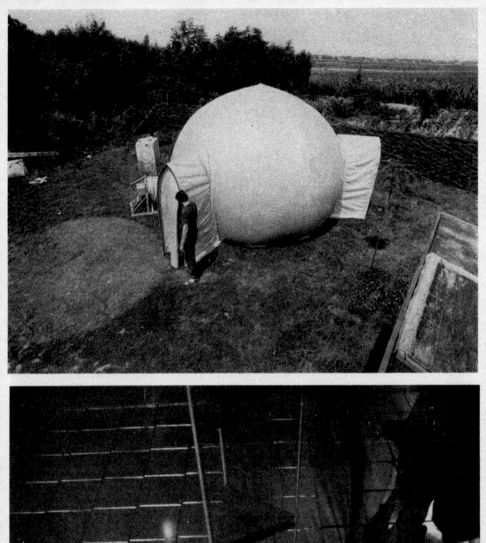

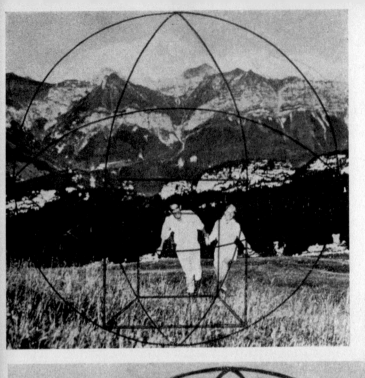

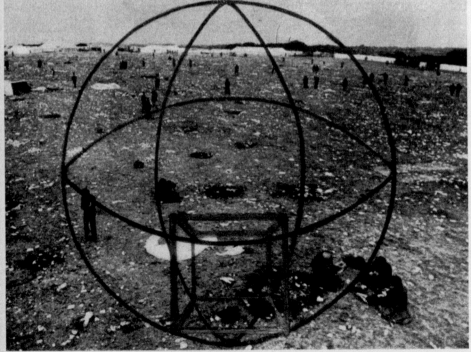

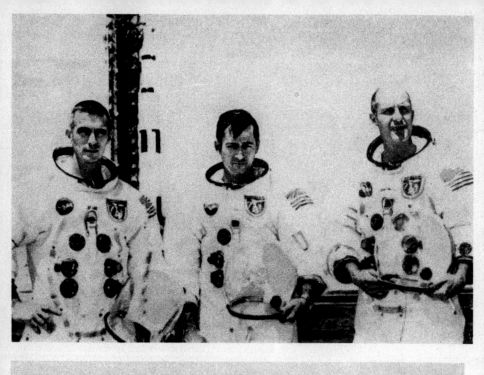

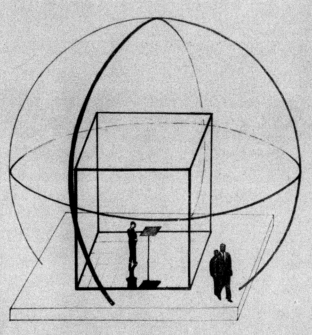

Roland Flexner

www.hosfeltgallery.com/HTML/artists/RolandFlexner2.htm
See also: rolandflexner.com/index.htm

Roland Flexner is known for his delicate and precise works on paper, from graphite drawings of skulls, contorted faces, and ripples of water to more recent 'bubble' drawings involving ink, soap, and the resulting bubble that bursts onto paper.

Flexner's newest works are evocative, undulating abstractions based on the Japanese art of sumi-nagashi. During an extended residency in Japan, Flexner was introduced to this ancient decorative tradition, involving a highly refined, skillfully crafted form of ink, or sumi, and water. Sumi is floated on water in a tray, and manipulated into shapes even as it moves on its own. Paper is dipped onto the surface of the water to transfer the image; in the few seconds before it dries, Flexner can alter the image in various ways, with a brush or by tilting, blowing on, or blotting the ink.

The resulting works possess a sense of deep pictorial space, great complexity, and conjure numerous visual associations: rocky landscapes, fungus, ice-encased trees, patterns of erosion. They could almost be mistaken for photographs by the rich black and slightly granular, silvery texture of the ink, and the sharp 'focus' of the image. While the tiny, precise gestures of the artist are a crucial element in the process, these works inevitably derive from the vagaries of the materials and their reaction to the quality and motion of the air, the currents of the water, and the force of gravity, and thereby defer ultimately to chance and nature, but with the most astonishing, seductive results.

(1944–)

Peter Fritz

In 1993 in a bric-a-brac store the Viennese artist
Oliver Croy discovered somebody's oeuvre packed
away in rubbish bags: 387 model buildings and
a collection of ca. 3.000 slides. He bought them
all for about 500 euro. The slides document the
period from 1965 to 1975, often showing an obese
man, a bald-headed person of regular habits, or-
derly dressed, wearing old-fashioned glasses. The
slides are also showing several travels together with
his female colleague and his wife, on the trip with
their VW beetle. The destinations were, with few
exceptions, the Austrian Alps. The series carry the
titles 'Oktoberfest in Munich', 'Salzburg', 'Tristach
1970/71'... but in none of these slides a special
preference for architecture or 'house'-photography
is to be detected.

Croy did some research and succeed in seeking out
the summerhouse of the amateur handicraftsman.
He met a neighbour with whose assistance he
finally found out that this was the estate of Peter
Fritz, an insurance clerk in Vienna, who had died
in 1992.

Each of the 387 buildings is unique. With his
models Peter Fritz created an idiosyncratic image
of the 1950s and 60s. He built the world as it is
and, at the same time, in a way that could make it
more interesting: wonkier, far more colourful with
extraordinary extensions and numerous advertise-
ment hoardings. He used cardboard, which he
usually covered with wallpaper, snippets taken
from magazines, sticky-back plastic, cigarette
packets, insulating tape etc. peter fritz built the
world like it is, and at the same time like as it
could be.

online-catalogue: www.BauNetz.de/arch/sondermodelle

ALLGEMEINE VERSICHERUNGS A.G.

Frank Gaard

*Art is a map of a person's being—like a map of the past,
of desire, of psychologies....I like bright colors, and feel-
ings. I like my work to be evocative...It's fascinating that
the human mind is inclined to want to know why.* —FG

Frank Gaard, the second artist to participate in the
Walker's Billboard Project located on Hennepin
Avenue at 12th Street, has been an active and indis-
pensable member of the Twin Cities arts community
for the past 35 years. Born and raised in Chicago, he
moved to Minneapolis in 1969 and was a profes-
sor of fine arts at the Minneapolis College of Art
and Design from 1969 until 1987. He created and
published the legendary underground zine *Artpolice*
(1974–1994), in which he blended cutting social
criticism with a brutish drawing style often compared
to that of comic artist R. Crumb. An information
addict with a diagnostician's exactitude for the pulses
of politics and culture, Gaard draws from sources as
varied as the entertainment industry, art history, and
the media, collapsing them into a fascinating jumble
that exposes the dysfunctional ills of our society. The
Walker has several works by the artist in its perma-
nent collection.

Since the mid-1980s, Gaard has been creating por-
traits of family members, artist friends, and fictional
characters in vibrant palettes and infused with emo-
tional directness. His *Billboard Spectacle (In Memory
of Guy Debord)* is occupied by four figures: Min-
neapolis painter Douglas Padilla; "Ms. Rosamund,"
based on a character in *Dick Tracy*; novelist-essayist
Emily Carter as Dick Tracy in drag; and Twin Cit-
ies-based abstract painter Jennifer Nevitt. The title
pays homage to French philosopher Guy Debord
(1931–1994), whose 1967 book *The Society of the
Spectacle* incisively analyzed the social implications
of a life dominated by images. Gaard's polychrome
billboard, in spite of its title, is not a mere addition to
the spectacle but rather a talk-back to the impen-
etrable walls of images that turn our urban space into
a prison of homogenization. And looking down on
the traffic streaming into the heart of the city, the
four figures on the billboard join the ever-growing
pantheon of characters in the mythology of Gaard's
personal, social, and psychic life.

See also: http://frankgaard.com/

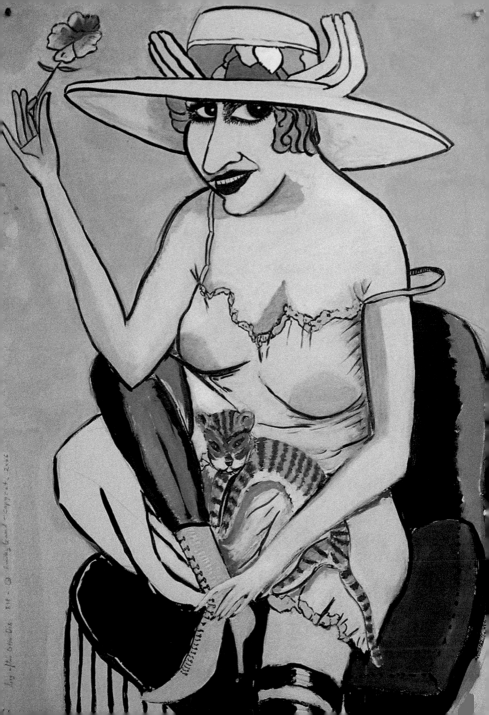

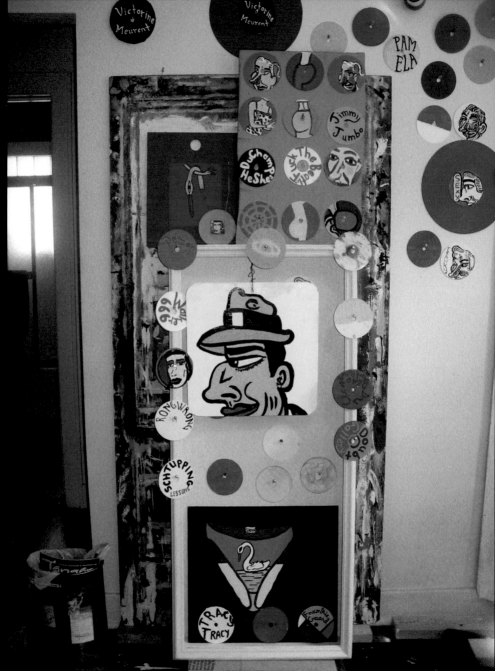

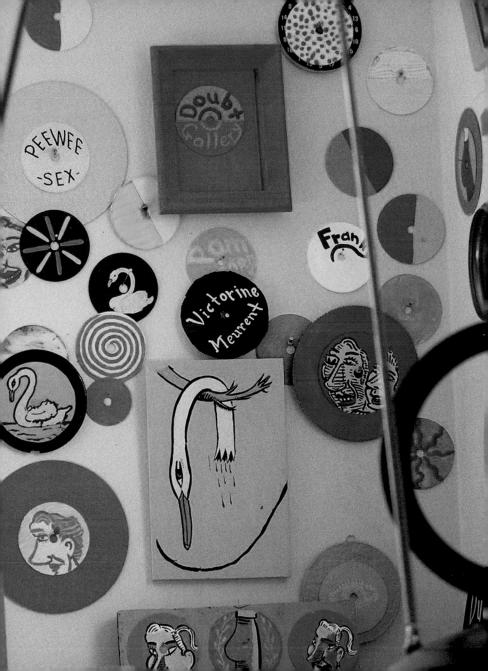

Peter Soul

Kathy Halbreich

A. James Speyer

Lisa Lyons

All Die All Vanish

Tony Stoos

Walter Hopps

Phillipe Vergne

Duchamp Expert

Herr Dr. ex-professor
FRANKIE
GAARD
BFA
MFA
ARTPOLICE 1999

Jan Groover

Using a variety of camera formats to affect percep-
tion and plane, Jan Groover creates complex,
abstract spatial arrangements in her still-life, por-
trait, and landscape photography. *Untitled #1308*, a
platinum/palladium print on luminous vellum-like
paper, aptly demonstrates her craftsmanship in
the darkroom with its finely-wrought delicacy. A
painter by training, Groover makes reference to
art history in her photographs, from Renaissance
perspective drawings to Cezanne's tabletops.

Groover was born in New Jersey in 1943. She
received her BFA in 1965 from the Pratt Institute,
Brooklyn, and her MA from Ohio State Univer-
sity in 1970. Her work has been the subject of
one-person exhibitions at the Baltimore Museum
of Art; Cleveland Museum of Art; the Corcoran
Gallery of Art, Washington, DC; International
Museum of Photography, George Eastman House,
Rochester, New York; and Museum of Modern
Art, New York. She is also the recipient of fel-
lowships from The National Endowment for the
Arts and the John Simon Guggenheim Memorial
Foundation.

(1943–)

Bibliography:
1. Groover, Jan. *Jan Groover: Photographs*. Boston: Little,
Brown, 1993.
2. Groover, Jan. *Pure Invention—The Tabletop Still Life*.
Washington: Smithsonian Institution Press, 1990.
3. Kismaric, Susan and Jan Groover. *Jan Groover*. New York:
Museum of Modern Art, 1987.

Frederick Hammersley

www.nmarts.org/pdf/frederick-hammersley.pdf

Painter Frederick Hammersley has worked
quietly and deliberately in the dining room of
his Albuquerque bungalow for four decades.
And, although he has spent the better part of his
adult life and artistic career in New Mexico, he
will forever be linked to the Los Angeles-based
Abstract Classicists of the late-1950s.

Hammersley received international recognition
in 1959 when the Los Angeles County Museum
exhibited his "hard edge" paintings along with
fellow Abstract Classicists John McLaughlin,
Lorser Feitelson and Karl Benjamin. The term
"hard edge" developed with these four artists
and refers to paintings with large areas of flat
color. Hammersley moved from Los Angeles
to Albuquerque in 1968 in order to teach at the
University of New Mexico. It was his large body
of work produced in New Mexico, defined by
meticulously executed geometric and organic
abstractions, for which he is best know.

About his move to New Mexico, author Arden
Reed has said, "It was Hammersley's move
from Los Angeles to Albuquerque in 1968 that
gave him the time and space to find and mine
his richest veins of gold." Hammersley's works
are in major public collections including the
Corcoran Gallery of Art in Washington, D.C.,
San Francisco Museum of Art, Santa Barbara
Museum of Art, La Jolla Museum of Art, Los
Angeles County Museum of Art, and locally in
the University of New Mexico Art Museum,
Albuquerque Museum and the Museum of Fine
Arts in Santa Fe.

(1919–)

F. Hammersley CLAIROL 1/15-B 4 DEC 69

Margaret Harrison

Margaret Harrison is a Senior Research Professor and Director of the Social and Environmental Art Research Centre (SEA), a multidisciplinary Research Centre whose core membership consists of artists across all media whose work engages with social and environmental issues, including, ecological concerns, art in public spaces, the built environment and landscape architecture. She is an artist member of the university wide community committee.

Professor Margaret Harrison is an artist with an international profile, her work on Rape (in the collection of the Arts Council of England) has since its first controversial showing at the Hayward Gallery in 1979, entered Art History and is now seen as a feminist classic.

She lectures and shows her work internationally, mainly in North America, but also Germany, Holland, Australia and Canada and recently at the Liljevalchs Konsthal Stockholme as well as UK venues such as the Institute of Contemporary Art, the Whitechapel Art Gallery and the Victoria and Albert Museum London. Her work is in several important public collections including the Tate Gallery, the Victoria and Albert Museum, kunsthaus Zurich, the Arts Council of England and the University of California. Her show at Intersection for the Arts in San Francisco was represented by the Ronald Feldman Gallery, New York.

(1940–)

Margaret Harrison '71

Barkley Hendricks

Barkley Hendricks's unique work resides at the
nexus of American realism and post-modernism,
a space somewhere between portraitists Chuck
Close and Alex Katz and pioneering black con-
ceptualists David Hammons and Adrian Piper. He
is best known for his stunning, life-sized portraits
of people of color from the urban northeast. Cool,
empowering and sometimes confrontational,
Hendricks's artistic privileging of a culturally
complex black body has paved the way for today's
younger generation of artists. This unprecedented
exhibition of Hendricks's paintings will include
work from 1963 to the present. Trevor Schoon-
maker, curator of contemporary art at the Nasher
Museum, is organizing the show. The exhibition
catalogue, distributed by Duke University Press,
will include contributions from Schoonmaker,
Richard J. Powell, the John Spencer Bassett Pro-
fessor of Art and Art History at Duke University,
Thelma Golden, Director and Chief Curator at
the Studio Museum in Harlem, and Franklin
Sirmans, Curator of Modern and Contemporary
Art at the Menil Collection.

(1945–)

Edi Hila

Edi Hila, born in 1944, studied at the Art
Academy Tirana during the 1960s. In the early
1970s he was condemned by the Hodscha re-
gime—along with many of his colleagues—to a
labor camp. During the following twenty years
his style of painting, with its strong metaphysical
overtones, achieved absolutely no public resonance.
After the opening of the country in 1991 and in
contact with the future generation of artists, he
has been successful in seizing hold of the present
situation of Albania in painted images. His motifs
are seemingly paradoxical buildings oscillating be-
tween relic and draft, figurative scenes in urban or
interior spaces characterized by temporal ruptures.

Albania is not only the poorest country in Europe.
Even today it is characterized by a few media-
encouraged clichés as unknown territory on the
geographical map. For this reason, the project
TIRANA TRANSFER is initiating a process of
exchange and evaluation in both directions: before
Edi Hila and his students come to Karlsruhe for
ten days in July, twenty students from the School
of Design in Karlsruhe (with Mischa Kuball) and
the Institute of Fine Arts (with Prof. Stephen
Craig, Erik Göngrich, Stephan Baumann and
Markus Graf) at the Architecture Department of
Karlsruhe University traveled to Tirana in May.
There they participated along with the Albanian
students in joint workshops which focused on the
urban and individual reality in Tirana. The results
of these workshops complement the exhibition in
the Badischer Kunstverein and will be accompa-
nied on three weekends by discussions, lectures
and film programs concerning Albania and its
artistic scene.

(1944–)

Jess Hilliard

Hi, my name is Jess, and I write things. I write
books, reviews, stories of animals with beards
doing humorous and courageous things—dogs
and cats and monkeys and squirrels (most of them
with beards) and also about animals that haven't
even been found yet. And I also write science and
magic journals, and also about the histories of such
things as cookies, muffins, paper bags, matches,
pencils, tiny fruit, and money found embedded
in the pavement. But the thing is, I do not tend
to get paid for my work, and it would be so much
nicer if I could get paid to do what I love. I am
looking for help in finding publications to write
for in which I will be paid. You see, at first, years
ago, I thought the answer was in finding a "sugar
momma"—some sort of wealthy, and probably
mythical, creature who would not only drape me in
fine robes, provide me with the tastiest snacks, but
who would also fund all of my writing. But I never
found one. And I'd put up flyers all over town! So
I thank you in advance for showing me the way to
places that will pay for my writings—or if any of
you out there either are, or know where I can find,
a sugar momma, that would work too. Because
writing for a living would be really great. And it
wouldn't hurt to throw in a little bit of lovin' while
we're at it. So it'll be great hearing from you about
these exciting possibilities, and down below are
samples of things which I have written, not only
to entice you, but also to show you that, yes, I
really really really love to share my stories. Thanks!
Sincerely, Jess Hilliard.

Christmas Eve, 1990, 6:00am

I'm the first cup-of-coffee-customer in the lounge car. Yep, the seats are brown.
We're moving pretty slowly through the desert right now. The lounge car is all
windows, it's on the second story of the bi-level coach and it took me a while to
find it, pressing big black buttons that say "press" on them. Then whoosh, I'm
between cars, then whoosh, I'm walking past more sleeping families, single peo-
ple, etc. Union station is big, it has a high ceiling with many thrones back to
back—for we who wait, sit. The layover was almost six hours. I went looking for
a bathroom. All the sounds echoed at Union Station. Many Black people—many
smiling and friendly people. Two soccer players from Argentina kicked the ball
lightly to each other. One offered me his seat.

And there is one man here who I'm beginning to admire; he wears aviator style
seeing-glasses, hair parted non-fashionably in the center, some sort of interesting,
modern sports shoe ensemble and some baggy, loosely-fit, loud and colorful and
modern surf pants—have you seen them? It is apparent that this guy doesn't dress
"cool" or for shocking individualism; someone told him "that's what they're wear-
ing these days" or he saw them in a Macy's spring outlet or something and there
he was, smiling, intelligent, saying a few things to himself. But I don't think he
was nuts. He often left his spot in line, his things too, and wandered around in
and out of the crowd, the lines, smiling and speaking a gentle word or two to
himself, not really focusing on anybody or anything. Well, it looked like he was
going over something in his mind—was happily anticipating it. If this was a sur-
vival movie, he'd be the protagonist anti-hero who would surprise all the tough
guys in the audience by being the only survivor, well, besides the beautiful
woman. And I actually thought that and then I thought that we were lucky to
have him here. Not like those other people earlier...

Party Train

Of all the people to be on such a car—there we sat, my mom and I. At first it
was just one of those me-generated, slightly Okie-turned-Californian, loud, defi-
ant, permed hair and red spike heeled, party girl blabbing about her whole
life—she's a nurse, blah, blah, blah—and my mom predicted correctly that the

woman would tell us (the whole car actually) about her experience giving birth. Pretty soon a couple of Navy guys who were on their way to Kuwait started in with her, and then some more guys and pretty soon they were all loud, all drinking vodka on ice, and all talking about her life. Then she shouts out "Yippee, I knowed this was gonna be the party train, maybe we could all get together in Tulsa for New Years!"

The party train had voices that hurt my ears, but maybe, who knows, just maybe I should've taken the mission when the party girl shouted out, "OK boys, who's goin' for more ice?"

Later: The desert is mighty beautiful. There's the Burger Kings, semi-trucks trying to pass us, and mostly there are telephone poles—"the picket fence of the wild west." Did I hear someone call them "the picket fence of the wild west?" And just about as far out as I can see there are lots of those green desert bushes, the mesquite-oleanders, which some people make an edible jelly from. Five tables down from me is a Black man with a red shirt, a gold neck charm, a gold ring, a black jacket and hair only on the periphery of his head (peppered gray). He's eating, with a spoon, cold cereal from a little brown cardboard box, which is the size that shoes might come in... that is, I see him chewing and looking down into his little cardboard box, but apparently he only takes a bite when I'm not watching.

Now here is a man talking to himself who very well could be nuts (I mean, I don't think he's nuts, but I guess he could be). The anti-hero is in my car! I went around looking for the lounge at about 5:30am, it was dark, nighttime still, everyone was sleeping, just a little blue light on here and there to show you the way. Well, I got up and walked three rows back and there was the anti-hero, awake I think, or smiling and thinking about something anyway. The lounge is my most favorite spot on the train because it's all windows. You can see the sandy soil outside, some of it flat, some of it in mounds or dunes. You can also see the deserty foothills in the distance. They appear to be both far away and close to the tracks at the same time.

When I got up to go to the lounge there was this lady snoring in the row next to mine. So I stood up and what do you know, she stood up too. We pretended not to notice this coincidence, but then we both went looking for the lounge-we even

got lost together. It's funny, we both knew what the other was looking for—I think maybe she was even a little attracted to me. She turned to me and said "Don't go back on me now, if ya chicken out we'll never find it." So I kept following her. I don't know I, I think she was kind of excited to have a companion.

I had a strange feeling though, about the whole thing, like she didn't know how old I was or something. Somehow whenever people get around me they don't know how old I am, or, well, that's how it seems. Like that "chemistry" feeling so often gets mixed in and saturated with a maternal kind of nature that just comes out to me. Yeah, I even get it from men sometimes, I don't know, I never really thought about any of this before, some of my conclusions are entirely experimental at this point. Actually, it's not something I'm interested in thinking much about. I mean, it's just this feeling, it's no big deal, I mean it was nothing, very subtle, she probably wasn't even aware of it, if it was there at all.
But still you can kind of feel it, so anyway I followed her. Okay let me say this, I'm not at all attracted to her, it was just a mixed kind of crush, slash, maternal thing that I got from her. Well anyway she's just this older lady... So we found the lounge car, and we walked in and I was hoping to sit alone, but seeing that there was no one else there, I just had this feeling that somehow I'd have to end up sitting with her for awhile—at least until my mom came and I don't know what would happen then. I don't know, I just had the feeling that I wasn't gonna get to

I don't drink coffee. I treat it as a recreational drug—either for selfishness or for socializing

be alone like I really wanted. Like even if we sat apart she wouldn't just let me treat her like a stranger. Then all of a sudden she says "it's cold as hell in here!" and she left, just like that. I had the whole place to myself.

Last night I found one dime and one penny, and I have a great new book called Pat The Bunny, it's really funny. And I just finished my coffee. Wow, what a little mess I have made, a little cylinder of half and half, a little Amtrak sugar bag—11 calories real sugar—one plastic stirrer and one Styrofoam cup which I'm going to see if I can get refilled. It's kind of a mission, I mean they'll probably try to throw it away, give me a new one, but I'm going to go for it anyway. I'm going to see if

Mark Hogancamp

http://chelseaartgalleries.com/White+Columns/Mark+Hogencamp+_28Esopus+Magazine_29.html

On April 8, 2000, Mark Hogancamp was attacked by five young men in a Kingston, New York, parking lot. The assault left the ex-navyman, carpenter, and showroom designer in a coma for nine days; he emerged with brain damage that initially made it impossible for him to walk, eat, or speak. State-sponsored physical and occupational therapy helped him regain basic motor skills. But after less than a year he discovered that without insurance, he could no longer afford it. Determined "not to let those five guys win," Hogancamp turned to art as a therapeutic tool. It wasn't the first time: Before the attack, he had filled sketchbooks with intense and accomplished drawings relating to his struggles with alcoholism. But now, a shaky right arm and impaired hand-eye coordination thwarted his efforts.

Frustrated but resolute, Hogancamp reached further back into his creative past. He began by revisiting his childhood hobbies of collecting toy soldiers and building painted models. Commandeering a pile of scrap wood left behind by a contractor, he constructed "Marwencol," a fictional Belgian town built to one-sixth scale in the backyard of his home. He populated it with action figures and dolls representing Word War II personages like Gen. George Patton, as well as stand-ins for himself, his friends, and his family. Finally, he dusted off an old camera and began using it to capture staged events ranging from pitched battles between occupying German and American forces to catfights in a town bar. Through these exercises, Hogancamp sought to regain the capabilities that he recalled having had before the attack. Hogancamp's photographs first appeared in *Esopus 5* (Fall 2005). Since their publication, he has added several structures to the town and, armed with a new camera, he has been busily documenting a series of new narratives (stills from which will appear at White Columns for the first time). All of these images evidence Hogancamp's desire to conflate the historical and the personal, the specific and the universal. While he might view them as a means to a continuing recovery, it is impossible not to recognize—in their painstaking execution, obsessive attention to detail, and undeniable emotional resonance—the unadulterated vision of an artist coming into his own."

—Tod Lippy, the Editor of ESOPUS

Dorothy Iannone

Since the 1960s, Dorothy Iannone has been making vibrant paintings, drawings, prints, and objects depicting male and female figures in states of physical union and ecstasy. These works narrate the artist's life in intimate detail and, departing somewhat from the dominant feminist discourse of the 1960s, emphasize personal freedom and spiritual transcendence through complete devotion to, and union with, a lover. In 1967, Iannone met the artist Dieter Roth in Reykjavík, Iceland. They fell immediately in love and began an intense seven-year relationship that became the primary subject matter of her artwork (the two remained close friends until Roth's death in 1998). Iannone's artist's book *An Icelandic Saga* (1978–86) illustrates in vivid detail her journey to Iceland and fateful encounter with Roth, her decision to leave her husband and comfortable life in the United States, and her move to Reykjavík to begin her new life.

Her paintings during that period convey the couple's everyday life and activities, with primacy given to the sexual aspect of their relationship. The abstract patterning in *At Home* (1969) provides a two-dimensional map of the couple's home, replete with plants, shelves full of books, and furniture. In paintings such as *I Begin to Feel Free* (1970), Iannone depicts herself and Roth in a number of sexual positions, the colors and patterns of their bodies echoed in the abstract forms that surround them. The titles of these paintings, suggesting intimate words spoken between the lovers, are inscribed on their bodies. Although they allude to timeless themes of love and spirituality, Iannone's paintings were immediately read as politically radical in the European art world of the 1970s. She famously pulled her works from a 1972 group exhibition in Berlin after the organizers attempted to censor imagery they found offensive.

Although painting remains her primary medium, Iannone has also incorporated time-based media into her work. In the large painted box *I Was Thinking of You III* (1975/2005), a video monitor serves as a surrogate head and shows the artist's face as she reaches orgasm. She has also made audio-based painted boxes that play the sound of her singing and music by members of the German band Kraftwerk. Such works lend immediacy to the states of ecstasy and spirituality so prevalent in Iannone's work.

(1932–)

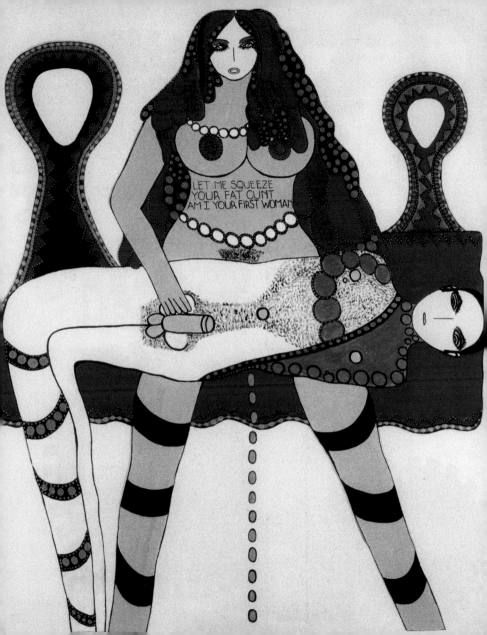

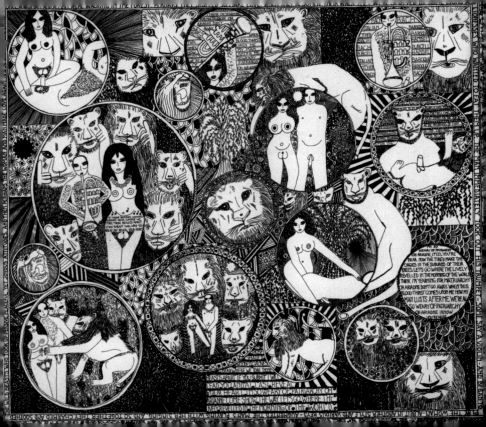

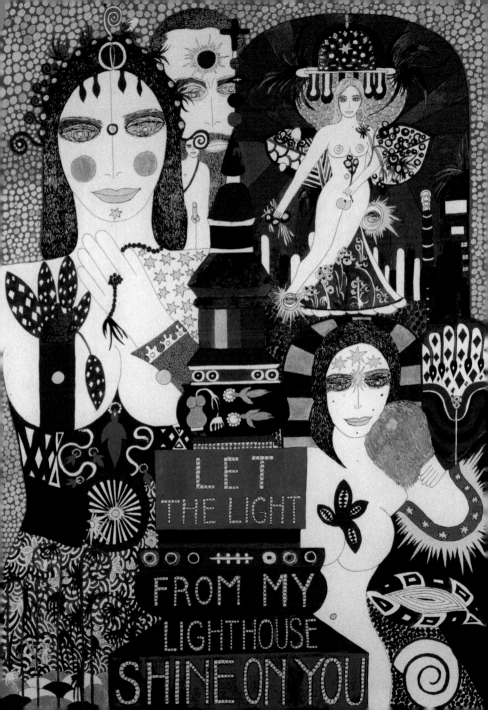

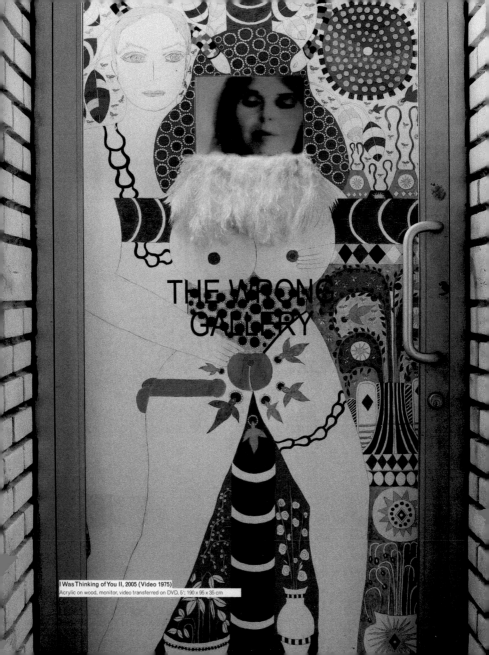

THE WRONG GALLERY

I Was Thinking of You II, 2005 (Video 1975)
Acrylic on wood, monitor, video transferred on DVD, 5'; 190 x 95 x 35 cm

Will Insley

http://query.nytimes.com/gst/fullpage.html?res=9905E7DC153B
F93BA1575AC0A962948260

This year it's the equally mysterious but more
sinister cosmos of Will Insley, "The Opaque Civi-
lization," expressed by models made of mushroom-
brown masonite, photo-montages, drawings and
shaped canvases. Organized by the guest curator,
Linda Shearer, Insley's art looks toward the future
and has affinities with the awful schemes for mass
living and working that architects are prone to and
all too often get to realize. Some of the structures
could be models for the kind of industrial park
that skulks close to the ground and produces who-
knows-what toxic wastes.

"ONECITY," the chief project in the show, has,
the artist says, "very little to do with advanced
planning theories of the present" or with the "uto-
pias of the future, but rather with the dark cities of
mythology, which exist outside of normal times in
some strange location of extremity."

An imaginary labyrinth 650 miles square, symbol-
ized by a floor plan that paces off at about 30 feet,
it is "situated" between the Mississippi and the
Rockies and consists of many 2 1/2-mile-square
structures, each divided into an "Over-building"
and an "Under-building" and each containing nine
arenas. Like the "Star Trek" scripts, the artist omits
the logistical nuts and bolts, making paraphrase
difficult.

(1929–)

Text from: *Art: Will Insley's Visions of a Labyrinthine City*
by Vivien Raynor. Published: *The New York Times*, September
28, 1984.

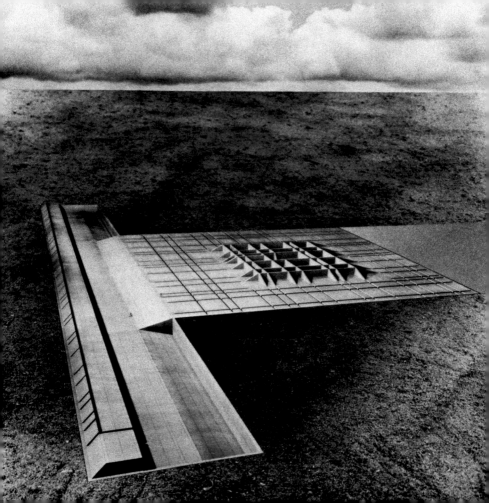

Jess

Jess was born Burgess Collins in Long Beach, California, and educated as a chemist. He was drafted into the military and worked on the production of plutonium for the Manhattan Project. After his discharge in 1946, Collins worked at the Hanford Atomic Energy Project in Richland, Washington, and painted in his spare time, but his dismay at the threat of atomic weapons led him to abandon his scientific career and focus on his art.

In 1949, Collins enrolled in the California School of the Arts (now the San Francisco Art Institute) and, after breaking with his family, began referring to himself simply as "Jess." He met Robert Duncan in 1951 and began a relationship with the poet that lasted until Duncan's death in 1988. In 1952 in San Francisco, Collins, with Duncan and painter Harry Jacobus, opened the King Ubu Gallery, which became an important venue for alternative art and which remained so when, in 1954, poet Jack Spicer reopened the space as the Six Gallery.

Many of Collins' paintings and collages have themes drawn from chemistry, alchemy, the occult, and male beauty, including a series called *Translations* (1959-1976) which is done with heavily laid-on paint in a paint-by-number style. Collins also created elaborate collages using old book illustrations and comic strips (particularly, the strip *Dick Tracy*, which he used to make his own strip *Tricky Cad*). Collin's final work, *Narkissos*, is a complex, beautifully-rendered 6'x5' drawing owned by the San Francisco Museum of Modern Art.

(1923–2004)

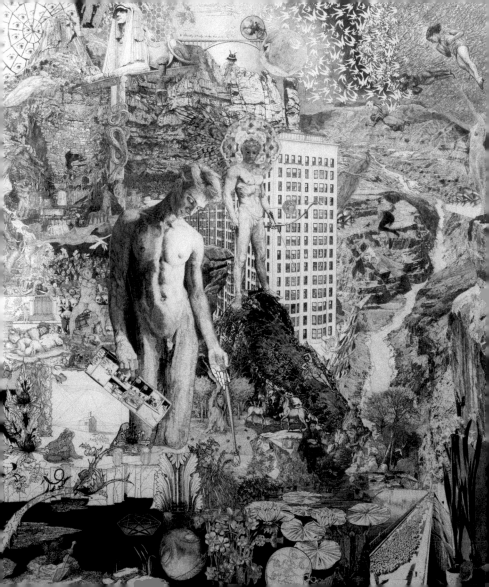

DICK RACY

YOU HAVE TO STAND RIGHT HERE, CONFESS—

WA-WA BA-WAA WAAA

AND IN 3-D MAGEES SECT

FRY? WHO ME? WHAT DO YOU MEAN? JUST LIKE A BABY? BIRK RODE HIS BIKE?

A REVOLVER QUIT WORRYING AND LATER FOUND FOOD, CONVICTED OF WEIGHT.

I'VE HAD TO NEGLECT MY BABY BUSINESS THESE LAST FEW MONTHS! PLUS I CAN GO CRY WELL, I'LL BE! THATS ALL IN MY WORK.

BROKEN PIECE IN THE LOCKER ROOM.

OH STOP CRIME!

WHAT OUT? I'VE GOT SOMETHING ON ONE OF THE KIDS! HURRY!

I'VE TOLD THE WHOLE STORY! NO BABY IS GUILTLESS, I FEEL ELECTRIC NOW—I'M READY RIGHT IN THE WOODS

THIRTY MINUTES LATER.

THERE ISN'T A FIGURE AROUND FOR HALF A MILE.

THAT'S WHAT MAKES IT ALL THE MORE SPOOKY.

Fig. 3.—Ida, Duncan & I

Stephen Kaltenbach

"Room Constructions: Blueprints and Models"
by Stephen J. Kaltenbach

In 1967, conceptual artist, Stephen J. Kaltenbach
produced a series of blueprint drawings proposing
12 "Room Alterations." For his upcoming exhibi-
tion (his second at ANOTHER YEAR IN LA),
Kaltenbach will exhibit the blueprints as well as
scale models of several of the *Room Alterations*.

These room construction blueprint drawings
and actualized museum works pre-date his UC
Davis classmate and fellow conceptual artist,
Bruce Nauman's corridor pieces by a couple years.
The real history here is not that Kaltenbach did
something before someone else; the moment was
about his minimal discoveries. As he referenced
in a November, 1970 *Artforum* interview about
his *Room Constructions*, "that experience showed
me that my primary concerns were with reducing
the number of elements that could be removed
before the work itself disappeared and that the
possibility of nothing being acceptable as art was
not acceptable to me at that time." He went on to
state, "So I felt that once I had arrived at the point
where I was really minimal, nothing but a simple
geometric shape, then other things would have to
be done to reduce the experience. I accomplished
that by reducing the visual complexity in the room
or space where the piece was to be seen."

Asked recently about the *Room Constructions*,
Kaltenbach said "these room alterations were an
attempt to move further into minimalism: as was
most of the work for the following three years.
During my graduate studies I was interested in the
removal of sensory and connotative information
from the viewing experience. Previous work had
been composed to interact first with furniture and
then with the room's surfaces; floor, walls and ceil-
ing. By increasing the scale and by using common
interior finish materials I was attempting to merge
the sculptural form with the interior: to make
them act visually and conceptually the same."

(1940–)

**Become a
legend**

Tina Keane

Tina Keane studied at Hammersmith College of Art and Sir John Cass School of Art (1967–70) and got an MA in Independent Film and Video from London College of Printing (1995–96). She has worked across a range of media from performance and installation to film, video and digital art.

Tina Keane has exhibited widely both nationally and internationally and was Artist in Residence at various institutions including the Banff Centre in Canada. She is a founder member of Circles—Women in Distribution and curator and programmer of exhibitions and screenings including *The New Pluralism* exhibition at the Tate (with Michael O'Pray, 1985). She has won awards from the Arts Council, Channel 4, the British Council and London Production Board.

Keane has been a Visiting Lecturer at many colleges and universities throughout the UK and abroad, including Harvard University. Since 1982 she has been Lecturer in Film & Video at Central Saint Martins College of Art & Design, London, where she has also been Research Fellow since 2003.

(1948–)

Patrick Keiller

Keiller was born in 1950, in Blackpool and studied at the Bartlett School of Architecture, University College London. In 1979 he joined the Royal College of Art's Department of Environmental Media as a postgraduate student. For a time he taught architecture at the University of East London.

His first film was *Stonebridge Park* (1981) followed by *Norwood* (1983) and *The Clouds* (1989). These films are typified by their use of handheld camera and voice-over, a technique that was further refined in his longer films *London* (1992) and *Robinson in Space* (1997).

Both *London* and *Robinson in Space* are narrated by an unnamed character (voiced by Paul Scofield) who follows his friend, the unseen Robinson around London. Robinson is involved with research into the 'problem' of London and in the later film, *England*. The films are seen as a critique of the British economic landscape under the Conservative governments of Margaret Thatcher and John Major.

In 2000, Keiller directed *The Dilapidated Dwelling*. This film was made for television, but was never broadcast. It features the voice of Tilda Swinton, and its subject matter is the state of British housing.

(1950–)

Sister Mary Corita Kent

Corita Kent, also known as Sister Mary Corita Kent, was born Frances Elizabeth Kent in Fort Dodge, Iowa. Kent was an artist and an educator who worked in Los Angeles and Boston. She worked almost exclusively with silkscreen and serigraphy, helping to establish it as a fine art medium. Her artwork, with its messages of love and peace, was particularly popular during the social upheavals of the 1960s and 1970s.

At the age of eighteen Kent entered the Roman Catholic order of Sisters of the Immaculate Heart of Mary in Los Angeles. She also studied at the University of Southern California where she earned her MA in Art History in 1951. Between 1938 and 1968 Kent lived and worked in the Immaculate Heart Community. There she was a teacher and chairman of the art department. She left the order in 1968 and moved to Boston, where she devoted herself to making art. She died of cancer in 1986.

Kent created several hundred serigraph designs, for posters, book covers, and murals. Her work includes the 1985 Love Stamp and the 150-foot-high natural gas tank in the Dorchester neighborhood of Boston.

(1918–1986)

Partial list of publications:
1. 1967 *Footnotes and Headlines: A Play-Pray Book*, Sister Corita
2. 1969 *city, uncity*, poems by Gerald Huckaby, pages by Corita Kent
3. 1970 *Damn Everything but the Circus*, Corita Kent
4. 1992 *Learning By Heart: Teachings to Free the Creative Spirit*, Corita Kent (posthumously) and Jan Steward
5. 2000 "Life Stories of Artist Corita Kent (1918–1986): Her Spirit, Her Art, the Woman Within" (Unpublished Doctoral Dissertation, Gonzaga University), Barbara Loste
6. *Eye*, No. 35, Vol. 9, edited by John L. Walters, Quantum Publishing, 2000.
7. 2006 *Come Alive! The Spirited Art of Sister Corita*, Julie Ault
8. Corita Art Center http://www.corita.org/

LET
THE
SUN
SHINE IN

When he used this word "cup" he was talking about his cross ... when he invites us to partake of his cup, he is not inviting us to take a little sip of grape juice, he is inviting us to participate in wall-breaking, in living and dying as a representative of God's shalom ...
reconciliation

WHERE HAV
e ALL
the flowers
GONE ?

WHERE HAV
e ALL
the flowers
GONE ?

Konrad Klapheck

www.kettererkunst.com/bio/KonradPeterCorneliusKlapheck-1935.shtml

'With the aid of my machine pictures I could, without trying, revisit the past and come to terms with the difficulties I was then experiencing in my own life. Beneath every successful picture lay another picture, one that could only be inferred, which gave meaning to what was happening on the surface. I decided to build up an entire system from machine themes and to tell my autobiography through them.' (Konrad Klapheck).

Born on 10 February 1935 in Düsseldorf, Konrad Klapheck attended higher secondary school for classical languages and literature before studying painting between 1954–58 at the Düsseldorf Art Academy. His teacher there was Bruno Goller, who is best known for symbolically alienated representations of utilitarian objects from everyday life and supported Klapheck's interest in this theme. Studying Surrealism early on, Klapheck had visited Max Ernst by 1954. He spent five months in Paris in 1956–57 and from 1961 maintained close ties with the Paris Surrealists around André Breton. In 1955, when Informel was at its height in Germany, Klapheck painted *Schreibmaschine* [*Typewriter*], in which a typewriter is depicted with exaggerated realism against a simple background. In the years that followed, Klapheck continued to paint in the Superrealist manner, thus heightening the objects he represented to a menacing monumentality. His works convey an impression of extremely smooth surfaces. Apart from the paintings, prints began to take an important position in Klapheck's work in the late 1970s. During that time he worked with the Frielinghaus Printing Workshop in Hamburg. In 1979 Klapheck became a professor at the Düsseldorf Art Academy, where he still teaches. Widely acclaimed, Klapheck's work has been shown at retrospectives and acquired by important museums. In 1964 he took part in Documenta 3 in Kassel and two years later the Hannover Kestner Society mounted the first retrospective of his work. A film, directed by Wiebke von Bonin, was made about the artist in 1981.

(1935–)

See also: www.konradklapheck.de/

Hilma af Klint

http://en.wikipedia.org/wiki/Hilma_af_Klint

Hilma af Klint was a Swedish artist and mystic whose paintings were amongst the first abstract art. She belonged to a group called 'The Five' and the paintings or diagrams were a visual representation of complex philosophical ideas.

Early life

The fourth child of Captain Victor af Klint, a Swedish naval commander, and Mathilda af Klint (née Sonntag), Hilma af Klint spent summers with her family at their farm Hanmora on the island of Adelsö in lake Mälar. In these idyllic surroundings Hilma came into contact with nature at an early stage in her life and this deep association with natural forms was to be an inspiration in her work. From her father she adopted an interest in mathematics.

In 1880 her younger sister Hermina died and it was at this time that the spiritual dimension of her life began to develop.

She showed an early ability in visual art and after the family had moved to Stockholm she studied at the Academy of Fine Arts for five years during which time she learned portraiture and landscape painting . Here she met Anna Cassel, the first of the four women with whom she later worked in 'The Five' (de fem), a group of artists who shared her ideas. Her more conventional painting became the source of her financial income while the 'life's work' remained a quite separate practice.

Spiritual and Philosophical Ideas

The project on which 'the Five' were engaged involved, in 1892, recording in a book a completely new system of mystical thought in the form of messages from higher spirits. One, Gregor, spoke thus: 'all the knowledge that is not of the senses, not of the intellect, not of the heart but is the property that exclusively belongs to the deepest aspect of your being...the knowledge of your spirit'.

It is interesting to note that af Klint's work ran parallel to the development of abstract art by other artists such as Piet Mondrian, Kasimir Malevich and Wassily Kandinsky who were, like af Klint, inspired by the Theosophical Movement founded by Madame Blavatsky. Af Klint's work can also be seen in the wider context of the modernist search for new forms in artistic, spiritual, political and scientific systems at the turn of the 19th century.

Work

Through her work with the group 'the Five' Klint created experimental automatic drawing as early as 1896, leading her towards an inventive geometric visual language capable of conceptualising invisible forces both of the inner and outer worlds. Quite apart from their diagramatic purpose the paintings have a freshness and a modern aesthetic of tentative line and hastily captured image: a segmented circle, a helix bisected and divided into a spectrum of lightly painted colours. She continued prolifically to add to the body of work amounting to over 1000 pieces until 1941. She requested that it should not be shown until 20 years after the end of her life.

(1862–1944)

See also: http://hem.bredband.net/hilafk/eng/index.html

Budhas ståndpunkt
i
jordelifvet

Mahatmernas nuvarande
Ståndpunkt

Mahansbacka Ständpunkten

Budhismens lärosystem

Den kristna religionen

Leonard Knight

Leonard Knight is the builder and chief architect of Salvation Mountain. He was born in November 1, 1931 in Vermont. He lives at the mountain near Slab City, a few miles from Niland, California, and approximately 150 miles from San Diego.

In 1967, Knight went to visit his sister in San Diego. It was here where he experienced his first religious feelings after he rejected his sister's attempts to teach him about Jesus: "I was about thirty-six years old and I'd never spent one minute, hardly, thinking about God or the Lord. I remember (to my knowledge, it was on a Wednesday, about ten-thirty in the morning in 1967, in my van, by myself) and i just started saying 'Jesus, I'm a sinner, please come into my heart.' I figured, hey, I'm all alone with Jesus, there ain't no harm in me keeping repeating this. And, man, for twenty minutes I was just saying it over and over again, and it changed my life completely to the good."

Salvation Mountain is Knight's accomplishment which began with the failure of another dream. For three years, Knight built his testament to God and Jesus out of watered-down cement and sand, until one day when it literally exploded in a cloud of dust. Knight began to rebuild the mountain, this time using adobe clay, which he has continued to work on to this day. Currently, he lives in a donated truck converted into a house near the base of the mountain and spends his days maintaining it and building the adjacent "Museum," an enormous dome of straw bales, adobe, auto glass, wood and paint.

(1931–)

See also: www.salvationmountain.us/bio.html

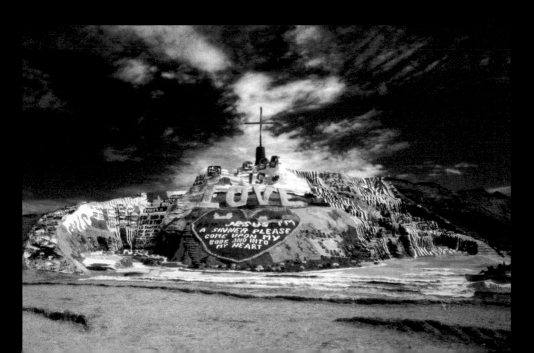

Christopher Knowles

Christopher Knowles is a U.S. poet who has autism. In 1976, his poetry was used by Robert Wilson for the avant-garde minimalist Philip Glass opera *Einstein on the Beach*.

Aside from the major success of *Einstein on the Beach*, Knowles mounted shows in the 1970s. In 1978, the American poet John Ashbery wrote in *New York Magazine* (of a volume of Knowles's poetry):

"Christopher has the ability to conceive of his works in minute detail before executing them. There is nothing accidental in the typed designs and word lists; they fill their preordained places as accurately as though they had spilled out of a computer. This pure conceptualism, which others have merely approximated using mechanical aids, is one reason that so many young artists have been drawn to Christopher's work."

In 2004 Knowles stayed in Long Island for the summer working with Robert Wilson. For one week during the summer the Harty family stayed in the house he was residing in, and escorted him to his place of work. Christopher has continued to collaborate with Robert Wilson, and Wilson has used Knowles's texts in many of his operas.

Although Knowles has produced very little solo theatrical work, he is a major artist whose drawings and typings (*Typings*, a volume of poetry, received good notices) are represented by Gavin Brown's enterprise in NYC.

(1959–)

ROCK YOUR BABY

Long time into take me home rock your baby. Take me rock your baby. And then.
Will it cause you to get back on the highway. Will it get use to it.
It was gone for ever. So it could get some gas to get some one to talk.
So it could get it up to the top of the mountain, it was fun down the hill too.
Let's get together and say to be a winner.
Long time into take me home rock your baby. Take me rock your baby. And then.
Will it cause you to get back on the highway. Will it get use to it.
It was gone for ever. So it could get some gas to bet some one to talk.
So it could get it up to the top of the mountain, it was fun down the hill too.
Let's get together and say to be a winner.
Long time into take me home rock your baby. Take me rock your baby. And then.
Will it cause you to get back on the highway. Will it get use to it.
It was gone for ever. So it could get some gas to get some one to talk.
So it could get it up to the top of the mountain, it was fun down the hill too.
Let's get together and say to be a winner.
Long time into take me home rock your baby. Take me rock your baby. And then.
Will it cause you to get back on the highway. Will it get use to it.
It was gone for ever. So it could get some gas to get some one to talk.
So it could get it up to the top of the mountain, it was fun down the hill too.
Let's get together ahd say to be a winner.
Long time into take me home rock your baby. Take me rock your baby. And then.
Will it cause you to get back on the highway. Will it get use to it.
It was gone for ever. So it could get some gas to get some one to talk.
So it could get it up to the top of the mountain, it was fun down the hill too.
Let's get together and say to be a winner.
Long time into take me home rock your baby. Yake me rock your baby. And then.
Will it cause you to get back on the highway. Will it get use to it.
It was gone for ever. So it could get some gas to get some one to talk.
So it could get it up om the top of the mountain, it was fun down the hill too.
Let's get together and say to be a winner.
Will it get Long time into take me home rock your baby. Take me rock your baby.
Will it cause to get on the highway. You. Back. Long time take me home rock yr.
Long time take me home rock your baby. Rock your baby. Rock your baby. Rock you
Long time into take me home rock your baby. Longer time in these ones to get so
Will it cause you to get back on the highway. Will it get use to it.
It was gone for ever. So it could get to nage mage. Is like a diamond in the.
Long time into take me home rock your baby. Take me rock your baby. And then.
Will it cause you get back on the highway. Will it get use to it.
Long time into take me home rock your baby. Take me rock your baby. And then.
Will it cause you to get back on the highway. Will it get use to it.
It was gone for ever. So it could get some gas to get some one to talk.
So it could get it up to the top of the mountain, it was fun down the hill too.
Let's get together and say to be a winner.
Long time into take me home rock your baby. Take me rock your baby. And then.
Will it cause you to get back on the highway. Will it get use to it.
It was gone forcever. So it could get some gas to get some one to talk.
So it could get it uo to the top of the mountain, it was fun down the hill.
Long time take me home rock your baby. Take me rock your baby. And then.
Will it cause you to get back to the highway to get some gas to make wonderful.
And it was the one to get some gas to be on the one to say we were giving them.
A story to get some guessys to gwt gests of your own to get some gas to get so.
So it would be so dark to see you for were you hy hey get down for a ride to se
Look for the most for give up some gas to get some stories up with seeing up to
So it could makexsiome wonder s c vision here we go to get some gas get get get
get get get get out of the putrw of futures for us to get some like that to use
so you could go andxski for a second. Here we go to the story to know your sent
sentence for us. So it could be real wrong to to to to to to to to get some gas
for real. So it could be the one of the most wonderful for us for the last to.
So it could get some horses to know that to get some tracks to get some to get
some to get some gas to get some gas to get some to get some gas to get some to
getssome gas to get some to get some gas to get some gas to get some gas to win
the game for you. So you go down the road to feel of your own to get some steel
for you. Some of those is for the others for the us for the use to see you in t
Long time take me home ride your baby rock your baby. Rodk your baby brations.
So it could go to the signal sing vghud ghost of for you to get some gas for us
So here is the story for the chairs for you for my friends for us liied bgh nm;
So it could go into the stomach for the best for ghosts wre tyuiop if you just
If there wasxa game going on for the most. So it could go off vto the mountainsf
So it could be wonderful to have for the last one for see you for the other t..
Long time into take me home rock your baby. Take me rock your baby. And then.
Oh thank you very much I am tired I am tired I can not help it that was it for.
Long time please begiving to somebody for you please to know that for the other
Alright that's the n the end of the wonderful rock your baby help me help me up
Long time into take me home rock your baby. Take me rock your baby. And then.
Long time home baby thank yo

```
ABRACADABRA
ABRACADABR
ABRACADAB
ABRACADA
ABRACAD
ABRACA
ABRAC
ABRA
ABR
AB
A
```

Christopher Knowles
Puevfgbcure Xabjyrf

Bob Wilson
Obo Jvyfba

 mad at you angry with you
 znq ng lbh natel jvgu lbh

 freaky freak
 sernxl sernx

 taperecorder
 gncrepber

taperecorder ffff
gncrerpbeqre

 be
 or

CHAPTER ONE

MR. BOJANGLES
HOW COULD I SEND YOUR MESSAGE TO YOU
THE MORNING HAS BEEN BROKEN
YOU KNOWN THAT
HORSES IN CREDITS BROADWAY
RADIOS FOR FUN
STOP LOOK LISTEN TO THE HEARTBEAT
LOVE GROSE WITH MY ROSEMARY GOES
HELLO IT'S ME
SUMMER BREEZE
HE WAS THE MOST
EVERYTHING IS BEAUTIFUL
I THINK I LOVE YOU
COME ON BABY LIGHT MY FIRE
LIKE A ROLLING STONE
A MAD MAN
THESE ARE THE DAYS
CHAPTER EIGHT I FEEL THE EARTH MOVE
LOOP AND LET DIME
SO FAR AWAY
GIVE YOU UP
(GIVE ME LOVE)—GIVE ME PIECE ON EARTH
I FEEL THE EARTH MOVE
YOU ARE SO BEAUTIFUL
WHEN YOU GET START IT
JUST YOU AND ME
SUNSHINE SUPERMAN
LAST TIME I SAW HIM
ALL YOU NEED IS LOVE
REACH OUT IN THE DARKNESS
THE HUSTLE
LOVE WILL KEEP US TOGETHER
SWEARIN TO GOD
PHILADELPHA FREEDOM
LADY MOTHERLAUGHT
SEARCHING BAGS ALL TOGETHER
GET DANCING
FOR THE GOOD TIME
CRACKLING ROSY
FIRE
LADIES
KILLING ME SOFTLY WITH HIS FINGERS
MANDY
MR. AND MRS. JONES
A HORSE WITH NO NAME
I LIKE DREAMING
YOU ARE THE WOMAN
SIR DUKE
BEEEESCOPE
DO YOU KNOW THE WAY
I'M NEVER NEVER GOING TO GIVE YOU UP
BRANDY
GET DANCING
CHRIS
DI DI

CHAPTER TWO

THE C TYPING
BLACK ABRACADABRA
RED ABRACADABRA
MY GRANDMOTHER,S LETTER
E AND ING
FEELINGS
THE WORDS
THE OVER LETTERS
THE LETTER TYPING
SENTENCES LETTER
ROCK YOUR BABY
ROCK THE BOAT
THE TIMES
EYEGLASSES
THE ALPHABET LETTERS
THE SONGS
THE RHYMINGS
GET WRECK
THE LIFE AND TIMES OF MADDOM DAME
THE NET WORK OF HOWARD BETEL
THE TOP 65 OF 1967
TYPING DESIGNS OF TYPINGS OF C,S

Július Koller

Central to Július Koller complex art is the concept
of the sign, most apparent in his foremost emblem,
the question mark, but also utilised in text or com-
binations of letters, e.g. when the artist designates/
denominates an object or a situation, an act aiming
to inscribe it in a cultural context.

The actual, non-fictive, action is often termed a
'cultural situation' and is also central. Koller de-
scribed his earlier performance work as 'anti-hap-
penings', an indication that their intention was not
to be read as illusionist acts. Koller's actions are
conceptual, yet they always take place in a reality.
A cultural situation does not submit to a given hi-
erarchy but, on the contrary, may be characterised
by its simplicity and commonplaceness.

Since 1970, Július Koller has utilised the letters
U.F.O. in his work. U.F.O., which in its original
form stood for 'Universal-Cultural Futurological
Operations' and later took on many other mean-
ings, arose in a political situation characterised by
the 'normalisation' that was a consequence of the
relatively free late-60s political climate. Whereas
Koller's actions continue to aim towards the actual,
the denotation U.F.O. points towards a more per-
missive future. Originating from the same period
is a series of self portraits titled: *U.F.O-naut J.K.*

Much of Július Koller´s work contains various
references to sport. In this context, sport repre-
sents a society or a situation based on rules that
apply to everyone and includes 'fair play'. For the
Index exhibition, Július Koller presents *Stockholm
Cultural Situation*, a performance where the artist
plays table tennis with himself.

(1939–)

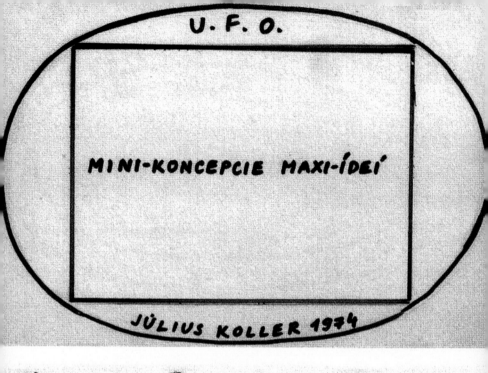

U. F. O.

MINI-KONCEPCIE MAXI-ÍDEÍ

JÚLIUS KOLLER 1974

UNIVERZÁLNY FANTASTICKÝ OTÁZNIK

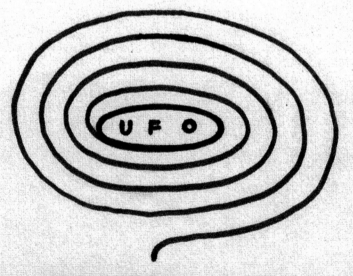

U F O

JÚLIUS KOLLER 1973

JÚLIUS KOLLER 1978

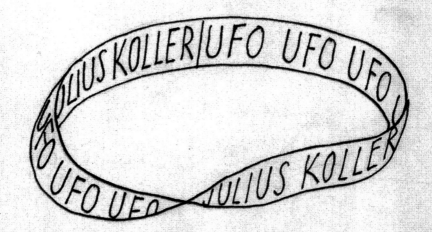

UNIVERZÁLNY FILOZOFICKÝ ORNAMENT

JÚLIUS KOLLER 1979

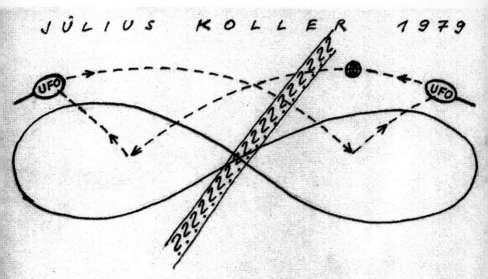

UNIVERZÁLNA FYZKULTÚRNA ORGANIZÁCIA

Panos Koutrouboussis

Panos Koutrouboussis, a resident of Athens since 1940, is a great humorist who follows the path of Zen unconventionally and without manifestos. Story-writer, visual artist, film director and translator, he has loved American comics, the world of Karaghiozis, short comedy films, French poetries and sci-fi and horror magazines. His first contact with art was through drawing. As a key member of the Hut of Simos the Existentialist around 1953–54, he made the drawings for the gang's excursion programmes. He has shot short films with an ironic slant, designed photographic covers with grand-guignol themes for LPs and published drawings in the British underground publications *Oz* and *International Times* and elsewhere, while many of his compositions of dummies and unreal creatures became front covers for sci-fi books. He began to write systematically in the 1960s, and participated in the independent/surrealist magazine *Pali* (1964). His crazy fun stories with references to the local folk element, often written in archaic Greek, and his longer works of fiction, began to be published in 1978. He is also the inventor of tachydramas—brief, one-page theatrical plays.

THE STRANGER IN A ROOM.

Jirí Kovanda

Jirí Kovanda´s performance work takes place in
public space, without a stage and often without
an audience. Since the mid-70s he has made
small incursions into what we perceive as normal
behaviour by inserting an element of uncertainty.
In a performance dating from September 1977, he
walks down a sidewalk in Prague and bumps into
people, seemingly unintentionally. In a later work,
from 2002, he spends a day at an art symposium
in Bratislava in the elevator with a lock of his hair
and a finger taped to the inside of the elevator. In
other works, he does not feature himself but makes
installations and 'interventions' in ephemeral ma-
terial such as salt or leaves. Both artistic methods
are not immediately recognisable as art and nor
are they always presented as such. The observer
find himself in a situation which is open to vari-
ous interpretations and possibilities, a situation
that could be seen as, if not political, then at least
related to society and reality. Through an inexpli-
cable addition, an interruption or displacement in
the commonplace, our perceptions also become
displaced. Jirí Kovanda´s work creates a gap in
existing conditions. It is fundamentally about how
we choose to perceive. Through methods that are
as minimal and poetic as they are down to earth,
Jirí Kovanda provides an alternative view on our
surroundings. Jirí Kovanda's new work for *Index*,
Untitled, is an intervention being performed by the
artist on the roof of the art hall.

(1953–)

x x x

26.listopadu 1977
Hradec Králové

Co nejtěsněji přitisknut ke stěně,jdu kolem celé místnosti,
uprostřed které stojí diváci...

x x x

23.ledna 1978
Praha,Staroměstské náměstí

Dal jsem si sraz s několika přáteli...stáli jsme v hloučku
na náměstí a hovořili...náhle jsem se rozběhl,utíkal jsem
přes náměstí a zmizel v Melantrichově ulici...

BÍLÝ PROVÁZEK DOMA /WHITE STRING AT HOME/

19.-26.listopadu 1979
Praha

VĚŽ Z CUKRU

jaro 1981
Praha, Vyšehrad

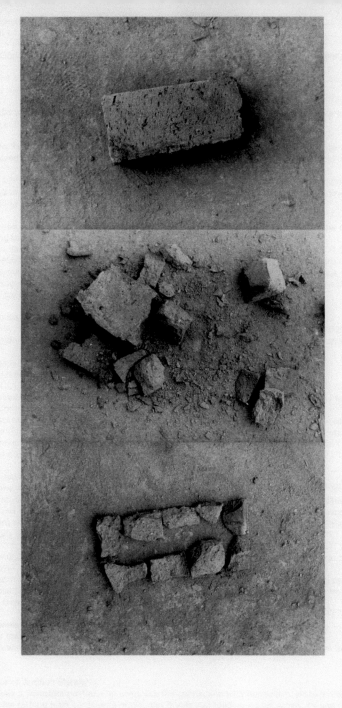

Evgenij Kozlov

Evgenij Kozlov was born in Leningrad/St. Peters-
burg in 1955. He starts copying the masters of the
Hermitage Museum when he is only three years,
old and his passion for art will never leave him. In
his childhood and youth he studies the classical
approach towards art but then becomes increas-
ingly interested in contemporary art tendencies
and techniques.

In 1982 Evgenij Kozlov becomes a member of
the leading Leningrad avantgarde art group of
the eighties "The New Artists". The desire of the
young "inofficial" Russian artists to perform in
public and change the course of art-history finds
parallels in the political scene with Gorbatchev`s
Perestroika. Together with "The New Artists"
Evgenij Kozlov activley participates in art-exhibi-
tions and performances; at the end of the eighties,
the group has their first international shows in the
U.S.A. and Western Europe.

In 1989 Evgenij Kozlov opens his studio "RUSS-
KOEE POLEE/The Russian Field" on the Fon-
tanka Embankment in Leningrad. It immediately
becomes a meeting place of artists, international
curators and journalists.

In 1990 the Berlin photographer Hannelore Fobo
meets him in his studio and is fascinated by the
artist and his artwork. Eventually, Evgenij Kozlov
moves to Berlin in 1993 where, a year later, they
both open "RUSSKOEE POLEE/The Russian
Field No 2" in an old factory in the historical
center of Berlin, formerly East-Berlin. Again "The
Russian Field" becomes a center for the Russian
and international art-community in Berlin, but
most importantly, the size of the place gives the
artist the possibility to further develop his artistic
ideas on a large scale.

Starting with the new millenium, Evgenij Kozlov
shortens the name of his studio to the last two let-
ters "E-E", to stress his absolute liberty in style.

(1955–)

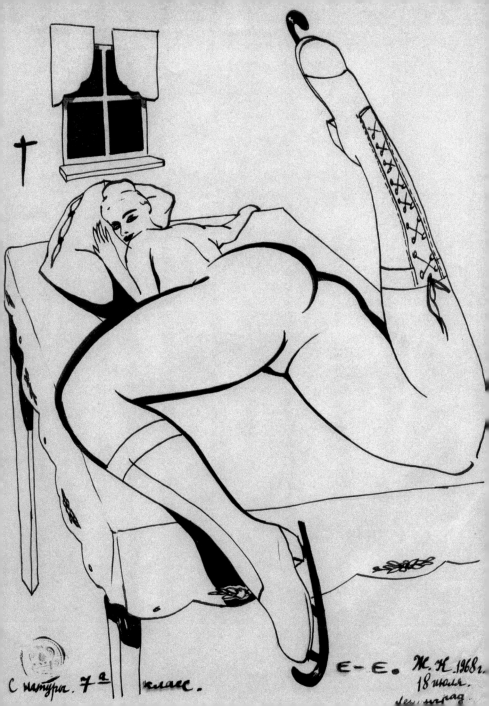

С натуры. 7ª класс.

Е-Е. Ж.К. 1968 г.
18 июля.

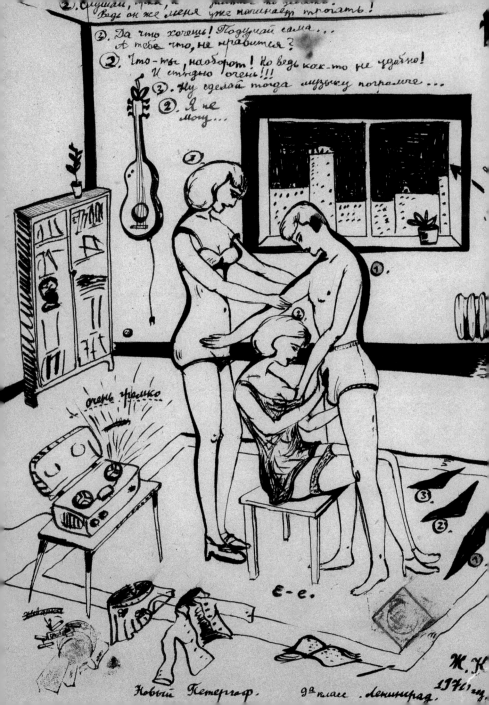

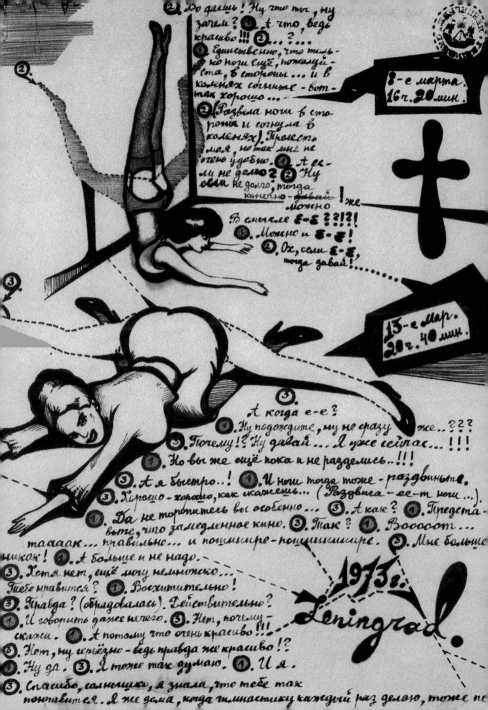

Jaroslaw Kozlowski

If I want to say anything I use words which are
usually taken from a different context. In general
they keep their original meanings, but in particular
they acquire new sense because of their contextual
change. These words are more or less suitable to
point our some aspects of my interest, but often it
is difficult or almost impossible to find the right
words to express what should really be expressed.
They are too simple or too complex, too pathetic
or too obvious, too precise or too enigmatic. In fact
they are mostly wrong and confusing, nevertheless
I still have to use them.

In my work I use images, objects and sounds
which are usually also taken from a different
context. Like words some of them still keep their
original meanings, some others get new meanings
because of the change of their context. However,
in both cases there are often small 'gaps' between
all these images, objects and sounds and their
original or given meanings, as well as between
the meanings and all possible sense I want them
to generate. These small 'in-between-gaps' affect
the work as much as—for example—quotation
marks affect the meaning and sense of a sentence.
Since they are almost invisible everything looks
the same, but nothing is the same anymore. First,
because all elements of the work are losing their
identity, second, because all fiducial points are dis-
sipating. Therefore the structure of relations and
dependences among the elements of the work as
well as its logical structure become corrupted.

Corruption involves the inner system of value of
the work, but it is not destructive for the work
itself. It is more a kind of clearance which gives
access to unexpected insights into another logic
and different system of values that transforms
meanings and sense.

All these changes are not spectacular. On the con-
trary, they take very discreet course. I am not able
to control them. As a matter of fact I do not even
know when, where and how they happen. The less I
do understand them, the more 'real' they seem to be.
—Jaroslaw Kozlowski, November 1989

(1945–)

Jarosław Kozłowski

GREY
THOUGHTS

Somewhere in the Universe

Someone is thinking in two

His thoughts are very grey

But sometimes grey means blue

Somewhere in the Universe

Someone is thinking clear

His thoughts are very grey

But sometimes grey means green

Harry Kramer

http://documentaarchiv.stadt-kassel.de/miniwebs/documentaarchiv_e/08192/index.html

Harry Kramer is known in Kassel particularly for his active role in establishing the "Kunstlernekropole" at the Blauer See in the Habichtswald.

The hairdresser from Lingen, as the artist often ironically called himself, also worked as an actor, dancer and puppeteer in his younger years. Already in the 1950s and continuing into the '60s, Kramer emerged as a widely renowned artist—for example, with a mechanical theater (1952) and particularly with his so-called automobile sculptures, which he also used in making several experimental films. In the manner of Tinguely, Harry Kramer became one of the central protagonists of kinetic art with his moving objects. These represented one of the attractions of Documenta 3 in 1964 in the section "Light and Motion".

As a professor and teacher at the Kassel University Art School, Harry Kramer earned great recognition in the 1970s and '80s with collective works and performances produced with his students.

The Harry Kramer Archive is located in the nearby Aschrotthaus, Oberste Gasse 24, 34117 Kassel. An appointment may be made to view the extensive materials of the bequest, which include personal effects, original artworks and archival materials relating to Kramer's artistic production as well as to his teaching activities.

(1925–1977)

Jim Krewson

Jim Krewson is a multimedia artist living in the mountains of upstate New York. He has been producing video art, oil portraits, chocolate and vanilla cakes graphically depicting sexual acts, airbrush paintings of nude celebrities and lewd online personal ads, films of stuffed animal Taco Bell employees, screaming, fit-throwing sculptures and Old Time banjo songs for the better part of 20 years. His work has appeared in periodicals such as *Time Out New York, The New York Times, The New York Press, The Wall Street Journal, Vice, Barracuda* and *Swank*. His artwork can be seen as props on Saturday Night Live, and the films *Mrs. Doubtfire, So I Married an Ax Murderer*, and *Get Shorty 2*.

Shows include:
1. The Hotel 17, 1996
2. The Knitting Factory (with Alex Bag), 1996
3. PS1, 1998
4. The Andrew Kreps Gallery, 1999
5. The Gavin Brown Gallery (with Rob Pruitt and Jonathan Horowitz), 2002
...upcoming "cat" art show in Tokyo, Japan, as well as upcoming shows in New York

Ferdinand Kriwet

Ferdinand Kriwet, born in Dussledorf in 1942, is a multimedia artist and poet who has produced many seminal films and sound works for radio and television, in particular throughout the 1960's and 1970's.

His works *Apollovision* (1969–2005) and *Campaign* (1972/73–2005), exhibited in collaboration with BQ gallery, rank today as outstanding artistic documents of these spectacular events in the history of mankind. Kriwet created the work *Apollovision* whilst in America at the time of the moon launch, his aim being to compose a work of perception derived from all information he gathered on radio, television and newspaper about the Apollo 11 launch. He describes these films as "Bild-Ton-Collage" sound-picture-collages, and in parallel Kriwet developed Concrete poetry, radio pieces composed of noise and sound bite samples and publications.

Kriwet's works are an attempt at communicating an idea of listening to something that constantly surrounds us on short, medium and long wave frequencies. His politically engaged and avantgarde approach was influenced by aesthetic and Conceptual currents in Constructivism, New Music, Beat Generation and Pop.

(1942–)

H A

MAD dra amt c **RY** A **RD**

ENT anglement ertraining

BEAT

TI **TAN**UDE

T**II**LT

for tat

Tetsumi Kudo

A Japanese artist who moved to France in 1962, Tetsumi Kudo's first works were part of the Neo-Dada current which, in nineteen-fifties Tokyo, looked for ways to mix performances and installations that gave new importance to the object. The singular nature of Kudo's world was made evident in *Philosophy of Impotence*, his first Paris happening. Prompting doubt and defiance, both his acts and his objects question human freedom in hyper-mediatized modern society. Using every instrument of control, from box to cage, from deposit receipt to transistorised garden, he set out to recount the metamorphosis of modern man. An ironic narrator, in the different stages of his work Kudo considers the bio-chemical survival of the human phenomenon and envisages its organic transformation. Heads are locked in cages, human limbs are connected to plants by electronic circuits, hands are held captive in an aquarium because Kudo cultivated, with perverse refinement, a sense of humour and cruelty. In his world, man and technology are not in opposition. Raised together, they engender a new culture which he named "new ecology". Man as we knew him has disappeared from Kudo's world, despite the flowers, cigarettes and crucifixes, the last remaining souvenirs of a long-ago existence. A new world takes its place, a world that no doubt remembers the unbearable violence of Hiroshima and which resolutely drapes itself in fluorescent colours. Described by Alain Jouffroy as an "Objector" in 1965, Kudo showed his ability to associate, in a disconcerting manner, the disciplines which preside over all new forms of research, beginning with art, ecology, technology and fundamental science. His last works, made with coloured wires, are about "black holes" and represent structural relations between the two worlds of East and West. At a time when the body becomes an experimental medium for contemporary creation through artificial limbs, cyber appendages, and attributes in chrome or latex, when it comes to us encircled by genetics, cloning and new technologies, Kudo's work reveals and elucidates his remarkable intuitions. The first major showing of Kudo's work in France, this exhibition is an opportunity to retrace the artist's trajectory from his arrival in France to the years before his death in 1990. Certain of the works, including some from European collections, have rarely been shown before.

(1935–)

COMMISSION OF
Public nuisances

Emma Kunz

"People such as Emma Kunz live at best once every 500 years, and even then we do not always have the good fortune to receive such a witness as that delivered in her bequeathed work." (Prof. H. Larcher)

Emma Kunz lived from 1892 to 1963 in the German-speaking part of Switzerland. In her lifetime she was recognized as a healer; she herself described herself as a researcher. Now she has acquired an international reputation through her artistic work. Even in her schooldays, Emma Kunz occupied herself with exceptional happenings. When she was 18 years old, she began to use her abilities of telepathy, prophecy and as a healer, and she began to exercise her divining pendulum.

She achieved successes through her advice and treatments that often edged on the limits of miracles. She herself rejected the term miracle because she attributed it to the ability to use and activate powers that lie dormant in everyone. Not least, it was this gift that permitted Emma Kunz to discover in 1941 the power of the Würenlos healing rock that she name AION A. From 1938, Emma Kunz created large-scale pictures on graph paper. She described her creative work as follows: "Shape and form expressed as measurement, rhythm, symbol and transformation of figure and principle". As visionary artist, she bequeathed to us a fascinating collection of her works of art that encodes immeasurable knowledge. The pictures are probably the most direct way to experience Emma Kunz's personality.

(1892–1963)

Manfred Kuttner

www.tate.org.uk/modern/exhibitions/theartistsdiningroom/
kuttner.shtm

Manfred Kuttner belongs to an older generation of
German artists and, despite differing approaches
and starting points, his early work from the 1960s
has strong resonances with the work of younger
abstract artists.

Kuttner first studied at Dresden Art Academy in
the former German Democratic Republic (East
Germany). In the early 1960s, he moved to West
Germany and enrolled at Düsseldorf Academy of
Art, where he became friends with such influen-
tial figures as Gerhard Richter, Konrad Lueg and
Sigmar Polke.

The painting process itself was a subject of
Kuttner's work, as it was for Richter, Polke and
Lueg. However, while the other artists (influ-
enced by American Pop art) took popular culture
imagery as their starting point, Kuttner focused
more on non-representational, abstract painting,
using geometric patterns, high colour and contrast,
collaged elements and layered overpainting.
During the early 1960s a newly invented lumi-
nescent paint—Pelikan's Plaka paint—came onto
the market, and Kuttner readily adopted it, as it
adhered to almost all surfaces and came in luridly
bright colours. With these fluorescent colours,
Kuttner began to not only paint on canvases, but
also to cover entire objects, including the Art
Academy's piano and typewriter.

(1937–)

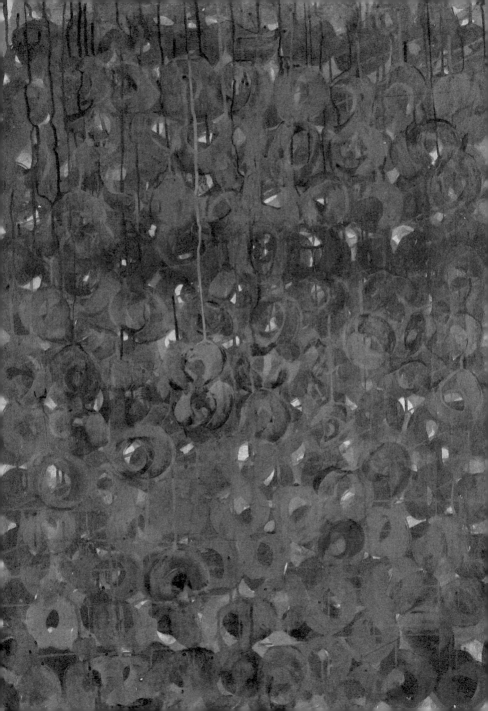

Paul Laffoley

Text From: http://www.myspace.com/paullaffoley

By Laffoley's account, he spoke his first word ("Constantinople") at the age of six months, and then lapsed into 4 years of silence, having been diagnosed with slight Autism.

He attended the progressive Mary Lee Burbank School in Belmont, Massachusetts, where his draftsman's talent was ridiculed by his Abstract Expressionist teachers. Laffoley attended Brown University, graduating in 1962 with honors in Classics, Philosophy, and Art History. In 1963, he attended the Harvard Graduate School of Design, and apprenticed with the sculptor Mirko Basaldella before being dismissed from the institution. Thereafter, he moved to New York to apprentice with the visionary architect Friedrich Kiesler. He was also hired for the design team of the World Trade Center, but was soon after fired by the chief architect, Minoru Yamasaki, for his unconventional ideas.

In 1964, Laffoley began working (and living) in an eighteen-by-thirty foot utility room to found the Boston Visionary Cell, where he has produced the large majority of his art. Working in a solitary lifestyle, each 73 1/2 x 73 1/2 inch canvas can take one to three years to paint and code. By the late 1980's, Laffoley began to move from the spiritual and the intellectual, and evolved to the view of his work as an interactive, physically engaging Psychotronic device, similar to architectural monuments such as Stonehenge or the Cathedral of Notre Dame, with their spiritual aura and transpersonal functionality.

During a CAT scan of his head in 1992, a piece of metal 3/8 of an inch long was discovered in the occipital lobe of his brain, near the pineal gland. The CAT scan was advised by his dentist, after noticing something unusual in a routine x-ray before a root-canal. The dental technician asked Laffoley "Uh ... Sir, have you ever been shot in the head?" Local Mutual UFO Network investigators declared it to be "an alien nanotechnological laboratory." Laffoley has come to believe that the "implant" is extraterrestrial in origin and is the main motivation behind his ideas and theories.

He has produced an estimated 600 of his immensely detailed canvases. Paul has been quoted as saying that at any given time there are dozens of these works already fully-articulated in his mind, waiting to be painted and circling like airplanes in a holding pattern waiting to land.

In the summer of 2001, Laffoley fell from a 20-foot ladder and broke both legs. His right leg subsequently became infected and was amputated below the knee. He documented some of his theories about why his fall occurred in the oil painting *The Fetal Dream of Life into Death* (2001–02).

After his amputation, in honor of his lost foot, Paul took some of the proceeds from his art and consulted Hollywood special effects guru Stan Winston (special effects creator for top films including—*Aliens*, *Predator*, *Terminator* series, *Jurassiac Park*, etc.) to create an anatomically correct, fully functional prosthetic LION'S FOOT, which Mr. Laffoley wears to lectures and special occasions.(Absolutely not kiding here. BTW, Paul is a LEO.)

Paul currently lives in Boston, Massachusets and is still producing his amazing transdisciplinary art.

(1940–)

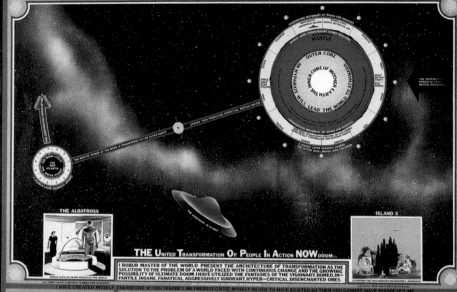

I, ROBUR MASTER OF THE WORLD

YOU MUST OBEY ME FOR ONLY I CAN SAVE THE WORLD

MANTLE · OUTER CORE · INNER CORE

THE INNER CORE OF MOTHER EARTH WILL LEAD THE WORLD TO...

THE ALBATROSS

ISLAND X

THE KEARSARGE IN FLIGHT

THE UNITED TRANSFORMATION OF PEOPLE IN ACTION NOW ooom...

I ROBUR MASTER OF THE WORLD PRESENT THE ARCHITECTURE OF TRANSFORMATION AS THE SOLUTION TO THE PROBLEM OF A WORLD FACED WITH CONTINUOUS CHANGE AND THE GROWING POSSIBILITY OF ULTIMATE DOOM. I HAVE UTILIZED THE FANTASIES OF THE VISIONARY, BORED, INFANTILE, INSANE, FANATICAL, AGGRESSIVELY IGNORANT, HYPER-CRITICAL DISENCHANTED ONES

I HAVE CREATED MYSELF THEREFORE IF YOU DISOBEY ME I MERELY CAUSE MYSELF NEVER TO HAVE EXISTED SO THEN YOU CANNOT HAVE DISOBEYED ME

THE MOON-LINK

BY A RECIPROCAL TRANSFER OF POWER FROM THE MOON TO THE EARTH BY THE MOVEMENT OF THE SHELLS AND THE MAINTENANCE OF THE MOON'S ORBITAL VELOCITY BY ELECTRONICS THE WORK OF MANKIND AS PURE SURVIVAL IS ELIMINATED.

LIVING STRUCTURES

IN OUR AGE OF DESPERATE SENTIMENTALITY WHAT COULD BE SO NATURAL AS THE USE OF GENETICALLY PROGRAMMED CREATURES, THUS MAKING OUR DESIGNED ENVIRONMENT A TRUE LEARNING EXPERIENCE WITH ITS RISKY EMOTIONAL GIVE AND TAKE.

THE URBAN FOSSICKATED OCTAVE

A FLYING CITY CONTRASTING THE WORLDSCAPE, WHICH CONTAINS PHYSICALLY AND CONCEPTUALLY ALTERABLE ENVIRONMENTS ON A DAILY, MONTHLY AND YEARLY CYCLE BECOMES THE NEW ACROPOLIS. THE COMPLETE INTEGRATION OF ALL KNOWLEDGE.

SPACE ISLANDS

THE KEEPER OF THE CUSP IS AN ISLAND BOTH PHYSICALLY AND CONCEPTUALLY. IT IS HERE THE UTOPIA IS MAINTAINED BY ALLOWING TOTALLY ALIEN MICRO-WORLDS TO DEVELOP PROVIDING NEW INFORMATION AND CULTURES.

DEDICATED TO THE ULTIMATE ELIMINATION OF STABILITY

HOMAGE TO POE, VERNE, WELLS AND MARCUSE

THE RETURN OF ROBUR

THE SYSTEMS AND A-HISTORICAL ENERGY SOURCES TO POWER THE TIME-SUIT.

NON-HUMAN META-ENERGY

HUMAN META-ENERGY

VISITATION

:VISITATION

FROM THE SUMMER

RETAIL INDUCTIBLE

THE AETHEIAPOLIS IS A STRUCTURED SINGULARITY MIND CITY THAT IS COMPOSED OF A GROUP SOUL MADE UP OF 64 SOULS, 32 FROM THE PRESENT, 16 FROM THE PAST, AND 16 FROM THE FUTURE

1. BELIEVERS
2. DISBELIEVERS
3. DOUBTERS

SEARCH FOR UTOPIA 1

2 SKEPTICISM OF UTOPIA

THE SOUL CRYSTALS AS RESIDENCES

THE TETRAHEPTAHEDRON

THE PRE-RESIDENTIAL TIME-MACHINES

THE SYMBOL OF UTOPIA

PURE BEING
EIDOS

EPISTEME

DIANOIA

PISTIS

EIKASIA

HYLE
PURE BECOMING
THE DIVIDED LINE OF KNOWLEDGE

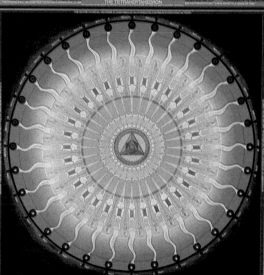

THE MONAD OF ABSOLUTE ALIVENESS

THE COSMIC OCTAVE OF FATE

THE ARCHITECTURAL-BODY OF THE AETHEIAPOLIS IS GENETICALLY MODIFIED IN PART. **THE HYDROMEDUSA** THE HYDROZOAN IS 680 FT. IN DIA. IN A BRINE POND 1000 FT. IN DIA. AND 50 FT. DEEP.

MILIEU AS THE MIND 3

CROSS SECTION

4 GROUP MYSTICISM

THE ASTRAL SPHERE

THE PROJECT HERMES DEVICE

THE EDISON ETHERIC WAVE DEVICE

Suzy Lake

Suzy Lake was born in Detroit, Michigan in
1947. In 1968, she immigrated to Montreal, Que-
bec following the 1967 Detroit riots. Influenced
by social and political involvement concurrent to
the early conceptual period, she is known for her
large-scale photography dealing the body as both
subject and device.

Lake was one of a pioneering group of artists in
the early 70's artists the to adopt performance, vid-
eo and photography in order to explore the politics
of gender, the body and identity. Early examples of
her work form part of a touring exhibition titled
*WACK! Art and the Feminist Revolution 1965—
1980*, first showing at the Los Angeles Museum
of Contemporary Art in March of 2007. In April
of 2007, her work will be featured in *Identity Theft*
with Eleanor Antin and Lynn Hershman at the
Santa Monica Museum of Art.

In a 1993 retrospective catalogue, Martha Hanna
responds to this politicization:
*Although she has not overtly addressed feminist issues,
the politics of feminism is an undercurrent in all her
major photographic works to date. The attention to
power relations that feminism implies may be seen in
Lake's work as symbolic of a personal struggle, and her
artwork is evident of her progress.*

Lake's work continues to use references to the
body as a means to investigate notions of beauty
in the context of pop and consumer culture. She
has a long exhibition career in Canada, and has
also shown her work in Europe, the United States,
South America and Asia. She is represented by
Paul Petro Contemporary Art (Toronto).

(1947–)

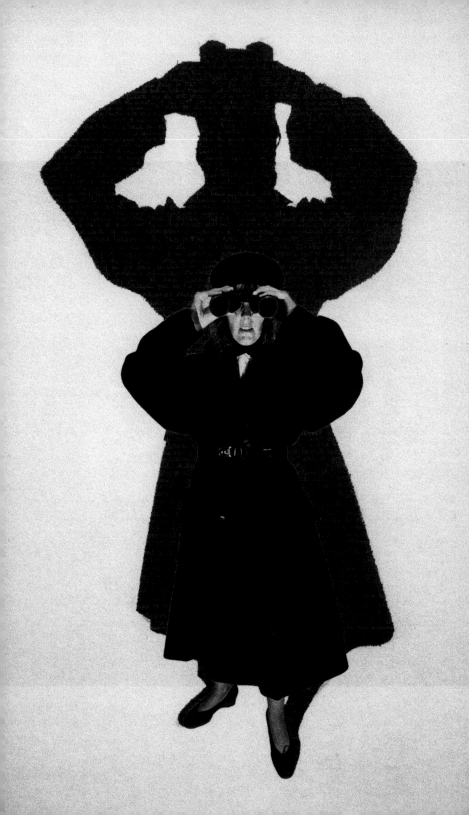

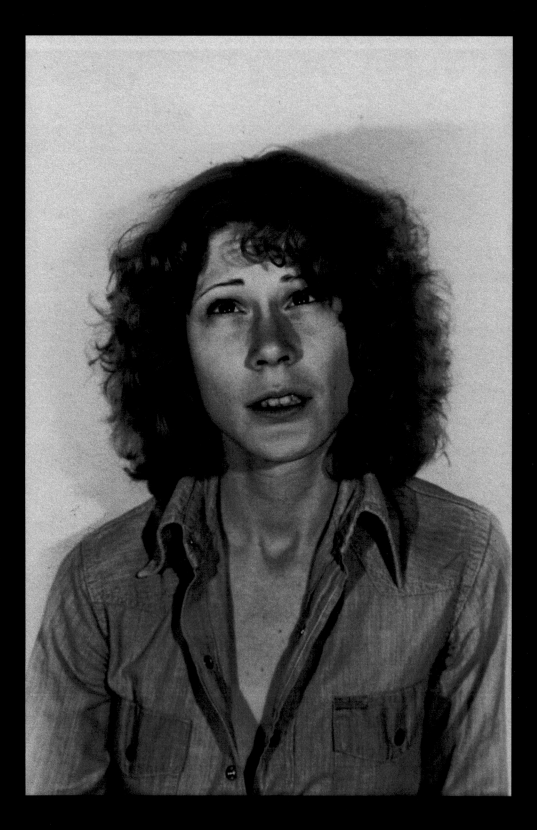

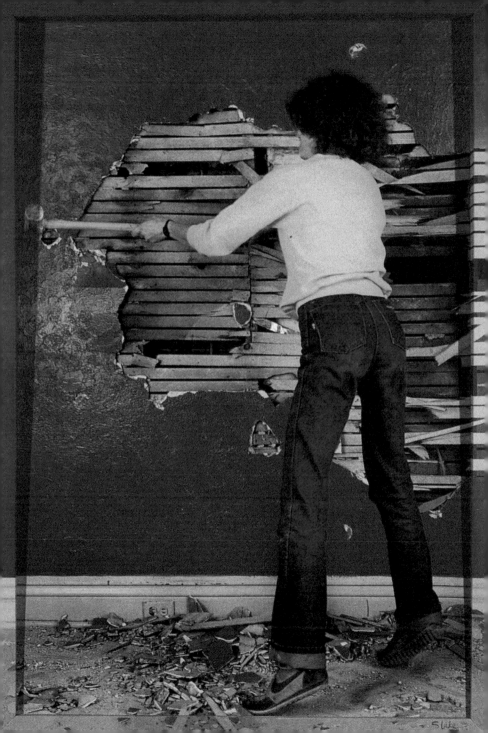

Ketty La Rocca

www.galerieimtaxispalais.at/ausstellungen/almeida_larocca/larocca_progindex_engl.htm

Ketty La Rocca, who died prematurely in 1976, was one of the most distinctive Italian artists of the '70s. The interdisciplinary nature of her work places her amid events, typical of the decade, that oscillated between visual poetry, installation, video and performance. La Rocca first appeared on the art scene in the mid '60s with collages made from newspaper images and words. Freely put together, the combinations resulted in fresh viewpoints that work ironically to undermine the tranquilizing messages of advertising. Here socio-political reality (for example, the exploitation of the woman's body, the threat of war, and the political and ecclesiastical manipulation of consciences) emerges as the hidden, repressed part of mass-media discourse. The pieces executed during the second half of the '70s deal with the derealization of preexisting images. Using photography, books, video and performance, she explored this territory touching up anthropological values. She used X-ray of her own skull as an icon upon which she traced invocations; she turned writing, action and image into the vehicle for a sentimental journey that announces at its point of departure, the forbidden means to be taken. There are reproductions of works of art, film posters, early-20th-century photographs, or autobiographical sites, where the artist traces the outlines of her journey, until the lines and the arbitrarily distributed stains make the initial image illegible (as in Margherita Gauthier, 1974, where the image is the playbill for a Greta Garbo film). The signs eclipses the very memory of the icon, the writing is lost in the pure graphical gesture, the gestural quality is diminished in the weak agitation of the tracing. Language is made autonomous from its relationship of reciprocal dependency on the image, and it is shorn of its semantic value to the point where it, too, can be dealt with as an image.

(1938–1976)

VERBUM

PAROLA

MOT

WORD

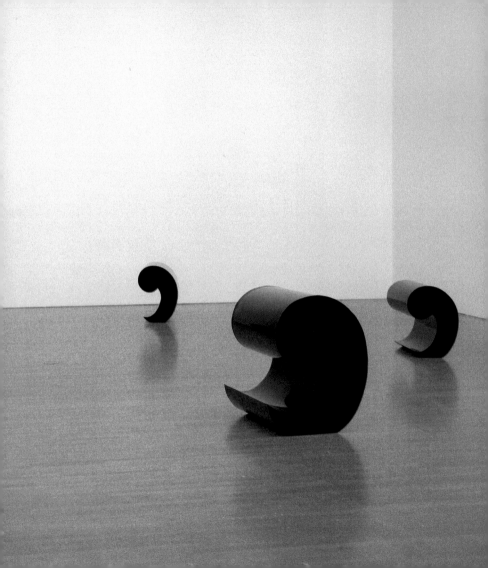

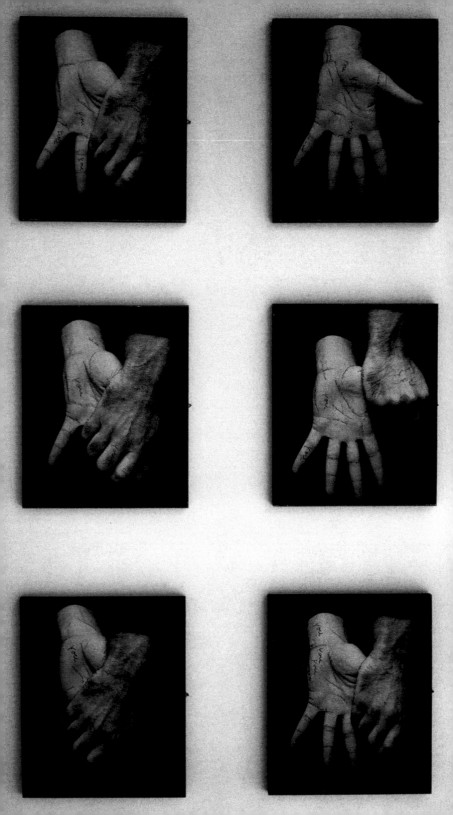

Michael Bernard Loggins

Michael Bernard Loggins was born in 1961 in San Francisco, California. He has been writing, drawing and painting at Creativity Explored since its inception in 1983. His exhibition resume includes San Francisco shows at Yerba Buena Center for the Arts, Inside out Gallery, The San Francisco Arts Commission Gallery, SOMARTS, Mission Cultural Center for Latino Arts, Southern Exposure, and The Market Street Kiosks. Michael's work has been shown nationally at the Mark Moore Gallery in Los Angeles and the Bronwyn Keenan Gallery in New York.

Michael was the focus of a documentary "Life Itself" (a title he came up with), released in 2001. Shortly before starring in "Life Itself," he was in a film by Miranda July.

His "Fears of Your Life" and "Fears of Your Life—A Whole Brand New One" have been enjoyed by a broad San Francsico readership since they were first published. In 2000, *138 fears (Part I)* were published in *The Sun*, a magazine of literature, poetry, and photography. In 2003 "Fears" was shared with a broad national audience when it was read on Chicago Public Radio's 'This American Life" with Ira Glass, and in the June issue of *Harper's* magazine.

Michael has a huge collection of 45s (somewhere in the neighborhood of 400-500 records) and enjoys singing. He has a cassette tape of songs that he has sung while accompanying himself on percussion (an empty coffee can).

Michael loves to write and draw. His writing usually takes the form of notes to people he likes, concerns about life (safety, allergies, emotions, etc.) and the re-telling of incidents and events in his life. His drawings usually deal with lighter subject matter such as animals, pocket TVs, idyllic worlds, and imaginary people.

(1961–)

spider

Rattle snake

Fears oF Your Life

by Michael Bernard Loggins

Kitchen Knife

Time Bomb

Firecracker

A Bat at night

Gun

PART ONE

Things that you are very Fearful of

1. Fear of Hospitals and Needles.

2. Fear of School and Dentists.

3. Fear of Black Cats.

4. Fear of Monsters being under my bed. Fear of intruders Coming into the house to steal things and hurt us all.

5. Fear of going to Jail as being Punish for doing something very Wrong and have to stay in For a long time.

6. Fear of being Followed.

7. Fear OF Dogs.

8. Fear of Strangers.

9. Fear of time Bombs.

Part II

what fears can do to you

Fear # 44.

Two Fear of my hand is Hurting and why is it Hurting when I'm writing according on how hard I'm Holding my Pen And If it keep on Hurting it liable to Hurt a lot worser Than Now. Says "michael Bernard Loggins."

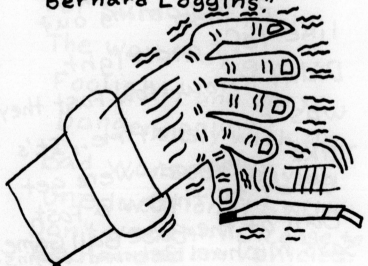

Helen Lundeberg

My work has been concerned, in varying modes of pictorial structure and various degrees of representation and abstraction, with the effort to embody, and to evoke, states of mind, moods and emotions. —HL

Lundeberg was born in Chicago and moved to Pasadena, California, with her family in 1912. She was a gifted child and as a young adult was inclined to become a writer. After taking an art class taught by Lorser Feitelson at the Stickney Memorial School of Art in Pasadena, however, Lundeberg was inspired to pursue a career as an artist.

With Lorser Feitelson in 1934, Lundeberg founded Subjective Classicism, better known as Post Surrealism. Unlike European Surrealism, Post Surrealism did not rely on random dream imagery. Instead, carefully planned subjects were used to guide the viewer through the painting, gradually revealing a deeper meaning. This method of working appealed to Lundeberg's highly intellectual sensibilities.

Themes of Post Surrealism continued in Lundeberg's paintings until the 1950s, when she began to explore geometric abstraction. Always based in reality, Lundeberg created mysterious images that exist somewhere between abstraction and figuration. Repeatedly described as formal and lyrical, Lundeberg's paintings rely on precise compositions that utilize various restricted palettes. This creates images that posses a certain moodiness or emotional content unique to her work.

In the 1960s and 1970s, Lundeberg continued her journey through abstraction, exploring imagery associated with landscapes, interiors, still-lifes, planetary forms and intuitive compositions she called enigmas. In the 1980s, Lundeberg created her final body of work—a confident series of paintings that deal with landscapes and architectural elements. Throughout her 60-year career, Lundeberg imbued her work with a personal vision, exposing the imaginative world of her mind.

Helen Lundeberg's works are included in the permanent collections of the Los Angeles County Museum of Art, the National Museum of American Art, Smithsonian Institute, Washington D.C., the Norton Simon Museum, Pasadena, California, the San Francisco Museum of Modern Art and numerous other public and private collections.

(1908–1999)

Manon

One of the first Swiss performance artists, Manon has fashioned a career for herself out of the identities of others. Whether exploring the limits of gender or the beauty of decay, Manon—through her personas, installations, and performance pieces—continually foregrounds the instability of place and self. Her most recent project, *She Was Once MISS RIMINI*, is one of her most brutal and touching. Here, she literally depicts imagined futures for an aging beauty queen.

Each exquisite image in this pictorial essay teases out the possible paths Miss Rimini—an alter-ego for Manon who "happened" upon a beauty pageant in the early 1970s and walked away with the crown—could have taken. A small-town diva? A hypersensitive viola player? Perhaps even a psychiatric patient?

(1946–)

Rimini, one summer in the Seventies.
A young woman, a beauty contest at a beachfront hotel.
The scent of happiness and a little glamour,
as she is crowned Miss Rimini.
Who is she now?
The artist takes on the persona of her fictional creation
over fifty times.

Robert Marbury

"Don't call it a comeback!"

Robert Marbury is the sole vegan-taxidermist of the founding members and has been developing his Urban Beast Project since 2000, when he received a generous gift of 800 stuffed animals from the Delias creative team. Drawing on his Anthropology background, Robert uses the project to investigate the ferine nature of animals and their interaction with humans in the urban environment. Robert is currently working on a visual anthology of imaginary urban beasts. Robert received a 2005 Minnesota Arts Board Grant.

M.A.R.T.—The Minnesota Association of Rogue Taxidermists—is a veritable rout dedicated to a shared mandate to advocate the showmanship of oddities; espouse the belief in natural adaptation and mutation; and encourage the desire to create displays of curiosity.

Co-Founder
Member since Nov 14, 2004

For more, visit: www.urbanbeast.com

John Patrick McKenzie

John McKenzie was born in 1962 in the Philippines. John moved to the United States with his family in 1964. He currently lives in San Francisco's Mission District and has been working at Creativity Explored since 1989.

John is a visual poet—a writer and artist creating strong visual images with words. His words are powerful statements of his inner world and his interpretation of what is occurring in the world around him. John expresses himself on paper, plexiglass, wood, glass, found objects, and furniture using markers, colored pens, watercolors, acrylics, and craypas. John has created a unique "typeface" of open and closed spaces in the letter formations, forming a signature visual style. He pays close attention to world news, and current events are often the subject of his artwork. John has large number of local "fanatic devotees" and has exhibited nationally and internationally.

(1962–)

John Patrick McKenzie likes meat pies
John Patrick McKenzie likes Pepsi-Colas
John Patrick McKenzie likes chicken pot pies
John Patrick McKenzie likes coconut cream pies
John Patrick McKenzie likes coffee ice creams
John Patrick McKenzie likes kids cereals
John Patrick McKenzie likes lumpias
John Patrick McKenzie likes athletics
John Patrick McKenzie likes to listening to the radio without
people singing

most culture humbug sexy people are humble like Linda Maria Ronstadt
most culture humbug sexy people are humble like Cher
most culture humbug sexy people are humble like Robert Redford
most culture humbug sexy people are humble like The Bee Gees
most culture humbug sexy people are humble like The Ruler
most culture humbug sexy people are humble like Chic
most culture humbug sexy people are humble like The Electric Light Orchestra
most culture humbug sexy people are humble like Josie and the Pussycats
most culture humbug sexy people are humble like The Bantams
most culture humbug sexy people are humble like The Associations
most culture humbug sexy people are humble like The Archies most culture humbug sexy people are humble
most culture humbug sexy people are humble like The Byrds like Carole King
most culture humbug sexy people are humble like Star Wars most culture humbug sexy people are humble
most culture humbug sexy people are humble like Charlie's Angels like Barbra Streisand
most culture humbug sexy people are humble like Corazon Aquino

most culture humbugs sexy people are humble like pink lipsticks

most culture humbugs sexy people are humble like jury duties

most culture humbugs sexy people are humble like...

most culture humbugs sexy people are humble like rated x movies

most culture humbugs sexy people are humble like pink panties crayola

most culture humbugs sexy people are humble like sixty-four color crayons

most culture humbugs sexy people are humble like bookmarks or bookmarkers

most culture humbugs sexy people are humble like bank cards

most culture humbugs sexy people are humble like culture fields

most culture humbugs sexy people are humble like...

most culture humbugs sexy people are humble like ice cream too

most culture humbugs sexy people are humble like strong and healthy...

most culture humbugs sexy people are humble like white suppositories or...

most culture humbugs sexy people are humble like... strange strangers

most culture humbugs sexy people are humble

most culture humbugs sexy people are humble like...

most culture humbugs sexy people are humble like... the movie

most culture humbugs sexy people are humble like...

most culture humbugs sexy people are humble

most culture humbugs sexy people are humble like pink earrings

David Medalla

David Medalla is a pioneer of land art, kinetic
art, participatory art and live art. At the age of 12
he attended Colombia University in New York
as a special student. He studied ancient Greek
drama with Moses Hadas, modern drama with
Eric Bentley, modern literature with Lionel Trill-
ing, modern philosophy with John Randall and
attended the poetry workshops of Leonie Adams.
He returned to Manila in the late fifties, where
he met the earliest patrons of his art. In 1960s
Paris, the French philosopher Gaston Bachelard
introduced his performance 'Brother of Isidora' at
the Academy of Raymond Duncan, later, Louis
Aragon would introduce another performance and
finally, Marcel Duchamp honoured him with a
'medallic' object. His work was included in Harald
Szeemann's exhibition 'Weiss auf Weiss' (1966)
and 'Live in Your Head: When Attitudes Become
Form' (1969) and in the DOCUMENTA 5
exhibition in 1972 in Kassel. In London, Medalla
edited the journal *SIGNALS*, (1964–1966) and
initiated in 1967 Exploding Galaxy, 'a kinetic
confluence of transmedia explorers', consisting of
several international multi-media artists. From
1974–1977 he was the chairman of Artists for
Democracy, a broad organisation dedicated to
'giving material and cultural support to liberation
movements worldwide'. In New York, in 1994,
he founded the Mondrian Fan Club with Adam
Nankervis as vice-president. He has lectured
widely at universities across the globe. Madella
sees himself as a citizen of the world, feeling at
home everywhere.

(1942–)

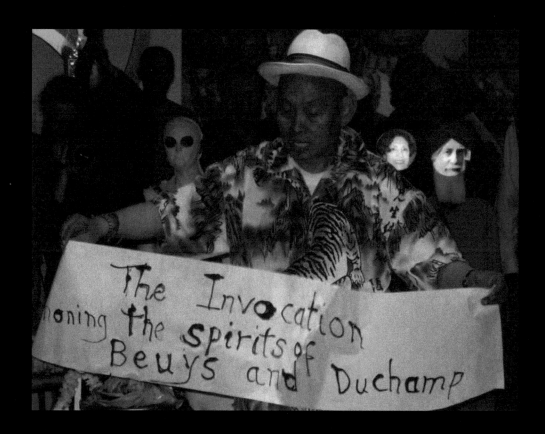

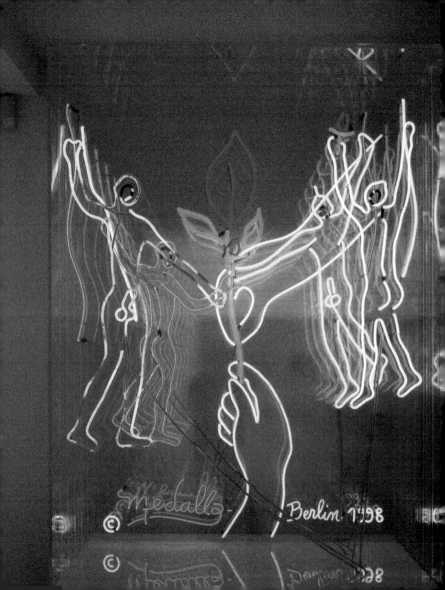

Médall © Berlin 1998

Dan Miller

Dan is a tall, thin young man with an intense gaze and an obsessive, perseverative aspect. Every interaction with Dan must involve a ritual conversational exchange that touches on repeated patterns of counting, spelling, question and response, and reassurance. These are his touch-points to the world.

Dan's artwork has always reflected his persona and his perception. Letters and words are repeatedly overdrawn, often to the point of obliteration or destruction of the ground. Images are drawn, painted, drawn again, then written over repeatedly. Images of obsessional objects, like lightbulbs or routers or electrical sockets, that inhabit his speech are repeated and reiterated.

Once you go past this initial and overpowering affect of Dan Miller, however, you find a bright, inquisitive mind and a gentle spirit that belies the initially intimidating physicality.

Dan continues to work in a variety of media, including drawing, painting, ceramics, wood sculpture, printmaking, and other mixed media projects.

Richard Allen Morris

Richard Allen Morris was born in Long Beach, CA in 1933. Morris, who received no formal art education, began exhibiting at the age of 26 and has had solo and group exhibitions throughout California since. This is his first solo exhibition in New York. Morris currently lives and works in San Diego, CA.

I have never been able to put the right words together to describe my work. All I can say is that its foundation is rooted in abstract expressionism, anything else is just jargon. —RM

(1933–)

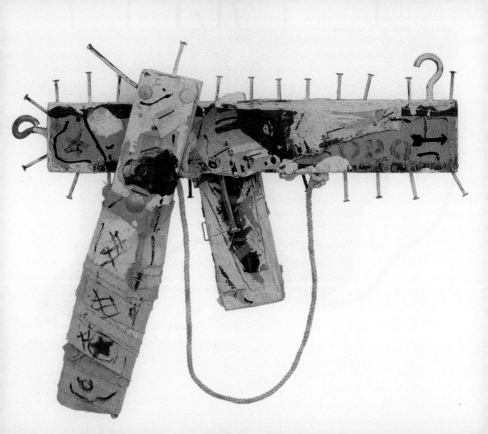

Ree Morton

Ree Morton was a remarkable presence in American art whose career began late and ended much too soon. She received her BFA from RISD in 1966 at age 30, and for the next 10 years worked with astonishing intensity. Her star in ascent, having produced a steady stream of works which combined painting, sculpture, writing and performance, she died in an automobile accident in 1977 at the age of 40. Her development did not follow a tidy trajectory. The consistency and seriousness of her effort were precisely what worried her most, as this show of notebook selections makes sometimes painfully clear. Organized and curated by Morton's colleague and friend Barbara Zucker, with Fleming curator Janie Cohen, the show featured selections from Morton's notebooks—pages of drawings, notes, journal entries, letters, collected quotes, plans for work, art world gossip; in addition there were a few objects.

In a short time Morton worked rigorously through formalism, and with great wit she ruffled up its serene masculinism. Along with Laurie Anderson, Eva Hesse, Dennis Oppenheim, Paul Thek and others, she opened the field to what the boys of proper modernism had pushed to the margins. Morton also opened her work to the theatrical at a time when that was still a high-art taboo. Jerzy Grotowsky is cited among her influences, and Laurie Anderson is the subject of a lengthy and insightful page of typing. Her reading of Raymond Roussel's *Impressions of Africa* provided raw material for at least one work (*Sister Perpetua's Lie*, 1973) and was technically crucial to the figural play of text in her later work.

The allegorical impulse is everywhere in these jottings and sketches. Morton's never finished notes are the output of a voracious reader. She makes some remarkable links, bringing together thoughts from disparate domains. For instance, a snippet from Bachelard's *Poetics of Space* follows further along with this idea: "De Chirico is aware that we are what Gaston Bachelard calls `corner dwellers,' that we sometimes need a shallow space to dream." This notion of "shallow space" underlines Morton's resistance to entrenched notions of "deeply rooted structures." She elaborates her position in a list titled "I

Hate" which includes "Symbolism, Abstract Expressionism, Surrealism, Greek Hellenistic Sculpture, Painters—Phony, Paintings—Rectangle, Bad Liars" and "Color Relationships." There is, of course, an "I Love" list, which includes "Good Liars."

(…)

One need only make a casual survey of developments in art over the last 20 or 30 years to recognize Ree Morton's pioneering role in American postmodern art, even among those more recent artists who have concerned themselves with issues of "text." Nothing comprehensive has been done with her work since Marcia Tucker mounted a retrospective in 1980 at the New Museum. Still, with so much current interest in the art of the 1970s, one hopes this remarkable show will inaugurate some serious considerations.

(1936–1977)

Gallo, Peter. "Ree Morton at the Fleming Museum," *Art in America*, September 2000.

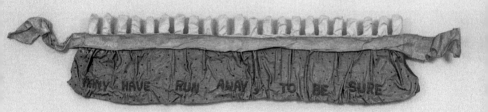

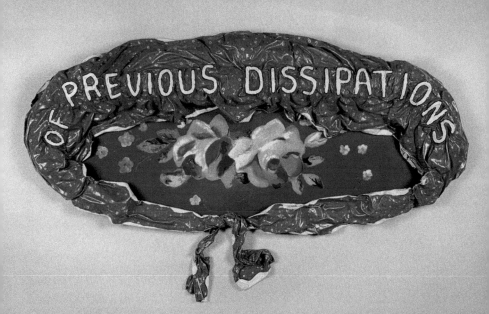

David Novros

Since the mid-1960s the work of American artist
David Novros has contributed to the history of
modern abstraction. His shaped monochromatic
paintings, pieced together in sculptural and geo-
metric compositions, are based on a close study of
European frescoes, mosaics, and cave paintings.
Critical to the development of Minimalism, his
"portable murals" site-specific techniques to estab-
lish a physical relationship with the viewer through
surface and color.

(…)

David Novros was born in Los Angeles in
1941 and studied at the University of Southern
California. He moved to New York in 1964 and
was among a group of artists, including Robert
Mangold and Brice Marden, who explored the
vitality of painting in the decades after Abstract
Expressionism. Since the late 1960s Novros has
vigorously investigated site-specific techniques.
Inspired by European frescoes, his experiments
with scale, context, and innovative media create
dynamic architectural experiences that expand the
physical boundaries of modern art.

(1941–)

Lorraine O'Grady

Assistant Professor (B.A., Wellesley College), is
also Core Faculty in Program in African American
Studies. She is a photo-installation and perfor-
mance artist, writer and critic whose work deals
with issues of hybridity, Diaspora, cultural politics,
and black female subjectivity. Her teaching inter-
ests include the esthetics of hybridity and
Diaspora, narrative and time-based art in all
media, and work executed in series.

Her earliest performances, done in 1980, were
Mlle Bourgeoisie Noire and *Nefertiti/Devonia Evan-
geline.* In 1991, she extended their preoccupations
to photo-installation work based in the diptych
form as a both/and critique of Western either/or
dualist philosophy. Her current project, *Flowers of
Evil and Good*, is a "novel-in-space" which explores
the relationship of Charles Baudelaire, the French
poet and founder of modernism, and Jeanne
Duval, his Haitian common-law wife, through
a 16-diptych installation of digitally produced
photographs.

One-person exhibits have been at Thomas Erben
Gallery (New York), Galerie Fotohof (Salzburg,
Austria), and the Wadsworth Atheneum (Hart-
ford, CT).

(1940–)

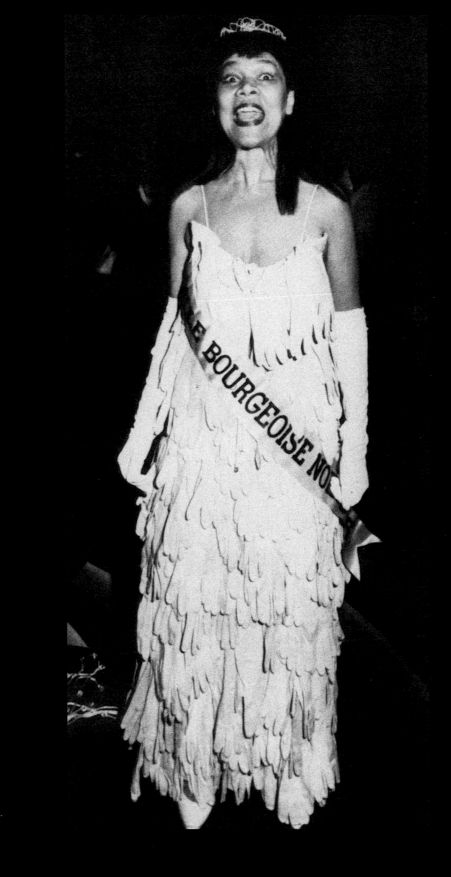

OHO

In the second half of the 1960s and early 1970s
the avant-garde group OHO had a very important
impact. When the group first began they were
centred around the notion of Reism (from the
Latin word 'es', i.e. 'thing'). The members of OHO
wanted to develop a radically different relationship
towards the world: instead of a humanistic posi-
tion, which implies a world of objects dominated
by the subject, they wanted to achieve a world
of things, where there would be no hierarchical
difference between people and things; the correct
relationship towards such a world is not action,
but observing. OHO used a number of media (and
their in-between forms), drawings, photographs,
film, video (the first video works in Slovenia
were produced in this context by Nuša and Srečo
Dragan), music, texts, but also a way of dressing,
living and behaving, to redirect the awareness of
people into Reistic observing. In the second phase
of development, the group established a dialogue
with the contemporary artistic avant-garde: the
artists used the principles of Arte Povera, Process
Art, Land Art, Body Art and Conceptual Art. It
is interesting, for example, to observe the opposi-
tion between the American Earthworks and OHO
Land Art works: these were small-scale, ephemer-
al, done with simple tools in a cultivated landscape,
and often very minimal, mild and poetic. Such a
relationship was one of the starting points for the
final phase of OHO's work, which represented a
combination of Concept Art and a kind of esoteric
and ecological approach. The group was just
starting an international career when the members
decided they should abandon art as a separate area
and really enter life; therefore, they settled on an
abandoned farm and started a community.

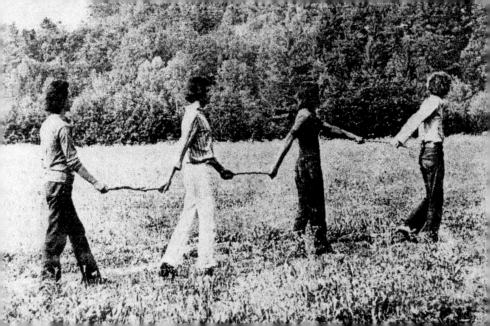

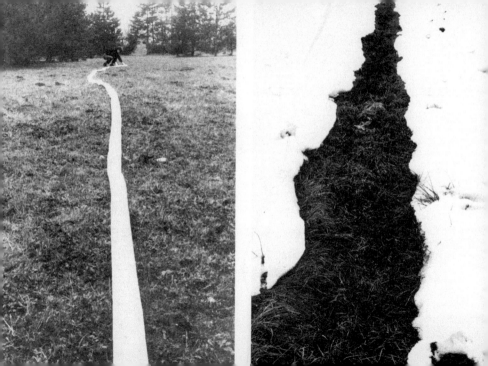

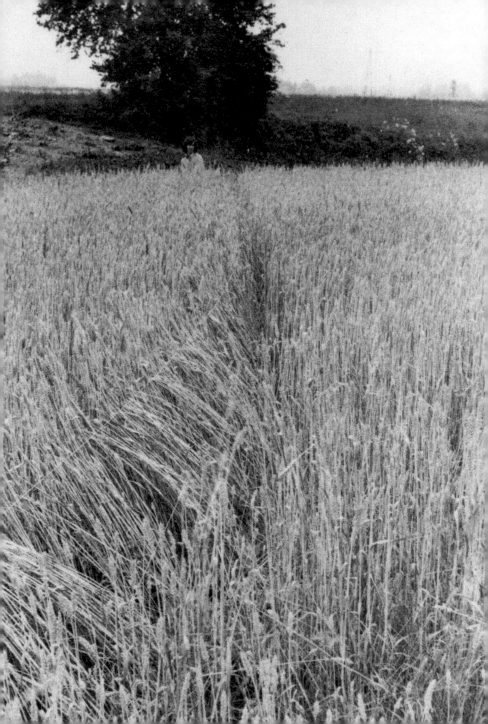

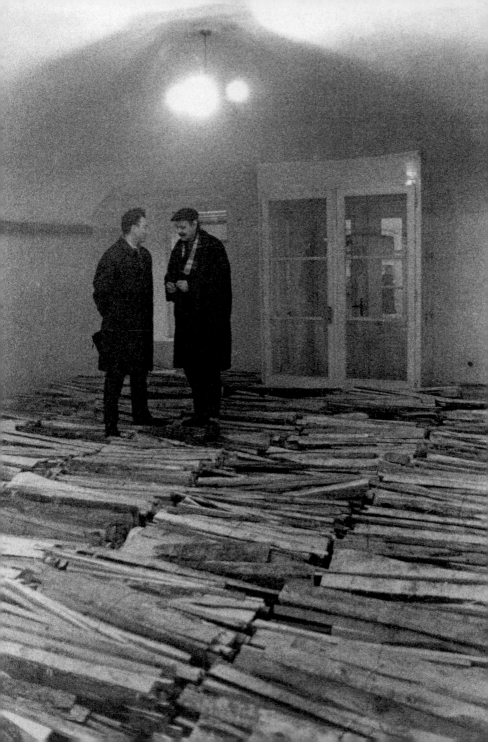

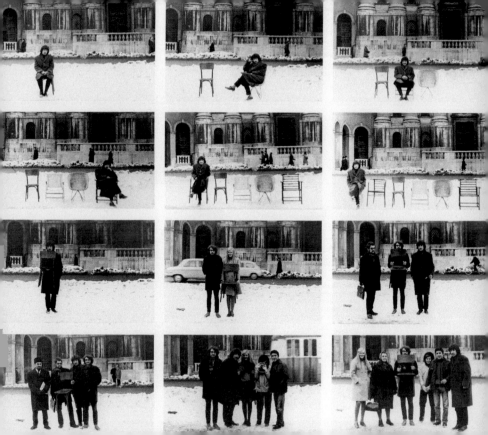

Niko Pirosmani

http://en.wikipedia.org/wiki/Niko_Pirosmanashvili

Niko Pirosmanashvili also known as Niko Piro-
smani is a late 19th-early 20th century Georgian
primitivist painter. His paintings are often of
animals, people dining, and people serving food.
His artwork is not well known outside Russia or
Georgia. Pirosmanashvili is also known in Russia
for a romantic encounter with a French actress
who visited his town; Pirosmanashvili was deeply
in love with her, and to demonstrate it, bought her
enough flowers to fill the square in front of her
hotel window (allegedly driving himself bankrupt).
The story became famous when it was recounted
in a poem by Andrei Voznesensky, and later into a
hit song by Alla Pugacheva.

Pirosmani was born in the Georgian village of
Mirzaani to a peasant family in the Kakheti
province. His family has a small vineyards He
was later orphaned and put in the care of his two
elder sisters. He move with them to Tbilisi in
1870. In 1872 he worked as a servant for wealthy
families and learned to read and write Russian
and Georgian. In 1876 he returned to Mirzaani
and worked as a herdsman. He gradually learned
painting. In 1882 he opened a workshop in Tbilisi
which was unsuccessful. In 1890 he worked as a
railroad conductor, and in 1895 worked creating
signboards. In 1893 He co-founded a dairy farm
in Tbilisi which he left in 1901. In 1918 he died of
malnutrition and liver failure. He was buried at the
Nino cemetery and the exact location is unknown
because it was not registered.

Pirosmani was the subject of a successful film by
Giorgi Shengelaya, made in 1969, that won the
grand prix on the Chicago Film festival in 1972.
Director Sergei Parajanov shot a short film entitled
"Arabesques on the Pirosmani Theme."

(1862–1918)

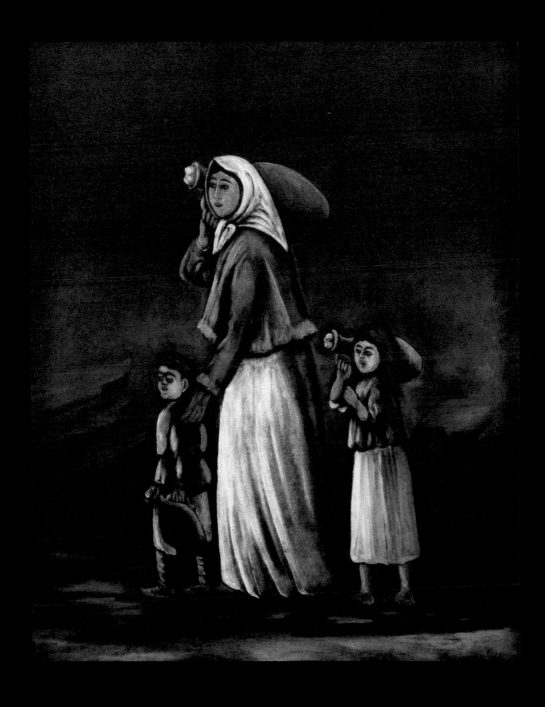

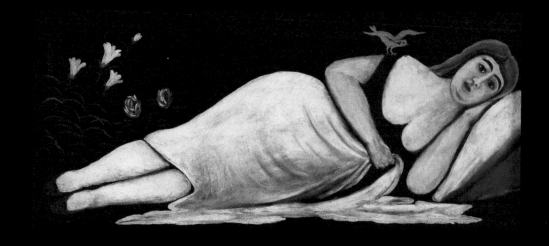

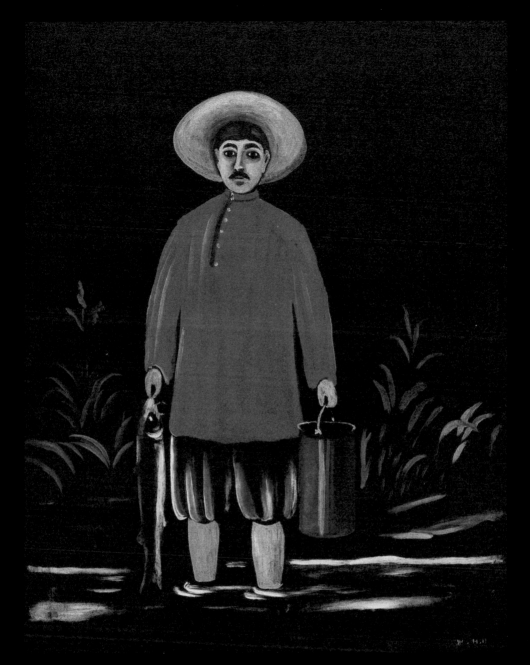

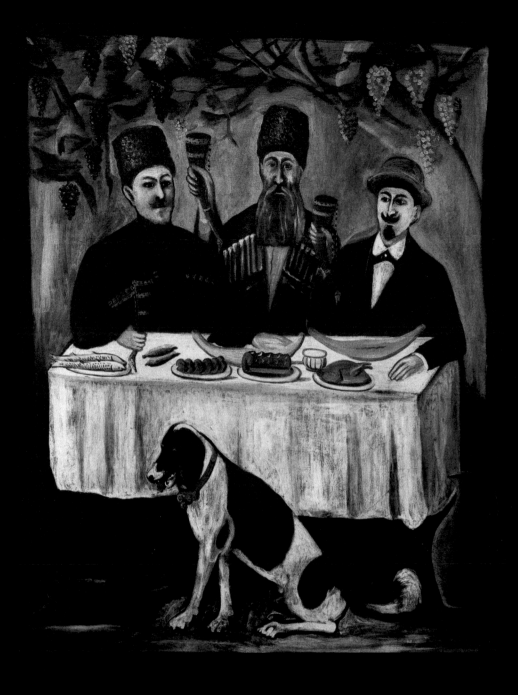

Charlotte Posenenske

Charlotte Posenenske made a rapid transition
from painting to objects during the 1960s, striving
to produce works that were "decreasingly recogniz-
able as 'artworks.'" After painting and stage design,
she moved into sculpture via what she called
"sculptural images," which consisted of creased
paper or tape attached to a flat support, usually
paper, cardboard, or sheet aluminum. Posenenske's
late sculptures were made in multiple editions and
were never signed. In 1967 and 1968, the last two
years of her artistic career, she simply provided the
material to form objects that could be altered and
rearranged by the "consumer." In 1968 Posenenske
came to the conclusion that "art could not con-
tribute to the solution of urgent social problems"
and ended her artistic career in order to become a
sociologist.

(1930–1985)

Emilio Prini

The ideas of Emilio Prini greatly influenced
the art critics of his day. He playfully uses light,
photography, sound and written texts to explore
the nature of experience and perception, and the
relationship between reality and reproduction. In
his many photographic works, the camera itself
and the processes of photography are the subject of
the work.

In one project he took thousands of photographs
with a single camera over a period of years, until it
wore out. In a similar piece he made an audio-cas-
sette player record its own internal workings until
it broke down. His series of *Perimeter* pieces were
simple acts of theatre, intended to make the spec-
tator physically aware of the space and boundaries
of the room. For the first of these, made in 1967,
neon lights were placed at the corners and centre
of the gallery, activated by sound. In another work
of the same year, a neon tube, cut to the size of the
gallery in which it was shown, was coiled around
a large wooden spool. *Bent Pole*, 1967, curves to fit
the width of the room.

Prini is also interested in the infra-structure of the
art world and its mechanisms. *Five spots of Light on
Europe*, 1967–68, for example, is a map highlight-
ing key cities in the European art world. In other
map works he has marked the location of both real
and imaginary projects.

(1943–)

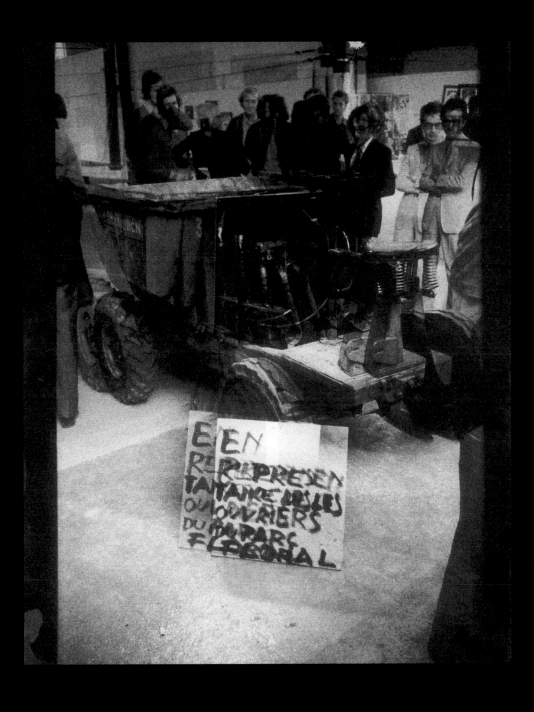

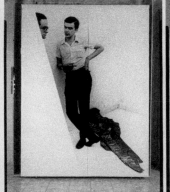

Noah Purifoy

Joshua Tree Environment

I think I always wanted to do environmental sculpture, something big enough to walk through, but it only became possible when I moved to the high desert of Joshua Tree eight years ago. I also wanted to devote some serious thought to the idea of sculpture: actually what is sculpture other than a three dimensional work of art. The first piece I built was a box-like structure made of 3/4" water pipes welded together and measuring 6x20x24 ft. My objective was to cure the tendency to copy Mondrian, what I call the "Mondrian straight-line syndrome" with organic sculpture. I have also been experimenting with the idea of sculpture-with-in-a sculpture (S-W-I-S). In Collage, a 30x60 ft patch work piece. I applied the S-W-I-S concept using a lot of toilet bowls, one of the free commodities accessible in this desert recycling community. In Shelter, a 30x40 ft. 2-story structure, there's not a straight line anywhere to be found. I started the White House in 1990 and completed the piece in 1993. I wanted to build a large structure to house rotating exhibitions but the building inspector came along and I had to remove the walls and ceiling and lower the floor two feet. So the White House houses different installations.

My resource for doing art is unlimited. Everything I see, look at, contemplate or get involved with gets interpreted as an aspect of art. Because of the extreme climactic conditions in the high desert, it has been interesting to watch the pieces as they weather. I recognize nature as an intricate part of the creative process. During my eight years here, I have found my need to loosen up (straight line syndrome), to further develop the S-W-I-S concept because it may be the center of some growthg possibilities. The adaptation of S-W-I-S as a tool for making art has allowed me, for the first time, to work at my own pace without feeling that a "work in progress" was just an excuse to procrastinate. It also enables me to work on several pieces at a time and admit that otherwise I would be extremely bored. I no longer feel guilty if I copy after myself. I am more confident in my choice of materials for outdoor sculpture (rags and old clothing) where I previously had doubt. After my experience

with one major piece that "took over' to become something else, my fear of not being in control has greatly dissipated with the realization that there are multiple possibilities, that instead of the results being catastrophic, the exact opposite may occur.

My work from the 60s, 70s and early 80s consists mainly of collages and assemblages using found or constructed objects to create a piece in which the original identities of the objects are integral to my aesthetic statement. For me objects are art forms in and of themselves and should not be tampered with. My choice of materials grows out of my lifetime interest in the mystery and the magic of relationships. With some pieces I have no idea in mind and the piece takes over and starts out in its own direction. Sometimes it's more fun to start out with no idea, except you may be disappointed in what you get. I have not yet looked too deeply into what really happens in the take over process . I believe it has something to do with the creative process as related to the synthesis of the intellect and the sensibilities.

—Noah Purifoy, 1997

(1917–2004)

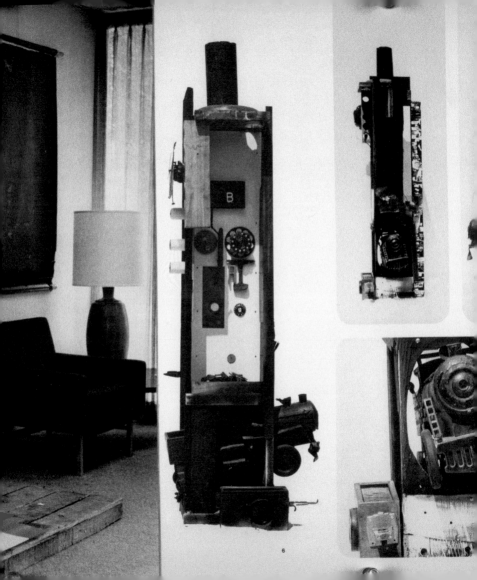

6

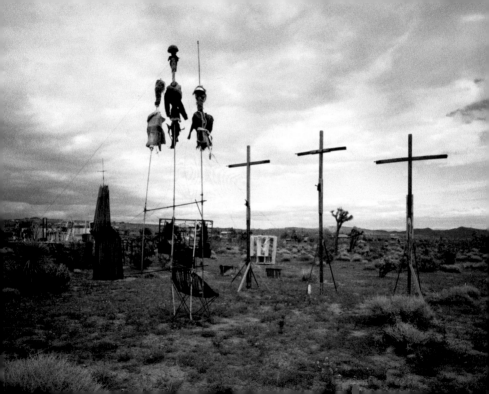

Miriam Schapiro

Schapiro found success early as a hard-edge geometric-style painter. Influenced by the feminist movement of the early 1970s, she changed her style radically, embracing the use of textiles as symbolic of feminine labor. She is credited with establishing the movement called Pattern and Decoration (or P & D). This art movement challenged traditional Western European art by foregrounding decorative patterns and textiles from other cultures such as Chinese, Indian, Islamic, and Mexican.

Schapiro coined the term "femmage," which stands for the female laborer's hand-sewn work (such as embroidery, quilting, cross-stitching, etc.) that rivals and precedes the "high-art" collage. *The Poet #2* combines pattern with painting. Schapiro comments, "I felt that by making a large canvas magnificent in color, design, and proportion, filling it with fabrics and quilt blocks, I could raise a housewife's lowered consciousness." Her involvement with consciousness-raising efforts, for which she traveled nationwide encouraging women to form support groups and emerge from isolation, earned her the nickname Mimi Appleseed.

(1923–)

Michael Schmidt

www.steidlville.com/artists/175-Michael-Schmidt.html

Michael Schmidt was born in 1945 in Berlin, where he still lives and works. He started working with photography in 1963 when he was a policeman. In 1969 he began teaching photography at the adult education centres in Berlin-Kreuzberg and Neukölln. In 1976 he founded and has since been the head of the Werkstatt für Fotografie at Volkshochschule Kreuzberg. Schmidt has received various prizes and funding for his photographic work which has been shown worldwide in group and solo exhibitions.

(1945–)

Jean-Frederic Schnyder

Though he has been seen at two Documentas and numerous European museums, this show (which travels to the Akron Art Museum Sept. 9-Nov. 5) was the Swiss artist Jean-Frederic Schnyder's debut in the United States. First recognized in the 1960s for witty, Duchampian constructions, Schnyder took a sharp turn in the early '70s, deciding, with no formal art schooling, to devote himself to painting. Schnyder's initial lack of rendering skills (he actually began by filling in compositions drawn by his wife), helped him anticipate the Bad Painting vogue over here by several years.

As his painting skills improved, Schnyder showed no particular allegiance to primitivizing forms of expression. But this doesn't stop Jean-Christophe Ammann, in an appreciative catalogue essay, from calling some of Schnyder's paintings "despicable." On one level, Schnyder's career can be seen as a conceptual project which takes individual artistic progress, as traditionally understood, for its subject. Among the works in this show were early '80s clunky still lifes, garish or muddy (or both) geometric abstractions and underdone palette-knifed cityscapes.

Later series show a continuing growth of painterly competence. His 1989–90 paintings of train station waiting rooms (not included in the exhibition) are blandly accomplished. The most recent series seen here, a numbingly similar progression of excavation sites from 1991, boasts an impressive new fluidity. In the interesting *Landschaft* series (1990-91) Schnyder uses paint in candy-colored, frosting-like reliefs, building up creepy, sweet variations on a kitschy Swiss cottage motif. Throughout his career Schnyder's appetites have been inclusive, consuming narrative painting, abstraction and symbolist work, not through appropriation so much as through subservience—in a kind of serial apprenticeship.

(1945–)

Text from Miriam Seidel's review of a show at the Moore College of Art and Design, Philadelphia, Pennsylvania, in *Art in America*, May 1995.

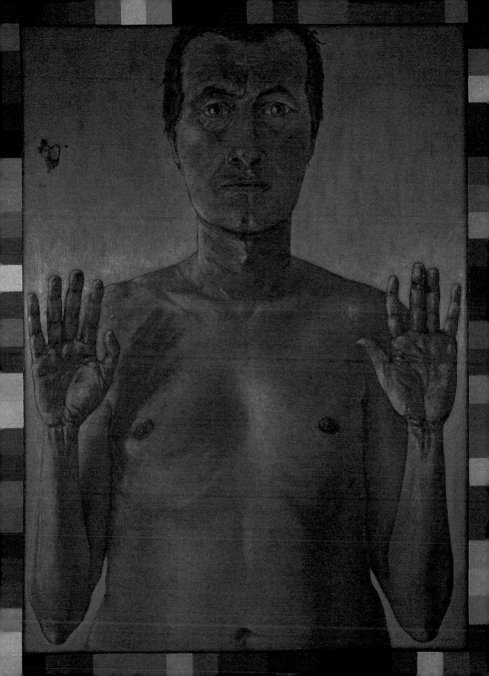

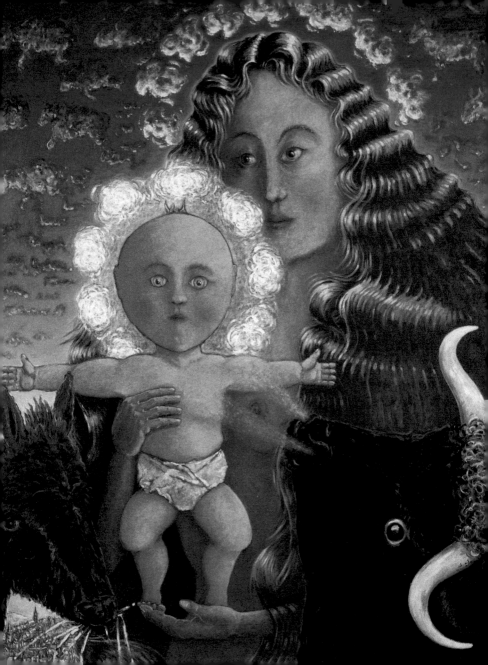

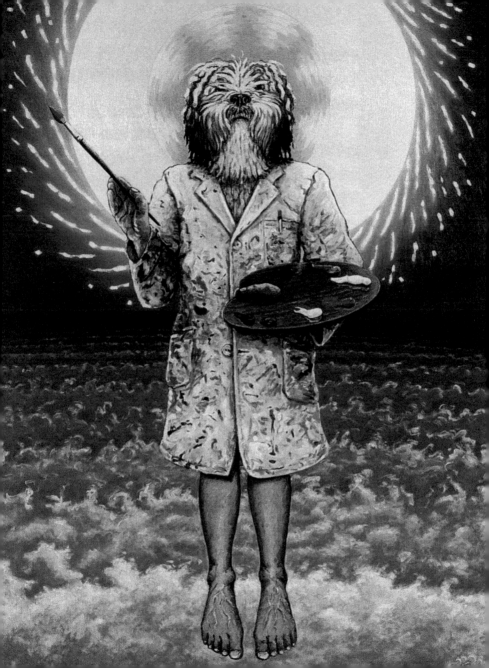

Colin Self

Colin Self was born in Norwich and studied at Norwich School of Art and later at the Slade School of Fine Art in London. He is considered a member of the British Pop Art movement of the 1960s, and has been included in most of the large survey exhibitions of the decade. Although he applauded the movement as a working class af-front to traditional fine art elitism, he had serious reservations about its celebration of wealth and consumerism.

(1941–)

Colin Self. 19·2·83.

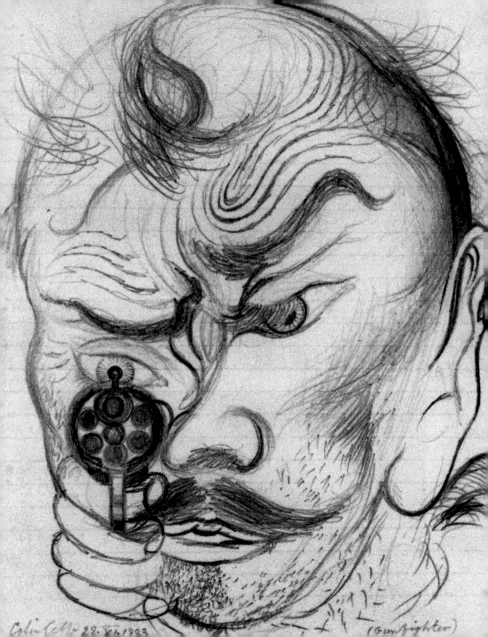

Colin Colvin 22. XII 1933 (Gunfighter)

Stuart Sherman

Stuart Sherman's influential art practice de-
fies classification. Celebrated as an avant-garde
performer, he also worked in film, video, and other
visual arts, in addition to writing plays and poems.
Sherman was an iconoclastic builder and manipu-
lator of mass-produced bric-a-brac; he used an
intuitive logic to purposefully transform objects
into rhetorical questions. He developed these
manipulations into an idiosyncratic performance
style that was quick-paced and conceptually witty.
The culminating tableaux, featuring Sherman and
disassembled or repurposed objects, evoke Rene
Magritte, Buster Keaton, and Samuel Beckett.

(1945–2001)

Sylvia Sleigh

http://en.wikipedia.org/wiki/Sylvia_Sleigh

Sylvia Sleigh (professional name for Sylvia Sleigh Alloway, 1916, Llandudno, Gwynedd, Wales) is a naturalised American realist painter. After studying at the Brighton School of Art, she had her first solo exhibition in 1953 at the Kensington Art Gallery. She married Lawrence Alloway, an art critic, before moving to the United States in the early 1960s when he became a curator at the Solomon R. Guggenheim Museum.

Around 1970, from feminist principles, she painted a series of works reversing stereotypical artistic themes by featuring naked men in poses usually associated with women. Some directly alluded to existing works, such as her gender-reversed version of Ingres's *The Turkish Bath* (the reclining man is her husband, Laurence Alloway). Philip Golub Reclining alludes similarly to the *Rokeby Venus* by Velázquez.

(1916–)

Sylvia was recently asked this question...

"How has feminism changed contemporary art practice?"

Love and Joy

Feminism to me is equality to all, as they used to say, "Equal pay—equal work". In relation to my paintings. I feel that my paintings stress the equality of men & women (women & men). To me, women were often portrayed as sex objects in humiliating poses. I wanted to give my perspective. I liked to portray both man and woman as intelligent and thoughtful people with dignity and humanism that emphasized love and joy.

I did this by placing my models in beautiful settings outside or inside against colorful landscapes or pleasing fabrics. To me, it made me think that the model was a jewel, being emphasized by their surrounding or environment. Feminism allowed me to express my thoughts freely. It gave me the freedom to show the beauty of the body—the most luminous parts equally. My style is the way I can best express these ideas.

Feminism gave us this intense freedom of expression thus allowing a change. Anything that helps to express the artist's ideas, whether it is to surprise, glorify, shock or simply express a philosophy will lead to a change or will simply allow an opportunity for change.

—Sylvia Sleigh, Monday, April 02, 2007

The title "Love and Joy" came from another question, by Sylvia's friend & neighbor Lillian Ben Zion—She asked her to sum up her work in two words.

www.sylviasleigh.com/wack.html

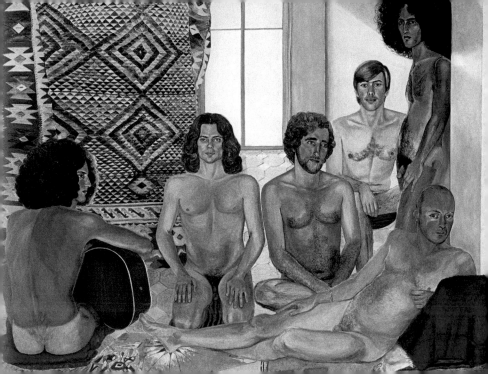

Barbara T. Smith

Barbara T. Smith is one of the pioneers of
performance and body art. Along with such art-
ists as Nancy Buchanan, Chris Burden, Allan
Kaprow, Suzanne Lacy, and Paul McCarthy, Smith
redefined the nature of art by creating durational
performances in which she used her own body
often at some personal risk.

Beginning in 1968, Smith was foregrounding
her own corporeal and gendered experience in
experimental performances such as "Ritual Meal"
and "Feed Me." In the *21st Century Odyssey*, Smith
embarked upon a journey quest for spiritual trans-
formation thus reinscribing the tourist landscape.
Her life-long commitment to alternative spiritual-
ity as in "Celebration of the Holy Squash" antici-
pates many contemporary artists who incorporate
spiritual practices in art making.

(1948–)

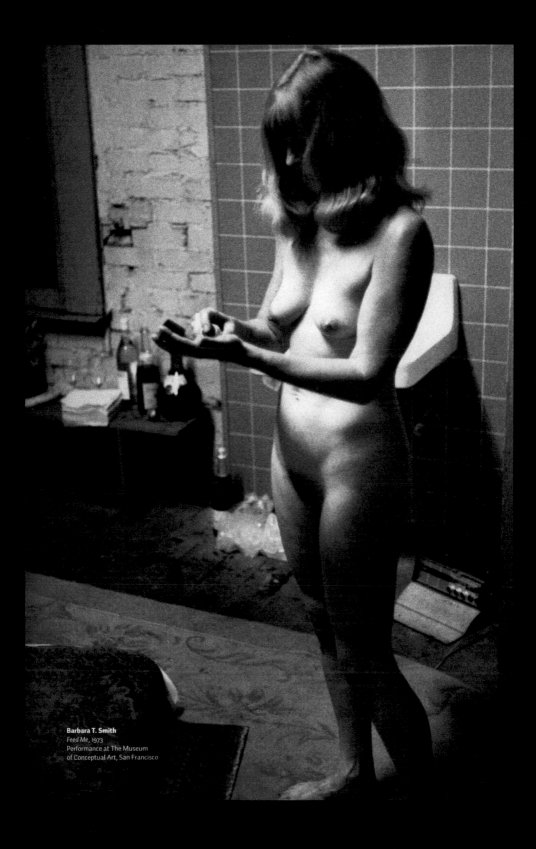

Barbara T. Smith
Feed Me, 1973
Performance at The Museum
of Conceptual Art, San Francisco

Francisco Sobrino

www.guggenheim-venice.it/inglese/collections/artisti/sobrino_bio.html

Francisco Sobrino was born in Guadalajara, Spain, in 1932. From 1946 to 1949 he studied at the Escuela de Arte y Oficios, Madrid, before moving to Argentina, where he attended in the National Fine Arts School, Buenos Aires, until 1957. In 1959 he moved to Paris and began to explore visual art, pursuing studies concerning the structure and dynamics of form, as well as color and perception. His work from this period was predominately black and white, depicting methodical shape progressions with optical effects. In 1960, along with Julio Le Parc, François Morellet and others, he formed the Groupe de Recherche d'Art Visuel (GRAV), active in Paris until 1968. The group's ethos centred on emphasising the social function of art, which they believed should no longer be seen as an individual product, but rather as a collective product. From 1961, Sobrino focused his research on three-dimensional constructions, combining modular elements of transparent monochrome and polychrome plexiglas with regular structures that, when overlapped, seemed to change if viewed from different angles.

In 1964 he exhibited at the Documenta, Kassel, and the following year he took part in the exhibition *The Responsive Eye*, held at The Museum of Modern Art, New York. During this period he built a large stainless steel structure in Sarcelles, France, forming the first of his numerous urban interventions. He also explored the effects of light, focusing on reflections, absorption qualities, transparency, and optical illusions created by shadows. In the second half of the 1960s he made kinetic objects that could be manipulated by the viewer. Despite the disbanding of the GRAV group in 1968, he continued his research into three-dimensional constructions. From 1971 he was commissioned by Grenoble, Madrid and Paris to produce sculptures for installation in public places. In 1976 Sobrino studied how to incorporate solar power into his work, creating Scultura autoenergetica in 1981. Sobrino's work is part of major museum collections such as the Tate Gallery, London, and the Museum of Fine Arts, Boston. He currently lives in Paris.

(1932–)

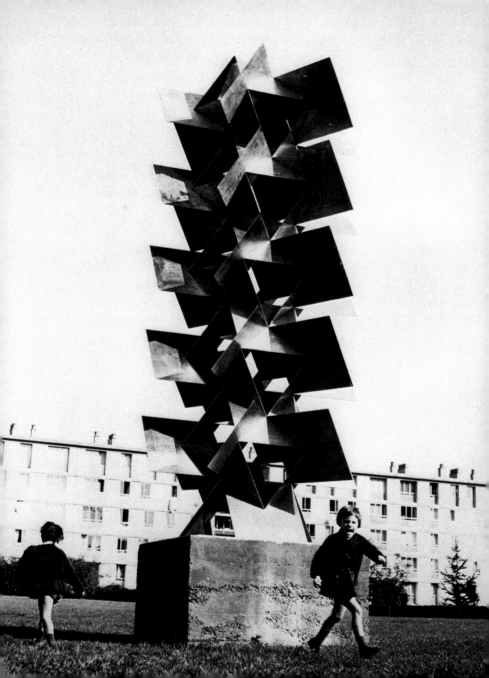

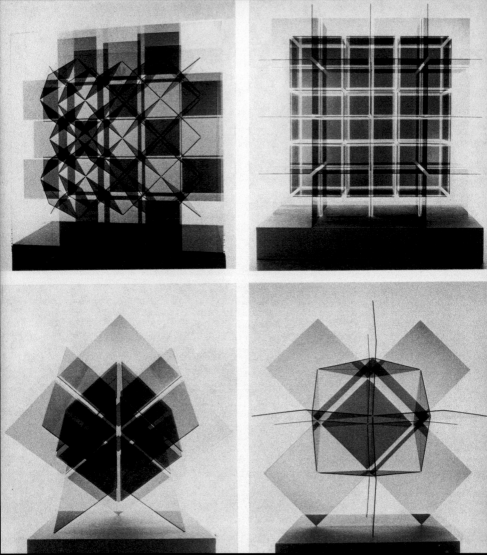

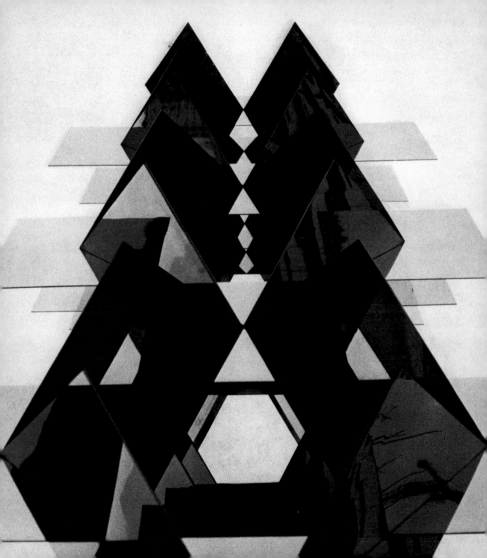

Anita Steckel

In the early 1960s, before feminism had been fully defined as a political movement, Anita Steckel took women's issues, mixed them with current politics and fleshed out a raucously original visual polemic. Steckel's medium was montage, part John Heartfield, part Hannah Hoch and totally contemporary; a uniquely New York mix of autobiography, sexual politics, political outrage and social observation, both visual and literary. She showed her work on 57th Street at the Hacker book store's gallery. At the dawn of Pop Art, Steckel called her art "Mom Art." At a time when painting and sculpture were paring down, becoming cooler, more minimal and "modern," Steckel's work was defiantly retrograde; a contentious, Semitic predecessor to Michael Lesy's poignant, *Protestant Wisconsin Death Trip*. It is interesting to view Steckel's art beside other cosmopolitan Jewish New Yorkers like Saul Steinberg and her high school classmates Milton Glazer and Rosalyn Drexler.

By the 1970s Steckel's art came to be seen in the context of the emerging feminist gound swell. Widely reproduced in feminist journals and in the popular press—images from her *Giant Woman* series, in which female figures do ambivalent battle with New York's phallic architecture, graced Ms. and New York magazines. The explicit eroticism of Steckel's art drew much attention. A show of her work at Rockland Community College in 1971, "The Sexual Politics of Feminist Art," was threatened with closure by local politicians and the imbroglio was covered in the New York press. Another exhibition, this of male nudes by female artists at the Bronx Museum of Art (then located in the Bronx County Court building) led to the formation of the "Fight Censorship" group which included Judith Bernstein, Louise Bourgoise, Eunice Golden, Joan Semmel, Juanita McNeely and Hannah Wilke. Here Steckel came up with the memorable broadside that "if the erect penis is not "wholesome" enough to go into museums, it should not be considered "wholesome" enough to go into women."[1] Indeed, Steckel's art has documented a contentious if sometimes ambiguous engagement with the patriarchy: Hitler, Nixon, Reagan, Bush; Picasso, Leonardo, Van Gogh, Duchamp.

As a mirror to her art, Steckel's personal life is elucidating. Fresh out of New York's High School of Music and Art Steckel was Marlon Brando's live-in girlfriend while he starred on Broadway in *A Streetcar Named Desire*. Then, in the early 1960s, the artist had a long, if unconsumated, romantic relationship with Allen Ginsberg and later, a friendship with Diane Arbus who was attracted to Steckel's art and fascinated by her personality. In the 1980s Steckel showed with Fashion Moda, Colab, Group Material and ABC No Rio, venues where her work must have seemed of a piece with artists like Sue Coe. Currently she has a starring role in Richard Meyer's catalog essay for LA MoCA's gestating feminist exhibition.

1. *Hard Targets: Feminist Art, Male Nudes, and the Force of Censorship in the 1970s*, Richard Meyer, in preparation.

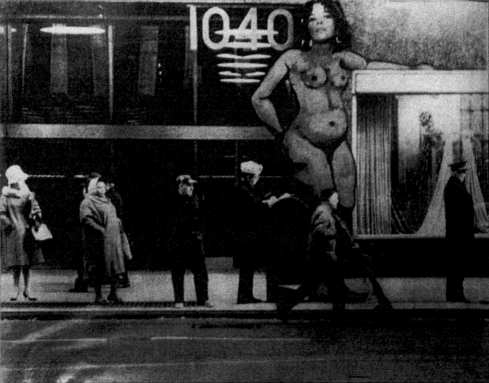

Harold Stevenson

http://query.nytimes.com/gst/fullpage.html?res=990CE7DA1F3
9F934A25756C0A9649C8B63

In 1962, Harold Stevenson painted one of the
great American nudes. Titled *The New Adam*, it
was a recumbent male odalisque—Sal Mineo was
the model—8 feet high and nearly 40 feet long,
stretching over nine panels. The face was partly
hidden, but no other anatomical feature was,
which is why the work was dropped like a hot po-
tato from the 1963 Guggenheim show for which it
had been created.

Mr. Stevenson, born in 1929, has continued to
produce monumental, confrontational nudes; a few
are in this micro-retrospective, which inaugurates
Mitchell Algus's Chelsea gallery, as *The New Adam*
did his SoHo gallery in 1993. The most interesting
piece is the oldest, the mural-size *Eye of Lightning
Billy* (1962). It is an image of a huge eye held open
by surrounding fingers and commemorates a friend
killed by a jealous lover.

The artist's signature style—suavely modeled
forms that look airbrushed but aren't—is already
in place, as it continues to be in *9/11 Twins*, an
ambiguously homoerotic take on the violence of
last fall. Forty years ago, Mr. Stevenson's work
was radical for its unapologetic approach to sexual
politics, and he has remained a political artist, as
his new work suggests. His output has been un-
even, but why *The New Adam* hasn't been bought
by a major American museum is inexplicable. It's
an art-historical landmark and one of the sexiest
paintings around.
—Holland Cotter

(1929–)

iris.time

UNLIMITED

Tiré à 4 000 ex. **1 nf**

Directrice : Iris Clert. Rédacteur, Le Brain-Trust. Siège Social, 28 Fg St-Honoré, Paris 8°. Anj 32-05 - 28 Février 1963 N° 4

GRANDE PREMIÈRE MONDIALE :

ADAM RETROUVÉ

NU PANORAMIQUE de STEVENSON

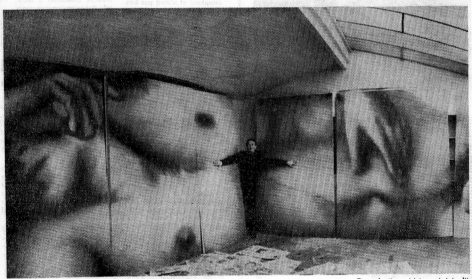

Photo : Loomis Dean. Reproduction strictement interdite

JEUDI 28 FÉVRIER 1963 à 21 h.
28 FAUBOURG SAINT-HONORÉ

PARIS VIII ANJou 32-05

du 28 février au 28 mars

Black tie **tenue de soirée recommandée**

NOS LECTEURS

NOUS ECRIVENT

THE SOLOMON R. GUGGENHEIM MUSEUM
1071 Fifth Avenue — New York 28, N. Y. — ENright 9-5110

January 29, 1963

Miss Iris Clert
28, rue du Faubourg-Saint-Honoré
Paris (8e), France

Dear Iris :

Thank you so much for sending me the photographs which certainly reveal a remarkable painting. Will you let me know exactly when you propose to exhibit it in Paris. I think you said some time in February. Is this still your plan?

I have decided that the Guggenheim Museum cannot exhibit Harold's painting. As you know, I was very interested in the work from its inception, and I like Harold's sketch for it very much. And I think that the painting itself is a powerful realisation of Harold's original intentions.

However, the exhibition here in the spring has developed a certain character as I have worked on it, which precludes my putting in this painting. I am stressing, in my choice of works, the achievement of these artists as painters. The novelty or the impact of their imagery is a secondary theme. Frankly, if I included Harold's spectacular nude, I believe that the whole weight of public attention would be drawn towards 'The New Adam'. For this reason, so as not to cause an imbalance in the exhibition, I cannot exhibit this painting at the museum.

You will see from what I have said that this is in no sense a criticism of the painting. On the contrary, I suppose it is a tribute to the painting that I feel I cannot show it.

Will you show Harold my letter, and I hope you will both understand my regrets at having had to arrive at this decision.

Very sincerely,
Lawrence ALLOWAY.

et vive Iris Clert !

Jean Paulhan.

de l'Académie Française.

PROFIL

(suite)

Stevenson a commencé par se livrer à d'étranges coptographies, explorant les ombres du corps humain. Et puis, installé enfin en pleine lumière, il a découvert les aubes et les crépuscules, les ciels grivelés, enluminés, truités, diaprés, ardoisés, amarante, nacarat dont les reflets colorent le visage, le ventre, les mains, l'âme de ses modèles auxquels ses couleurs ont rendu la vie.

Aujourd'hui, Harold Stevenson est connu. Demain il sera célèbre. Et cela ne m'étonnerait pas que, plus tard, la France soit fière de prêter ses œuvres aux grands musées des Etats-Unis où le Président et son peuple viendront le découvrir et lui rendre hommage.

Pierre BARILLET.

LE JEU du mois SOLUTION

1° L'univers intimiste... Texte de Monsieur Restany sur Joseph Sima.

2° Chacune de ses œuvres est un geste... Texte de Monsieur Restany sur Mathieu.

3° Ce style de X... est d'une telle évidence... Texte de Madame Dore Ashton sur Franz Kline.

4° Il y a là une démarche proche des investigations... Texte de Monsieur Derouidille sur Laubies.

5° Après cette pré-gestuelle de préparatifs... Texte de Monsieur Guegen sur Soulage.

6° Son œuvre, si librement riche... Texte de Monsieur Tapié sur Falkenstein.

Imp. A. Lapied, 24, r. Monsieur-le-Prince, VIe

Myron Stout

http://query.nytimes.com/gst/fullpage.html?res=950DEFD61431
F932A25756C0A9619C8B63

Myron Stout was one of those marvelous independent spirits who came of age with Abstract Expressionism. Abstract Expressionism was big, extravagant and self-obsessed. Stout's work was small, intimate and spare. Among mid-century geometric painters like Burgoyne Diller, Ilya Bolotowsky and Stuart Davis, he was the most poetic.

A modest, ascetic man of generous disposition, he could appreciate de Kooning ("the tremendous and vital energy of his struggle," Stout wrote in his journal) but declined to feel any influence himself. Instead, his mentor remained Hans Hofmann, who helped him see how to construct a purely abstract picture, while his great inspiration was Mondrian, about whom Stout observed that "the tangible and sensational world was still the raw material for the universality which he would create for himself." In other words, Mondrian, like Stout, remained firmly connected to nature and the real world.

(...)

Stout split his time between New York and Provincetown, Mass., where, until his death in 1987, he painted to the sound of the ocean. *Untitled, 1950 (Late September–December 10)*, in khaki shades, looks like cobblestones moving swiftly into the distance or like sand beneath a receding wave. *Untitled, 1950 (May 20)*, is like a Mondrian version of a stained-glass window, all bouncing, jazzy colors in a loose, busy grid.

"The canvas," Stout wrote, about another painting, "came not from any remembered form of flowers or flower beds but from a tree outside the door, a tree that the thin foliage of the lower reaches allowed the rising branches to be seen, rising, yet moving sideways, toward each other." In the end it came down to the most personal sort of encounter with nature, translated into gossamer abstractions.
—Michael Kimmelman

(1908–1987)

Ionel Talpazan

Ionel Talpazan is the subject of a book by the distinguished author Daniel Wojcik, Associate Professor of English and Folklore Studies at the University of Oregon: 'Mysterious Technology: Flying Saucers and the Visionary Art of Ionel Talpazan', projected publication date late 2003.

This book explores the art and life of this important self-taught visionary artist, who has created more than one thousand works of art inspired by his often traumatic and transformative experiences.

One childhood incident, where an encounter with a swirling blue energy seems to have been the trigger for his lifelong fascination with UFO's. Ionel considers these works (paintings, drawings and sculpture) to have a scientific as well as artistic value; his ultimate goal is to reveal to the world the mysterious technology and hidden meaning of UFOs.

Ionel Talpazan's work is represented in several museum collections and has been included in a number of exhibitions at the American Visionary Art Museum, Baltimore. He has appeared in the *New York Times*, *Wired* Magazine, *US News & World Report* and on CNN. Some of his images were also used in the sci-fi film *K-Pax*, starring Kevin Spacey and Jeff Bridges.

(1955–)

Mysterious Technology: UFO" And Science,.
Si Gautenberg USA-Aleemele robului...
US News & World Report, and on CNN.
Am creat Arta Mea Personală "Pictur-
ice, Planetele ior Arătat prin Arta Mea -
De aterizare Pe Alte Planete.
Intră 'Sau ieși Subteran -
Opiniile Mele Personale
că eXistă Sorme de Viață
Dat eXistă Plăci continue

Declar Oficial Poporului American
Vor Sci Valabile — Wired Magazine
Am creat Decene UFO Aproximativ de 40 de ani
Sculpturi Diagrame UFO "Pictur Astonim
Cam UFO bristal in Univers Și sistem
Deasemenea Am Sugerat cum UFO
In Diverse Planete din Univer
Sânt Urmatoarele eu cred
că Și civilizații in Univer
tale Supt teranea -

Tip sized drawing - Far
NASA

Riuri Vulcanice -
Oceane Sau Mări suptam
Altolua Supt Diverse Sorme
Inturnem Aspat Mediului
Respective. Planeta Noastră Pământ
Sai Singura Planeta din Univers cu Sorme de Viață Și civilizație Sixe. EXterioare - inturnem
Diverși Concrete eXsistă. Evoluția de viață și civilizația tale în cei Noi Pământeni Așa că...
sisteme de Viață Și civilizație Reade "EXsistă or Unde în Univers. Sunt totale formele
un Simal Acești Sânt Opiniile Mele Personale "In cea ce privește Universul. II

Riuri cu Apă Kea -
Sormele de Viață poate
Supt diverse Sisteme de
Inconjurat Al Planetei
E posebel K-sistem de inturnem Sc.

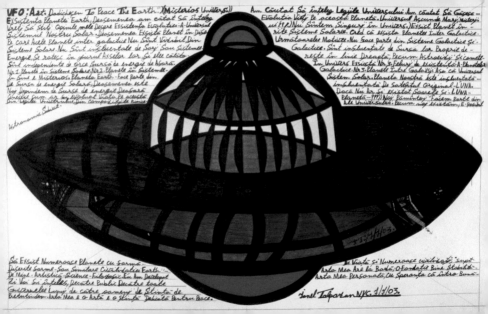

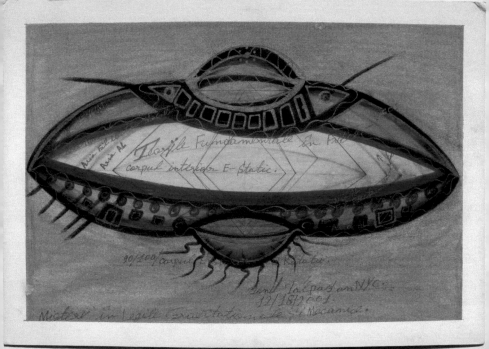

Al Taylor

http://query.nytimes.com/gst/fullpage.html?res=9F00E6D7143C
F931A25751C1A9659C8B63

Using stray, beat-up materials, Al Taylor made
works of elegant crudeness, sometimes affected
by Modernist art but always with a wry and witty
approach. They have many associations: this small
group of painted wood sculptures strung with wire
could refer to the rudimentary musical instruments
of a tribal culture, parts of a homemade sailboat or
an entry in a soapbox derby.

They also relate to African sculpture and to
Russian Constructivist motifs, particularly those
of Vladimir Tatlin, himself noted for his sensitiv-
ity to materials. The simplest work here is *Wire
Instrument (Danberry)*, a vertical slat of white-
painted plywood affixed to the wall at its top and
bottom by two triangular braces of raw wood, one
a reversal of the other. Between the braces, on
either side of the slat, hang loose wires, like the
broken strings of an instrument.

A figural play is made by a slat affixed to the wall,
with two strips of roughly equal size splayed out
from its bottom like legs. But the three parts are
attached by a triangular pattern of wires that has
a mastlike appearance. The most complicated
work is *Station of the Cross*, of Formica and wire,
a T-shaped wall construction with a projection
of linear elements sticking out from it. Loosely
strung wires, like skittish pencil marks in space,
again connect the several elements.

The show is accompanied by several black-and-
white drawings. But they gild the lily because
these works are drawings in themselves, caught
halfway between two and three dimensions. And
they are cool.

(1948–1999)

—Grace Glueck
New York Times, Art in Review: Al Taylor —"Wire Instruments,
1989-90." Published: December 12, 2003

Give warmth.

al India '65

ROTHSCHILD

Continued from Page 45

of the very rich. They have splendid homes and an abundance of unobtrusive servants. These days though they have something of a common touch, driving about in modest cars (in part to escape kidnaping) and lunching at relatively inexpensive restaurants.

Though he is the senior of the family, Baron Guy is not the richest of the French Rothschilds. His distinction is Édouard Rothschild, a younger cousin who moved out of the left and made investments in France and the United States. In recent years he had a string of racehorses and showed electronics ventures in the French Alps and a successful electronics venture in a ...

of the elephants in a zoo and ...

In the Bank ...

Feel right in your rags

Basic Rags

Our 100% ... Flannel

Our Bathrobe.

Get an an Acorn

Sons

Outdoor

OPEN ... CHRISTMAS

major investments, the ... — in the Zurich b ... owned with the English ... and is Rothschild Inc., the company.

According to legend, m Frenchmen, even those means, secrete a hoard of — or a gold bar under the m as insurance against dis rich, who tend to have num counts in Switzerland or stein, have been hit with co since the Socialist Baron Guy

cause h

try in August, voring his new his "J'accu ... illed that, s ... arse from had won ... d Prix Longcham ... as g rounds of a ... bey ordinarily ac ... hov ing the winner ...

It was a hot an Normandy, and Ba ...

... the reign of Louis XIII. A ing the morning at the gol DeauBill which is the ... of Southampto ... cool of the thick ... that Marie-Hélène, w ... ing a few friends or ... had redecorated to how ... re ision set, bookshel ... best selle ... ench ... ear ... chars

... est ... six de ... talk naturall ... dent and the ala ... in anti-Semitic attac ... the recent bombing ... s synagogue, which i ... wish community h ... me Minister at the ti ... re, ignored Jew ... ble deploring th ... t Frenchmen" ... the Baron praise business partner ... ld, who had ... ted head of ... ial body ... th ... of the com ... ss ... nation ... y in fur ... al targe Jew, ... their su The French

James "Son" Thomas

James "Son" Thomas was one of the great Delta blues musicians, as well as a self-taught sculptor. Born in Eden, Mississippi, he was taught to play guitar by his uncle and grandfather, but began to play seriously only after reaching the age of fifty. Soon afterward, Thomas' bottle-neck blues style was enthusiastically received all over the world.

Thomas worked for a while as a grave digger and this profession most certainly stimulated his creation of clay caskets and skulls with human teeth. He said he made his first skull as a little boy to scare his grandfather who was afraid of ghosts.

Thomas' music and sculpture were first documented by William Ferris, a folklorist and Director for the Study of Southern Culture in Oxford, Mississippi. In 1981, Thomas' work was included in the "Black Folk Art" show at the Corcoran in Washington, D.C.

(1926–1993)

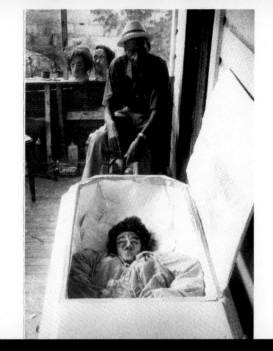

James "Son" Thomas displayed his coffin with deceased woman on his front porch for several months. He insisted that one day it would be bought and shown in a museum or gallery, and his prediction proved correct. Far from being an "outsider," then, Thomas has become very much an "insider." — Stephen Flinn Young
Photo by D.C. Young.

IT'LL COME TRUE
Eleven Artists First and Last

Show Dates
April 11 - May 16, 1992

Opening Reception
Saturday, April 11, 1992
7:00pm to 9:00pm

Festival Reception
Wednesday, April 22, 1992
6:00pm to 10:00pm

HOURS
Wednesday - Saturday 12 noon to 5pm

EXTENDED HOURS
DURING FESTIVAL INTERNATIONAL de LOUISIANE
April 23 to April 26, 1992
12 noon to 9:00pm

Benefactors
Allen & Gooch
Yvette Bleichner
Sylvia & Warren Lowe

Fortnightly Club
Delmar Systems
James Edmunds
Lafayette Building Association
Lafayette Parish Government
Carol Ross & Ron Gomez

Patrons
Nolan Albert
First National Bank
Gossen & Assoc.
Susan Hague
Ted Landry
Jackie Lyle & Conrad Comeaux
Mark Marcin & Kim Russo
Gerard Murrell
Gail Romero

acadiana arts council

This exhibition is supported in part by a
Partnership Award from the Acadiana
Arts Council with funds provided
by the City of Lafayette, Lafayette
Parish Council, Louisiana Division of
the Arts, and the National Endowment

Miroslav Tichý

After studying at the Academy of Arts in Prague,
Miroslav Tichý withdrew to a life in isolation in
his hometown of Kyjov, Moravia.

In the late 1950s he quit painting and became a
distinctive Diogenes-like figure.

From the end of the 1960s he began to take
photographs mainly of local women, in part with
cameras he made by hand.

He later mounted them on hand-made frames,
added finishing touches in pencil, and thus moved
them from photography in the direction of draw-
ing. The result is works of strikingly unusual
formal qualities, which disregard the rules of
conventional photography.

They constitute a large oeuvre of poetic, dreamlike
views of feminine beauty in a small town under the
Czechoslovak Communist régime.

(1926–)

Betty Tompkins

The large-scale photorealistic paintings of heterosexual intercourse which Betty Tompkins made between 1969 and 1974 were practically unknown when they were exhibited together for the first time in New York in 2002. Knowledge of Tompkins' paintings immediately broadened the repertoire of first generation feminist-identified imagery. More significantly, their materialization made manifest an unacknowledged precursor to contemporary involvement with explicit sexual and transgressive imagery. Shown at the Lyon Biennale in 2003 beside Steve Parrino's equally wayward abstractions, Betty Tompkins' work garnered extraordinary attention. The first painting in the series—there are only eight extant early *Fuck Paintings*—was acquired for the permanent collection of the Centre Pompidou/CNAC in Paris... Although Betty Tompkins' work is not included in LA MOCA's current *Wack! Art and the Feminist Revolution* exhibition, it figures prominently in Richard Meyer's essay for the show's catalog, *Hard Targets: Male bodies, Feminist Art and the Force of Censorship in the 1970s*. Meyer notes the essentialist bent of much early feminist-associated art and outlines the marginalization melded the phalocentric or coitus-concerned work of heterosexual women artists. Given the context, Tompkins' straightforwardness and refusal to moralize is bracing. This, coupled with a ferociously deadpan humor, makes the artist's images iconic.

Text from Mitchell Algus Gallery press release, 2007

Cleveland Turner

A treat for lovers of flowers as well as of folk art, the garden of Cleveland Turner, *The Flower Man*, is another wonderful spot to visit.

Turner was born near Jackson, Miss., and raised by his aunt. While the other children trampled her treasured flower beds, Turner was careful, and, in return, his aunt taught him how to make things grow, inspiring in the boy a lifelong ambition to have a "house full of flowers."

At 23, Turner moved to Houston and found work as a forklift operator. He also discovered wine and, he says, "drank that job down the drain" and spent almost eight years "sleeping in the weeds."

In 1982, Turner spent nine weeks in a hospital while recovering from alcohol poisoning. When released, he pledged to create that "house full of flowers" of which he had dreamed. He found gardening jobs and rented a small shotgun-style house. On the sides of his house, he has attached pictures of personal heroes and mementos of his boyhood. Scavenging for old furniture and spending what he could on seeds and paint, he turned the front yard into a magical garden.

The Flower Man's garden covers every available inch of the 700-square-foot area and spills into the ditch and the street beyond. The elevated beds flower year-round, and the amazing variety is an ever-evolving testament to the creative power of the gardener.

Cleveland Turner has just been given his first commission as an artist to create a site-specific installation for "Project Row Houses," a nationally recognized community arts program.

(1935–)

Jeffery Vallance

In 1978, Jeffrey Vallance purchased a frozen chicken at a local supermarket, named it Blinky, and ceremoniously buried it with a funeral deserving of a martyr. He then documented the sacred ritual with drawings, photographs and even a replica of the piece of Styrofoam on which the chicken had been frozen, which he named *The Shroud of Blinky*.

Since Blinky's funeral, Vallance has been documenting and displaying his personal mythologies, counterfeit relics and mythical travelogues. In his lifetime, Vallance has exchanged neckties with world leaders, been blessed by the Pope, searched for Bigfoot, discovered the faces of famous clowns in the Shroud of Turin, presented a fish change-purse to the President of Iceland, and examined the eye of the Virgin of Guadalupe. No matter how diverse the strands of his research, he always manages to weave them together to find an improbable, almost insane, synchronicity in it all.

Part intrepid explorer and part cultural anthropologist, Vallance has visited numerous foreign countries in an effort to gain a more authentic experience of their culture. In 1988, he was granted his first audience with the King of Tonga, the largest king in the world, to whom he presented a pair of extra-large swimming flippers. Vallance always performs his 'semi-official' diplomatic exchanges with a mix of deadpan humour and unblinking sincerity, although it is never clear which one is masking which.

Often, the only recording of a performance is a text that Vallance writes upon returning from his journey. These essays are usually a delirious intermingling of objective recording, ancient folklore, religious myths, historical fact, conspiracy theories, and the artist's own memory and imagination. To him, all are equally truthful and valid ways of documenting the event. Vallance creates his own authentic natural history by blending the fragments of the country's culture with the fertility of his imagination.

(1955–)

B L I N K Y

Jeffrey Vallance

I picked out a nice one
and named it Blinky.

Next, I drove to the Los Angeles Pet Cemetery to bury Blinky. Here is a photograph of the
cemetery office. I ordered the complete funeral service, including a powder blue casket
with pink satin lining, a lot, interment, flower vase, viewing room, and grave marker.

The casket and flower vase at graveside.

Postscript

After Blinky was purchased at the supermarket, I placed her on a piece of paper for the purpose of photo-documentation. Once lifted off the paper, a perfect imprint of Blinky remained in blood. Thus was formed the Shroud of Blinky. Like the Shroud of Turin, the image on the Blinky Shroud is a negative image scarcely visible in sepia monochrome.

Stan VanDerBeek

www.medienkunstnetz.de/artist/vanderbeek/biography/

VanDerBeek studied art and architecture first at
Cooper Union College in New York and then
at Black Mountain College in North Carolina,
where he met architect Buckminster Fuller,
composer John Cage, and choreographer Merce
Cunningham. VanDerBeek began his career in
the 1950s making independent art film while
learning animation techniques and working paint-
ing scenary and set designs for the American TV
show, "Winky Dink and You." His earliest films,
made between 1955 and 1965 mostly consist of
animated paintings and collages, combined in a
form of "organic development."

VanDerBeek's ironic compositions were created
very much in the spirit of the surreal and dada-
ist collages on Max Ernst, but with a wild, rough
informality more akin to the expressionism of
the Beat Generation. In the 1960s, VanDerBeek
began working with the likes of Claes Oldenburg
and Allan Kaprow, as well as representatives of
modern dance, such as Merce Cunningham and
Yvonne Rainer. Building his Movie Drome theater
at Stony Point, New York, at just about the same
time, he designed shows here using multiple pro-
jectors. These presentations contained a very great
number of random image sequences and continu-
ities, with the result that none of the performances
were alike.

His desire for the utopian led him to work with Ken
Knowlton in a co-operation at the Bell Telephone
Company laboratories, where dozens of computer
animated films and holographic experiments were
created by the end of the 1960's. At the same time,
He taught at many universities, researching new
methods of representation, from the steam projec-
tions at the Guggenheim Museum to the interac-
tive television transmissions of his *Violence Sonata*
broadcast on several channels in 1970.

(1927–1984)

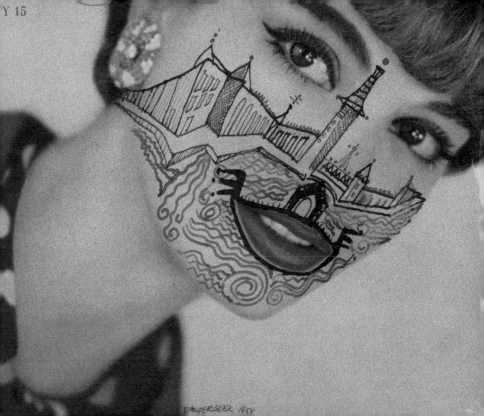

Y 15

VANDERBEEK 1958

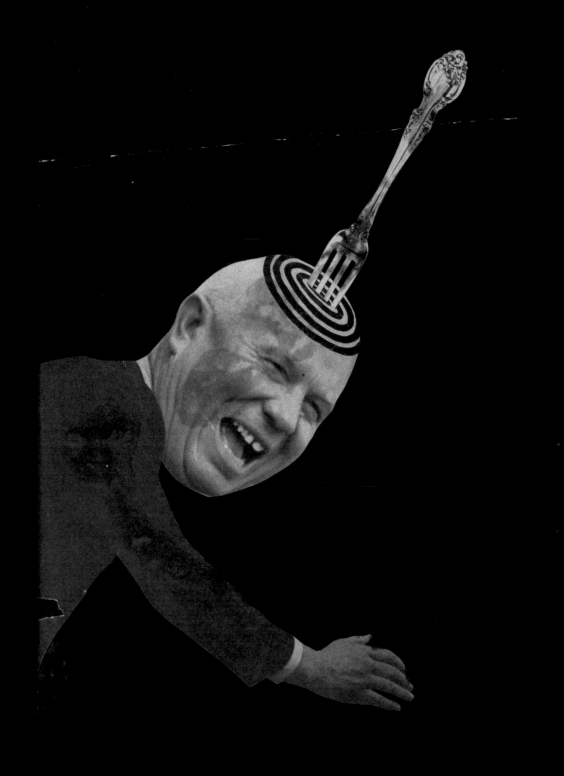

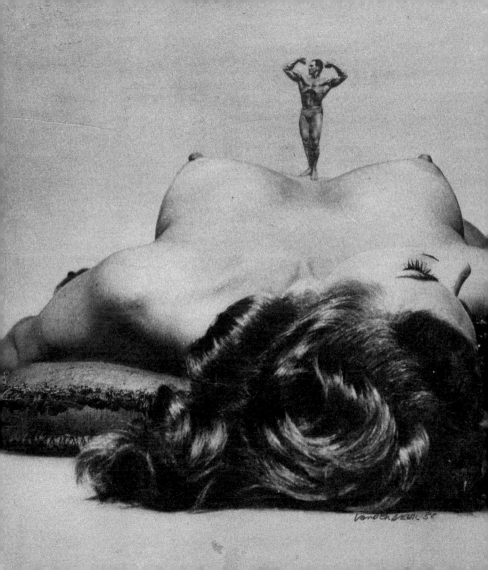

Daan van Golden

Daan van Golden has been working as an artist
for over forty years, a period of major change in
the world of modern art. Van Golden's response to
that change has been both exciting and complex.
Younger generations of artists particularly appreci-
ate the extraordinary way in which he presents his
paintings, photographs and other works in instal-
lations and publications, which then become works
of art in themselves.

Van Golden's earliest works were abstract-ex-
pressionist in nature. In 1963, while in Japan, he
embarked on a radical change in style and began
a series of painstaking depictions of textile and
wrapping paper patterns in enamel paint. His use
of existing commercial products betrays the influ-
ence of pop art, then in its ascendancy, but in van
Golden's hands such references take on a quality
of timeless elegance. His work thereafter uses a
highly diverse range of images, drawing on both
high and popular culture. Van Golden often sees
images within images; in Pollock (1991), for ex-
ample, he enlarges a detail of an abstract painting
by Jackson Pollock to suggest an animal figure. His
photographs, frequently taken during his travels,
also contain many autobiographical references,
for example the series documenting his daughter
Diana's life from infant to adult.

(...)

Daan van Golden lives and works in Schiedam,
the Netherlands. After attending technical school,
he enrolled at the Rotterdam Academy of Fine
Arts and Technical Sciences, where he specialized
in painting and took classes in graphic techniques.
He also worked as a window dresser for De
Bijenkorf, an exclusive chain of department stores.
He spent 1963 to 1965 in Japan and has travelled
widely since then, with long sojourns in such
places as Morocco, India, Indonesia, and North
and South America. His travels have found their
expression in his work.

(1936–)

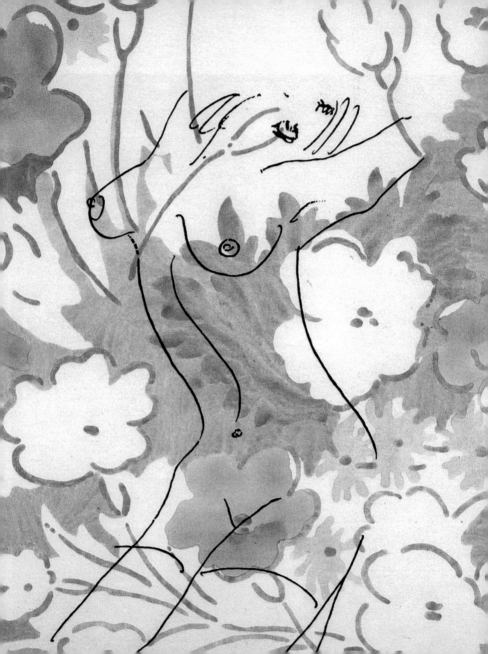

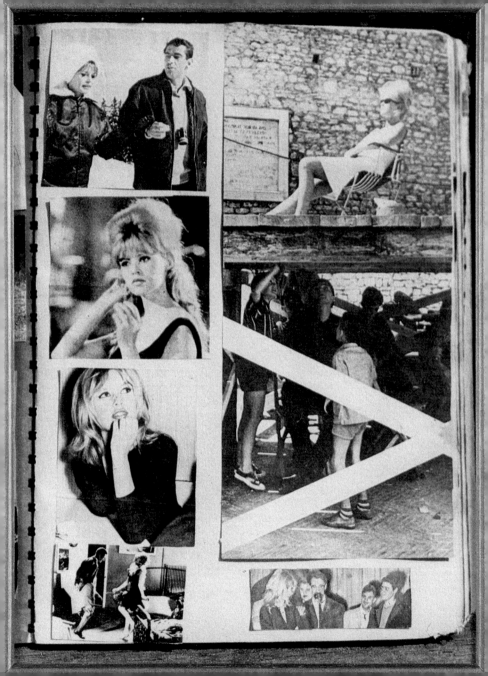

Eugene Von Bruenchenhein

Eugene Von Bruenchenhein was born in Marinette, Wisconsin, in 1910, a year when Halley's Comet came back into the near Solar System. His mother died when he was seven. His father, a sign painter, married again to a woman who not only wrote treatises on evolution and reincarnation but also painted on canvas. It seems likely that Von Bruenchenhein learned to paint from both of them at an early age. He attended Catholic schools in Green Bay and Milwaukee through the tenth grade, then dropped out to work first in the small family grocery business, then later in a greenhouse and flower shop. He married Eveline Kalke (who called herself Marie) in 1943, and a year later went to work in a commercial bakery. He stayed with the bakery until it went out of business in 1959, then spent the rest of his life in semiretirement. Shortly after his death in 1983, it was revealed that he had spent much of his life making art in seclusion. Thousands of drawings and paintings were discovered in his home, along with odd floral ceramic pieces, miniature furniture and towers made from gilded chicken bones, large cement sculptures, dozens of poems and written works, and hundreds of photographs of his wife Marie in exotic costumes and settings. She and his close family had kept his immense output a secret for decades. Although his early works were more traditional depictions of flowers and landscapes, among them was found a vast series of apocalyptic finger paintings, begun in 1954 in reaction to the development of the hydrogen bomb. Later works reveal interests in evolution and the origins of life, outer space, and futuristic cities. Throughout his house he had placed messages to himself, some in pencil scribbled directly onto the wall, and some on gilded homemade plaques. One in the basement said, "Create and Be Recognized!" while a plaque in the kitchen testified: "Eugene Von Bruenchenhein—Freelance Artist, Poet and Sculptor, Inovator [sic], Arrow maker and Plant man, Bone artifacts constructor, Photographer and Architect, Philosopher."

(1910–1983)

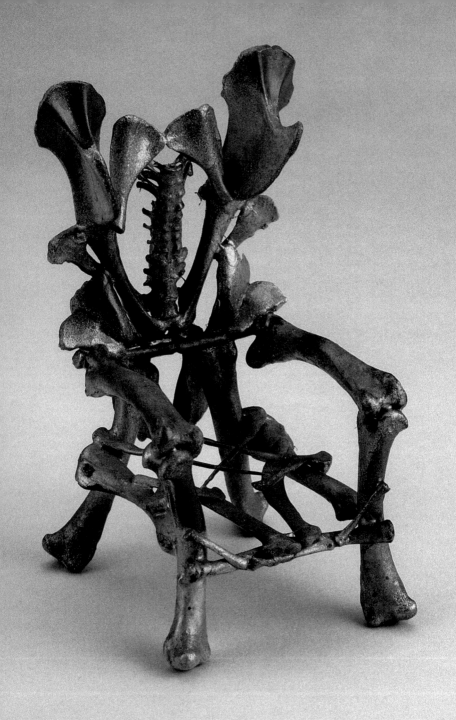

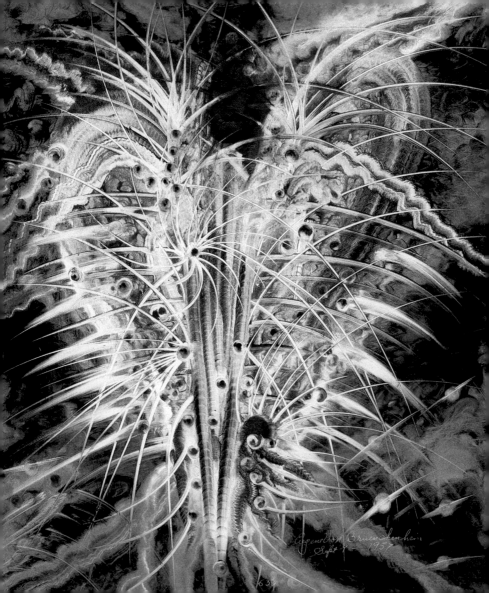

Ian Wallace

www.canadacouncil.ca/prizes/ggavma/sn127240198387656250.
htm?subsiteurl=%2Fcanadacouncil%2Farchives%2Fprizes%2Fggv
ma%2F2004%2Fwallace-e.asp

Ian Wallace has spent his entire career in Vancouver, from his education at the University of British Columbia to the present. He is one of the artists who have given Vancouver its reputation abroad as the leading art centre in Canada, and he has done this in the best way possible—by making work that holds a central place in the art history of the last 40 years.

Throughout the 1970s, Wallace developed a series of large format photographs for which he asked various friends to act out parts in fictional scenarios. A good example is *An Attack on Literature* (1975). In these works he explored both the expressive possibilities of montage and the narrative legacy of historical painting. Wallace was one of the first, if not the first, to see the possibility that large format photography could be a way of working out of conceptualism into a new kind of pictorialism, with strong roots in historic painting. This has become a very important position in contemporary art, and it is recognized world wide that the best exponents of it are to be found in Vancouver.

Wallace is an independent thinker who saw connections, resemblances and possibilities that metropolitan artists in London or New York didn't see, or couldn't see, because they led off the existing map of art history. He demonstrates how one individual, in a local context, can resonate with central problems in modern culture and offer a critical reflection on those problems that can have a world-wide influence. During his long career, Wallace has lived through the emergence of the global art world in a way that can teach us how to live in it now—openness and independence of mind lead to synchronicity and relevance.
—Robert Linsley

(1943–)

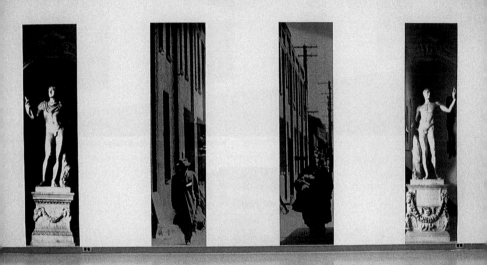

PAN-AM SCAN 1970

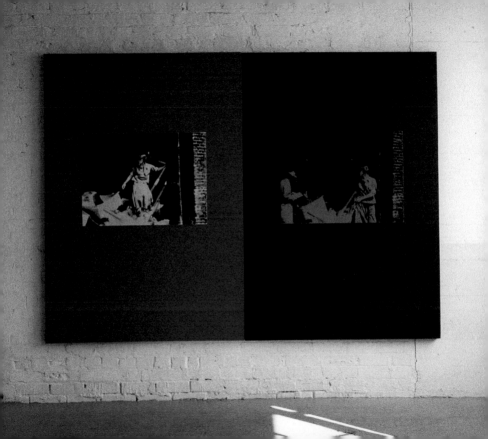

Melvin Way

Melvin Way moved from South Carolina to New
York City with his family in his youth. In his early
years, he expressed his creativity through music,
playing woodwinds and percussion in jazz and
rhythm and blues bands. He later worked as an
industrial machinist and chauffeur before entering
programs for homeless people in New York City.

He was discovered in an HAI workshop when
he quietly showed his cryptic drawing to Andrew
Castrucci, professional artist leading the HAI
workshop. Way did not actually join the group,
but developed a relationship with Castrucci who
encouraged Way and promoted his work.

Way creates his drawings on scraps of paper that
he works intensively, usually in ball-point pen.
Carrying the papers in his pockets, he often folds
and tears the drawing. His drawings recall chemi-
cal formulas, hieroglyphics or unique language that
appears to be forms of cryptic communication.
Way's detailed drawings resembling schematics
have already caught the attention of collectors.

He was featured in the publication, *Grand Street*,
and in an article by N. Karlins PhD in *Raw Vision*,
Spring 2001.

(1954–)

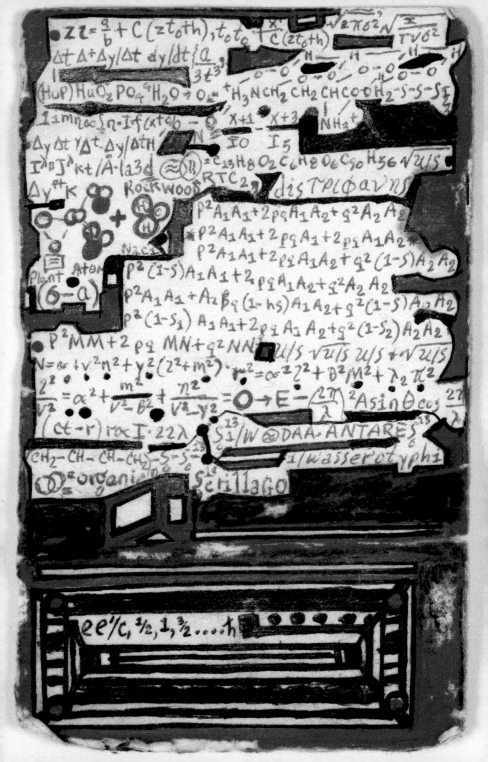

Emmett Williams

Emmett Williams was born in Greenville, South
Carolina, and grew up in Virginia, and lived in
Europe from 1949 to 1966. Williams studied po-
etry with John Crowe Ransom at Kenyon College,
studied anthropology at the University of Paris,
and worked as an assistant to the ethnologist Paul
Radin in Switzerland.

As an artist and poet, Emmett Williams col-
laborated with Daniel Spoerri in the Darmstadt
circle of concrete poetry from 1957 to 1959. In the
1960s, Williams was the European coordinator of
Fluxus, and a founding member of the Domaine
Poetique in Paris, France.

His theater essays have appeared in *Das Neue
Forum*, *Berner Blatter*, *Ulmer Theater*, and other
European magazines. Williams translated and
reanecdoted Daniel Spoerri's *Topographie Anecdotee
du Hasard (An Anecdoted Topography of Chance)*,
collaborated with Claes Oldenburg on *Store Days*,
and edited *An Anthology of Concrete Poetry*, all
published by the Something Else Press (owned
and managed by fellow Fluxus artist Dick Higgins
in New York and Vermont).

In 1996 he was honoured for his life work with the
Hannah-Hösch-Preis.

Emmett Williams was an American poet.

(1925–2007)

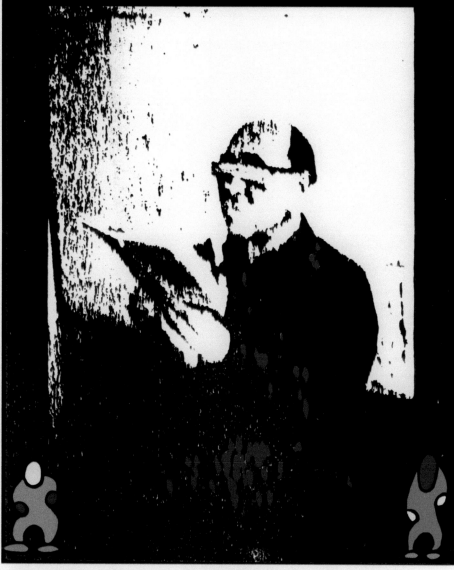

Schön, dass Sie wieder da sind!

REACTIONARY AMERICAN FLUXUS ARTISTS TRIED TO BURN UP
EUROPEAN FLUXUS ARTIST EMMETT WILLIAMS
WHEN HE RETURNED TO NEW YORK IN 1966
AFTER AN ABSENCE OF 17 YEARS.

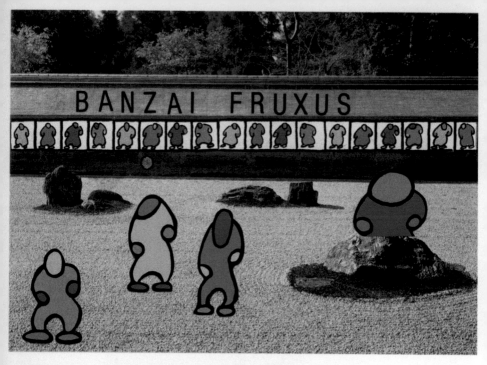

THERE IS ONE IMPORTANT THING THAT THE MASTERS OF ZEN
AND THE MASTERS OF FLUXUS HAVE IN COMMON:
THE EXTREME DIFFICULTY OF EXPLAINING, TO THE OUTSIDE WORLD,
EXACTLY WHAT IT IS THEY ARE MASTERS OF.

FLUXUS ARTISTS WERE AMONGST THE AVANT-GARDE
IN THE BATTLE TO SAVE THE ENVIRONMENT
AND ENDANGERED SPECIES.

HOMMAGE À ADOLF WÖLFLI (1864 - 1930), SWISS PRECURSOR OF ARTISTS AND COMPOSERS TOO NUMEROUS TO MENTION. TO MAKE A LONG STORY SHORT, HE WAS ALSO A CHILD MOLESTER WHO SPENT MOST OF HIS CREATIVE LIFE IN PRISON CELLS AND THE LOONY BIN.

JASPER JOHNS' <u>ALE CANS</u> MAKE A REALISTIC BACKGROUND
FOR THIS MEMORIAL TO ARTIST-INVENTOR JOE JONES.
"JASPER MADE HIS <u>ALE CANS</u> IN 1964", JOE CONFIDED TO
HIS DIARY SHORTLY BEFORE HIS DEATH, "BUT
I DISCOVERED BALLANTINE'S YEARS BEFORE THAT".

The Philadelphia Wireman

The Philadelphia Wireman sculptures were found abandoned in an alley off Philadelphia's South Street on trash night in 1982. Their discovery in a rapidly-changing neighborhood undergoing extensive renovation, compounded with the failure of all attempts to locate the artist, suggests that the works may have been discarded after the maker's death. The entire collection totals approximately 1200 pieces (and a few small, abstract marker drawings, reminiscent both of Mark Tobey and J.B. Murry) and appears to be the creation of one male artist, due to the strength involved in manipulating often quite heavy-gauge wire into such tightly-wound nuggets. The dense construction of the work, despite a modest range of scale and materials, is singularly obsessive and disciplined in design: a wire armature or exoskeleton firmly binds a bricolage of found objects including plastic, glass, food packaging, umbrella parts, tape, rubber, batteries, pens, leather, reflectors, nuts and bolts, nails, foil, coins, toys, watches, eyeglasses, tools, and jewelry. Heavy with associations—anthropomorphic, zoomorphic, and socio-cultural responses to wrapped detritus—the totemic sculptures by Philadelphia Wireman have been discussed in the context of work created to fulfill the shamanistic needs of alternative religions in American culture. Curators, collectors, and critics have variously compared certain pieces to sculpture from Classical antiquity, Native American medicine bundles, African-American memory jugs, and African fetish objects. Reflecting the artist's prolific and incredibly focused scavenging impulse, and despite—or perhaps enhanced by—their anonymity, these enigmatic objects function as urban artifacts and arbiters of power, though their origin and purpose is unknown. Philadelphia Wireman, whatever his identity, possessed an astonishing ability to isolate and communicate the concepts of power and energy through the selection and transformation of ordinary materials. Over the course of the past two decades, this collection has come to be regarded as an important discovery in the field of self-taught and vernacular art.

Paul Wunderlich

Paul Wunderlich, professor of graphic art and painting at the University of Fine Arts, Hamburg, is a painter, sculptor and lithographer who lives and works for part of the year in Hamburg and the rest in France. Married in 1963 to the photojournalist and fine art photographer Karin Szekessy (b. 1939, Essen), he sometimes paints and makes prints from the nude photographs made by Szekessy. Wunderlich belongs to the second generation of Fantastic Realists, sometimes called Magical Realists. These artists have remained faithful to the tradition although the imagery has remained contemporary. Paul Wunderlich, the most prominent among them, has developed a style slightly cooler in temperament and more analytical. Often borrowing from classical mythology, he emphasizes the human form within a context that blends together contemporary and historical references. With cool aloofness, Wunderlich transports the viewer into a world of surreal eroticism and aesthetic symbolism. Again and again, Wunderlich spices his Fantastic Realism with a startling dose of irony. After Picasso and Max Ernst no other artist has contributed as much to the sculpture of painters as Paul Wunderlich. The themes for his sculptures and objects are closely linked to his paintings, drawings and lithographs. Wunderlich sculptures and objects combine the simplicity of an idea with the refinement of the material, and imagination with perfection in shaping something into a perfect form. As an artist, Paul Wunderlich has remained faithful to his own artistic visions. Over a period of several decades, Wunderlich's complex and comprehensive body of work has led to numerous exhibitions in museums worldwide. In 1994–95, he had retrospectives in several Japanese museums (Tokyo, Osaka, Hokkaido, Gifu). Wunderlich has been successful in numerous international print competitions and has received many awards. In 1964, he was awarded the Japan Cultural Forum Award, Tokyo; in 1967, he received the Award Premio Marzotti, Italy; in 1970, he was awarded the Gold-Medal in Florence, Italy; in 1978, he received Gold-Medals at the Grafik-Biennale in Taiwan and in Bulgaria.

(1927–)

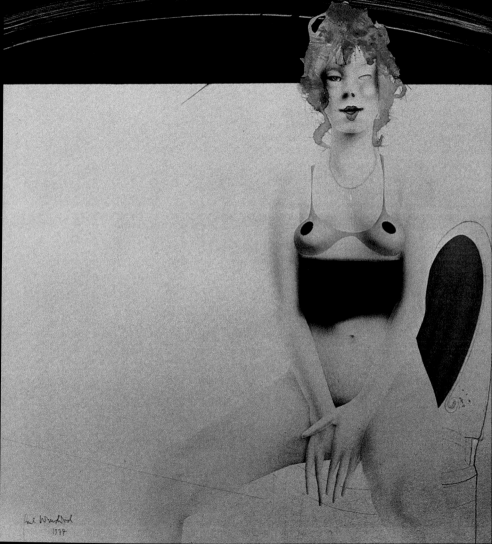